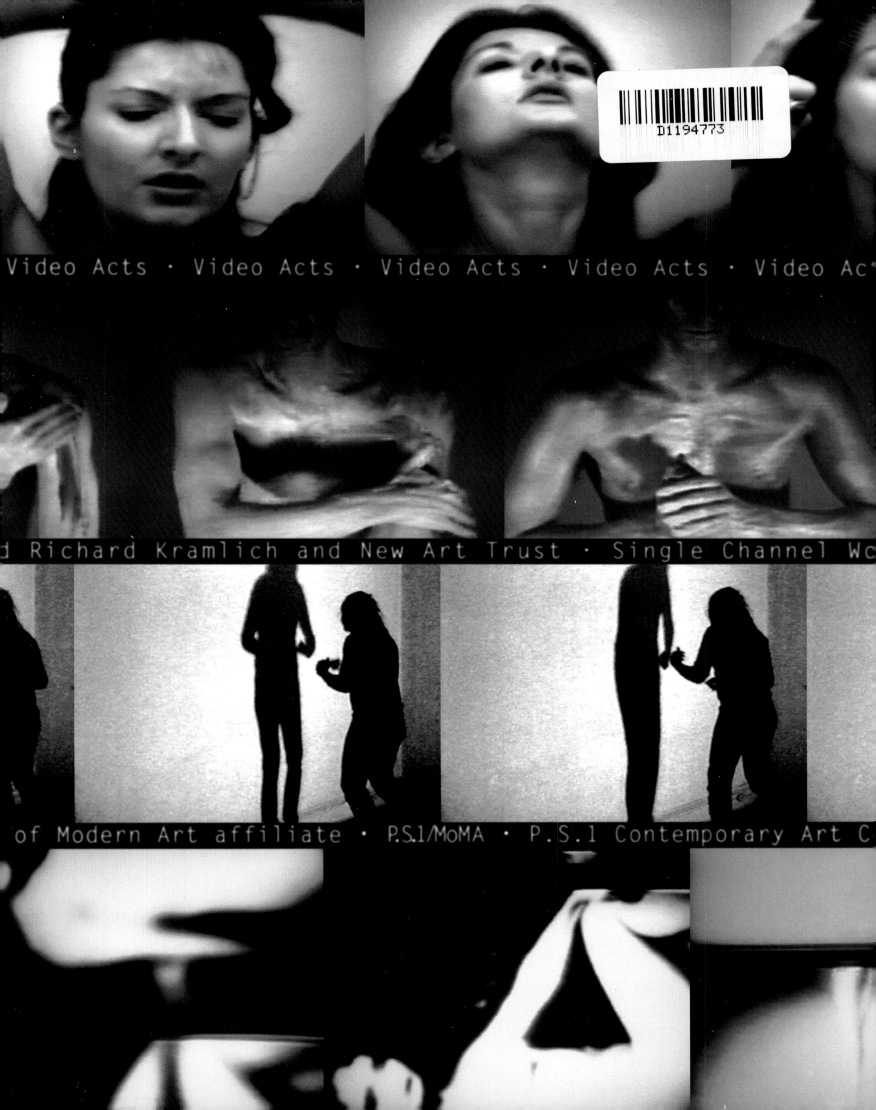

Video Acts · Video Acts · Video Acts · Video Acts · Video Act

Richard Kramlich and New Art Trust · Single Channel Wo

of Modern Art affiliate · P.S.1/MoMA · P.S.1 Contemporary Art C

Klaus Biesenbach with
Barbara London and Christopher Eamon

Video Acts

Single Channel Works
from the Collections
of Pamela and Richard Kramlich
and New Art Trust

This catalogue is published to accompany the exhibition organized by P.S.1 Contemporary Art Center, Long Island City, NY

Video Acts: Single Channel Works from the Collections of Pamela and Richard Kramlich and New Art Trust

P.S.1 Contemporary Art Center, a MoMA affiliate, New York
November 10, 2002 - April 2003

Exhibition:
Curators: Klaus Biesenbach with Barbara London and Christopher Eamon
Director of Operations: Tony Guerrero
Director of Installation: William Norton
Exhibition Coordinator: Amy Smith
Registrar / Project Manager: Jeffrey Uslip
Curatorial Assistant: Cornelia Tischmacher

Catalogue:
Editors: Klaus Biesenbach, Anthony Huberman, Amy Smith
Managing Editors: Rachael Dorsey, Rachael Zur
Editorial Assistants: Cornelia Tischmacher, Kate Green, Kristin Poor
Copy Editor: Mark Swartz
Texts: Klaus Biesenbach, Barbara London, Christopher Eamon
Idea and Concept: Klaus Biesenbach and New Collectivism
Art Direction: Klaus Biesenbach
Design: New Collectivism

This exhibition is made possible through the generous support of Lawton W. Fitt, Ronald S. Lauder, David Teiger, the exhibition fund of the P.S.1 Board of Directors, and the partners of New Enterprise Associates, with additional support from Scharff Weisberg Inc., Electronic Arts Intermix and Video Data Bank.

Thanks to Pamela and Richard Kramlich and New Art Trust

Kunst-Werke, KW, Institute for Contemporary Art, Berlin, Auguststr. 69, 10017 Berlin plans to host this exhibition and has provided additional support for the catalogue.

For Kunst-Werke, KW, Institute for Contemporary Art, Berlin, additional support for the catalogue is provided by Stiftung Deutsche Klassenlotterie, Berlin (DKLB-Stiftung) and by Dornbracht Armaturenfabrik, Iserlohn/Germany. www.dornbracht.com

P.S.1 Programs are supported by the New York City Department of Cultural Affairs, The Office of the President of the Borough of Queens, The Council of the City of New York, the P.S.1 Board of Directors, and the National Endowment for the Arts.

Cover:
Art must be beautiful, Artist must be beautiful, Marina Abramovič and Ulay, from *Performance Anthology, 1975-1980. Program 1: Four Performances by Abramovič,* 1975-76. Courtesy Electronic Arts Intermix (EAI), New York
Art Make-Up No. 1-4, Bruce Nauman, 1967-68, 40:00 min, color, silent, video from 16 mm film. Courtesy Electronic Arts Intermix (EAI), New York, © 2002 Bruce Nauman/Artists Rights Society (ARS), New York
Three Relationship Studies, Vito Acconci, 1970, 12:30 min, b&w and color, silent, Super 8 film. Courtesy Electronic Arts Intermix (EAI), New York
Vertical Roll, Joan Jonas, 1972, 19:38 min, b&w, sound. Courtesy Electronic Arts Intermix (EAI), New York

ISBN: 0-9704428-5-8

Published by P.S.1 Contemporary Art Center
22-25 Jackson Ave
Long Island City, NY 11101
Tel: 718.784.2084 Fax: 718.482.9454 email: mail@ps1.org
http://www.ps1.org

Printed and bound in Ljubljana, Slovenia

Available through D.A.P / Distributed Art Publishers
155 Sixth Avenue, 2nd Floor, New York, NY 10013
Tel: 212.627.1999 Fax: 212.627.9484
http://www.artbook.com

Table of Contents

Foreword

It is with great excitement and pride that I join P.S.1 Contemporary Art Center in welcoming the opportunity to work with Pamela and Richard Kramlich's world-renowned collection of video art. With its almost limitless scope and variety and its invaluable historical weight, the Kramlich Collection - and the New Art Trust, which was created by the Kramlichs - has offered P.S.1's curatorial team the opportunity to discover pertinent associations between works ranging from 1967 to 1998, lending this important exhibition a strong thematic focus.

Video Acts: Single Channel Works from the Collections of Pamela and Richard Kramlich and New Art Trust is an historic exhibition of video works created for display on a single monitor and demonstrates the ongoing relationship between video and performance art. Over 100 works are on view, including not only landmarks in the early development of this young medium - works by Marina Abramovič and Ulay, Vito Acconci, Joan Jonas, and Bruce Nauman, among others - but more recent work by Steve McQueen, Pipilotti Rist, and others who are redefining the genre. Video is today a familiar tool at the artist's disposal, but those who first experimented with the technology in the 1960s and '70s - as soon as affordable equipment became available - had to learn the capabilities inherent in the medium. Artists such as Nauman and Nam June Paik explored the formal qualities of this new time based art form, while Acconci and Abramovič and Ulay used video to record performances that often tested the artists' endurance. Notes for Abramovič and Ulay's *Relation in Time* (1976) seem to capture the spirit of *Video Acts:* "Art Vital: No fixed living place, permanent movement, direct contact, local relation, self-selection, passing limitations, taking risks, mobile energy."

Klaus Biesenbach, Chief Curator at P.S.1, along with Barbara London, Associate Curator in the Department of Film and Media at The Museum of Modern Art, and Christopher Eamon, Curator of the Kramlich Collection, developed a curatorial focus through their selections from the Kramlichs' and New Art Trust's vast video collections. Of course the artwork shines with the joint passion of Pamela and Richard Kramlich, who began collecting video art ten years ago. The Museum of Modern Art's 1999 exhibition *The Un-Private House* featured Jacques Herzog's and Pierre de Meuron's technologically savvy design for the Kramlich Residence and Media Collection in Napa Valley, California. I feel honored that we are able to present this look at one dimension of the Kramlich and New Art Trust's extraordinary and multi-layered collection.

Glenn D. Lowry
Director, The Museum of Modern Art

Introduction

Video Acts: Single Channel Works from the Collections of Pamela and Richard Kramlich and New Art Trust is many things: a glimpse at the ways in which performance and video have coexisted and developed together through the past thirty years; an historical investigation of the most significant artists using single channel video; an experiment in inventive exhibition design; and an exciting collaboration with the most prominent video art collectors in the world.

Unlike room-sized multichannel video installations, which provide an interactive spatial experience, single channel video works are usually gathered on compilation tapes and shown in succession on one monitor or in a special film screening. This method of display is unfortunate in that it allows most viewers to see only a few of the videos offered. *Video Acts* provides the necessary space and time for viewers to gain a comprehensive understanding of these under-recognized works by displaying each one on separate dedicated monitors.

The exhibition focuses on four video and performance artists whose provocative and prophetic work of the 1960s and '70s laid the foundation for single channel video art: Vito Acconci, Joan Jonas, Bruce Nauman, and the team of Marina Abramovič and Ulay. Each of dozens of performance-based videos by these artists is screened separately here, enabling viewers to visually and physically appreciate the breadth of their ideas. The influence of these artists in video and performance history is imperative: Nauman's and Abramovič and Ulay's experiments with placing the body in time and space through repeated actions and cyclical structures, Jonas' performance-based language of ritualized gestures, drawing, and symbolic objects exploring female identity, and Acconci's use of the body to activate and politicize public space are all still relevant. In fact many emerging artists - as well as musicians, performers, actors, and dancers - continue to explore extensions of these ideas today.

The exhibition branches out to include such major American and international figures as John Baldessari, Dara Birnbaum, Peter Campus, Valie Export, Gilbert & George, Dan Graham, David Hammons, Gary Hill, Mike Kelley, Paul McCarthy, Nam June Paik, Martha Rosler, Richard Serra, Katharina Sieverding, Bill Viola, and William Wegman, along with younger artists Steve McQueen, Tony Oursler, Darren Almond, and Pipilotti Rist,

who further develop and challenge the work of video's pioneers. As the exhibition demonstrates, single channel video endures as a cornerstone of media art, encouraging experimentation and innovation.

Video Acts: Single Channel Works from the Collections of Pamela and Richard Kramlich and New Art Trust is not a survey exhibition tracing the history of video art. Instead, born of a process of discovering and animating a critical private collection, it gives chosen selections the prominence and space they deserve as important components of the history of performance-based video art.

Glenn D. Lowry, Director of The Museum of Modern Art, has over the past several years developed a close friendship with Pamela and Richard Kramlich, and has long been eager to show their significant collection in New York. His interest helped make this project a reality. Glenn and I are indebted for this exhibition to P.S.1 Chief Curator Klaus Biesenbach, who, with the help of Barbara London, Associate Curator of Film and Media, The Museum of Modern Art; Christopher Eamon, Curator of the Kramlich Collection; and Amy Smith, P.S.1 Exhibition Coordinator, made the video selections. I would also particularly like to thank Pamela and Richard Kramlich for their remarkable generosity, their unwavering enthusiasm, and their continuous openness to new ideas and possibilities.

The installation was directed by the curator Klaus Biesenbach, designed by William Norton, P.S.1 Director of Installation, and assisted by Jeffrey Uslip, P.S.1 Registrar/Project Manager. Tony Guerrero, P.S.1 Director of Operations, supervised a smooth and organized production process. Anthony Huberman edited the catalogue with the assistance of Rachael Zur, Cornelia Tischmacher and Kristin Poor. We are also grateful to Galen Joseph-Hunter, Assistant Director of Electronic Arts Intermix, for her continued help. Finally, I thank the artists, most of whom have exhibited at P.S.1 in the past and are essential to our institution's exhibition history. Through *Video Acts*, we work with them once more and their energy has again enlivened us all.

Alanna Heiss
Director, P.S.1 Contemporary Art Center

Acknowledgment

When we began collecting video art over a decade ago, we were attracted to the diverse ways artists used the medium. Looking back over the history of video, we saw that the pioneering spirit of many of today's artists was present very early on, in the single channel tapes of the late 1960s and early 1970s. This early experimentation with video and its later use in installations struck a chord with us since we too had been involved in a vibrant community of experimentation — in the area of developing technologies. It was especially interesting for us to discover that northern California in the early 1970s saw both the development of the personal computer and an expanded use of the moving and projected image in art, notably at the Museum of Conceptual Art in San Francisco. Around the country, new art institutions and extraordinary tools were coming into existence that would have a dramatic impact on the world, and on art. As collectors, we were enthusiastic about the parallels between artistic and technological innovation. Today video artists are continuing to explore the limits of the video medium and the way we perceive space, time, and sound. Both Alanna Heiss and Glenn Lowry share in this pioneering spirit, for both of them have broken ground on projects that require a monumental commitment: Alanna in founding and expanding P.S.1, and Glenn in spearheading the ambitious expansion of The Museum of Modern Art. We are encouraged by their daring and are indeed grateful to them for agreeing to join us on the challenging path upon which we have embarked.

Klaus Biesenbach, Chief Curator at P.S.1, is responsible for conceptualizing this project, and he is without a doubt the energy behind it. We are pleased to see what he has brought to the exhibition. He sees the early video works with new eyes, and we are in turn seeing them anew. Many thanks must go to him and to the staff of P.S.1 for their hard work and dedication, and also to our advisors on the project — Barbara London, Associate Curator of Film and Media at MoMA, and Christopher Eamon, Curator of our own Kramlich Collection — for their insights and in helping shape this project. The entire team has made a tremendous effort, and we believe, as do our many collaborators, that in bringing to light a large number of previously unseen single channel videos, others may recognize firsthand their power.

Pamela and Richard Kramlich

Video Acts

Klaus Biesenbach

In *Video Acts: Single Channel Works from the Collections of Pamela and Richard Kramlich and New Art Trust,* P.S.1 presents an extensive selection of single channel video works spanning three decades and representing artists from both the United States and abroad. Instead of displaying these works in the traditional exhibition format – video festivals or special screenings with multiple works shown in succession – this innovative installation gives the appropriate space to over one hundred works by independently exhibiting each one. All of the selections are part of the important collections of Pamela and Richard Kramlich and New Art Trust. Working with a collection as rich and varied as this one has offered us an opportunity to develop a concise and relevant curatorial focus: the relationship between video and performance, and the ways in which the two have coexisted and matured over the last three decades. Rather than provide a sweeping historical survey of video art, the works in *Video Acts* emphasize a more tangible and–although this might seem contradictory to the medium–more tactile practice: the body caught on videotape. Just as video is by its nature reflective of the world around it, much of the medium's development reflects advances in technology. The invention of less expensive and more manageable video equipment in the 1960s revolutionized the medium of moving pictures, which had once been limited to financially well-backed filmmakers. Video artists could revise and edit their work with far greater ease than filmmakers could, and once equipment became available that they could own and use, video opened up to the experiments of a broad spectrum of artists. Freed of the need to hire large crews and buy or rent expensive equipment, artists could work with the properties of the moving image in their private studio spaces. Perhaps even more dramatic was the newfound possibility of giving into a nomadic impulse: artists could capture natural light, and its limitless variations, colors, movements, and forms, in real time.

Video offered artists a simultaneity of image, sound, and movement, opening up underexplored creative avenues. As the medium grew more familiar, it became not only a recording device but also a system for revealing the properties of the moving image. While some artists used video to document ephemeral performances, others challenged our assumptions about the mimetic nature of the medium and investigated its formal qualities to redefine the ways in which we interact with prerecorded images on a screen. Concurrently with the growth of video art, performance art too was becoming a primary artistic focus, and the history and protagonists of the two forms often crossed paths. It was a widespread tendency in the 1960s for artists to become less interested in material objects and to turn an inquisitive eye toward more ephemeral practices, and performance art, existing as a fleeting, unrepeatable moment, challenged the materiality of art. The legacies of the experimental performance artists of the 1960s were solidified late in that decade, becoming integral to the history of twentieth-century art, with the realization that the works could easily be documented on video and distributed to broad audiences. The turning of performances into replicable objects in turn led to questions about the nature of performance, and its relationship to an audience experiencing it in a specific time and place. Video incorporated the temporally and spatially removed viewer as a witness to the performance, making it both a material object and a recording of a moment in time.

Another object that appeared in the video art of the 1960s was the mirror, which quickly became a popular device in both performance and video. The video monitor clearly has a relationship to the mirror, and provided new opportunities for artists who were already interested in the multiple perspectives and vantage points that mirrors made possible. The two devices in combination also encouraged an abandonment of the material object: whether in video or in performance, artists were pointing instead to their own bodies. By watching themselves create art with their bodies in a "mirror," whether actual or in the

form of the video image, they made images of their bodies the art itself. Experimenting with the filming of a single body part, a certain pattern of movements, or a side of their body they usually could not see - notably the back - artists discovered a new kind of visual intimacy. Other artists placed mirrors in the natural environment, hoping to merge one landscape with another, or experimented with distortions, obliterating perspective through illusion.

Today, images distributed through the media on monitors and screens around the world play a central role in guiding the process of social identification: we use these images to gather an understanding of how to dress, how to behave, and how to carry our bodies. The reflective image of a mirror - which had been a point of reference for self-identity - is replaced by the reflective image of the monitor. The work of artists in the late 1960s - early experiments in the characteristics and possibilities of the video camera and monitor - reveals a prophetic understanding of this visual development and already hints at how the mass media images would later influence daily life by feeding us with reflections of ourselves. Artists such as Marina Abramovič and Ulay or Dan Graham juxtaposed their mirror image with a video portrait of the viewer, while the work of Jonas Jonas and many others pointed to how video could adopt the function of the mirror.

Artists' own words are always invaluable resources and perhaps can best articulate the themes, imageries, techniques, and approaches that characterize the exhibition as a whole. The questions I have asked some of the participating artists in the following interviews guide our understanding of the artistic context of the time, the decisions that shaped the making of seminal artworks, and the contemporary relevance of these revolutionary experiments. The interviews certainly highlight the diverse approaches to video and performance that permeate the exhibition, and offer more intimate insights into the artmaking strategies of some of video art's pioneer practitioners.

Interview with Marina Abramovič
by Klaus Biesenbach

When and why did you choose video as a means to document your performances?
In the early 70s the performance was a very new form of art. It was not accessible to the large audience. Sometimes the performance artist would do performances in alternative spaces in private settings for maximum of ten persons. To record performance on video in that time seemed a good solution to insure that a larger audience could see the work at a later point. Also it was the recorded memory of the event.

What were your influences in Yugoslavia? Could you compare the energy in Belgrade to New York in the 1970s?
There is a big difference between the energy in Belgrade and in New York in the 1970s. I was working together with only 5 other artists using the new medias. We felt like an island surrounded by social realism, abstract painting, and politically correct art. At the time there were no references. We felt that we were exploring completely new territory that didn't exist before.
Everything was against us: society, cultural traditions and our own families. This gave us enormous strength and determination that we had to go against all of this, no matter what. There was no understanding for such work and a market didn't exist.
I think in New York it was easier; there was a stronger tradition of Fluxus art from which performance developed as a natural reaction. There were a large number of artists working already in this direction. In dance, in film, in theater, music, and performance. There even existed magazines like Willoughby Sharp's *Avalanche* and Edit deAK's *Art-Rite*.
There were lots of places where you could perform, meet, and discuss.
Looking outside from Yugoslavia I was looking into works of John Cage, Joseph Beuys, Jack Smith, and Piero Manzoni.

Could you discuss the process of collaboration with Ulay?
When I started working with Ulay, what was most important for us was that our ideas get mixed in homogeneity. We said, at the time, that we had created something not myself or his-self but THAT-SELF.

The public will always ask, from whom is the idea? And they will never get an answer from us. We always signed the work with our two names and the position of his or my name would change. There was no priority.

At that time we lived in a car, which was a Citroen station wagon from the French police, very basic without any toilet facilities. We were busy with surviving and trying to find a way to live our lives and make our work without compromise. We issued the following statement:

Art Vital

No fixed living place
Permanent movement
Direct contact
Local relation
Self-selection
Passing limitations
Taking risks
Mobile energy

No rehearsal
No predicted end
No repetition
Extended vulnerability
Exposure to chance
Primary reaction

Can you talk a little bit about your process, what sort of preparation goes into your performances? What role does endurance play?
People always ask me this question. How do you prepare for a performance?
I don't prepare for the performance. What I do is put my mind into a time and place that the performance will take. Then I step, in this particular moment, from my normal life, in front of the public into mental and physical construction of the performance.
In the space of the performance I could push my mental and physical limits very very far. When the performance is finished and I step out into normal life I could never do the same.
Endurance is very important for me. It brings the performer and the public into another dimension of reality.

What is the relationship between the video and the performance?
There are different relationships between video and performance.

1. Video can be a pure document of the performance, without cutting or editing, present the real time of the performance; that's how most of the video registrations are made in the 1970s.
2. Video as an edited short version of the performance. Where you can see beginning, development, and the end.
3. The performer is performing only for the video, and the public could only see the video without seeing the real performance. For example the home movies of Vito Acconci.

Does the video documentation alter the perception of the performance?
Yes, the video documentation definitely alters the perception of the performance.
The performance is a dialogue of the life energy between the performer and the audience. The video is a second-best document. Definitely better than the photographs or slides but could never replace the live presence.

How does video as a time-based medium relate to your preference for repetitive actions?
These days the young generation of video or performance artists excessively uses the video media in loop form. It's interesting to see how from the 90s until now that these loops have become shorter and shorter. From 7 minutes to 3 minutes, and now from one and a half minutes to 30 seconds. Time has become condensed more and more. What really is different is that the artists of the 1970s made long duration performances, but the artists of today by constructing video loops are producing the illusion of the long process performance without going through the experience themselves.

What or who inspired your work during the 70s?
Nobody. I didn't have much access to books, I didn't travel and I was not aware of performance movements elsewhere. (I'm talking about the period 1968 until 1973). Later on I respected the work of Chris Burden, Gina Pane, and John Cage.

In what way has video evolved as a medium for artistic production?
Until the 1980s I used the video purely as a means of documentation, a way of recording my performances. In 1983, Ulay and I went to Thailand and made a video called *City of Angels* where we took the role of directors and used color for the first time. We cast people who had never been in front of a video camera like rick-

shaw drivers, women selling vegetables on the market, beggars on the streets, and so on. We filmed only twice a day, at the time of sunrise and the time of sunset. We never edited the tape or cut scenes or repeated. Our approach to this video was the same as our approach to performance. No rehearsal and no predicted end. This was a starting point where video stopped becoming just a document.

Why focus on your body?
Body is the only thing I can really relate to. It's real, I can feel it, I can touch it, I can cut it.

What role does mythology and rumor play?
I like mythology; I read everything I can put my hands on. Greek, Roman, Aztec, African, Chinese, Indian, Yugoslav, Albanian, Russian but after all that I make my own mix.

How did you respond to the unexpected? How important was improvisation?
Before I started performing I set up rules for myself. In the form of instructions. I try to follow them as close as I can but at the same time I am ready to expect the unexpected. When something unexpected happens I don't stop a performance but use it as a new element in the piece. I don't see this as improvisation because I believe that the performance has its own life.

Could you comment on the significance the audience plays?
When I do the performance the audience is extremely important to the point that I don't think I could make a performance without it. As I said earlier performance is about an exchange of energy between performer and the audience. Without this audience the performer has no function.

What roles if any does gender play in your work?
None. The gender is irrelevant.

Is there a ritualistic aspect to your body of work?
This I leave to free interpretation.

When you re-stage earlier performances, does the original meaning or intention change?
Yes. The new circumstances are different. The background of the audience is different and I am different.

Interview with Vito Acconci
by Klaus Biesenbach

When and why did you begin making videos?
My first videotape was done in fall 1970 (*Corrections*), for a show Willoughy Sharp organized – videotapes by people doing art. Willoughby had video equipment; therefore I – among other people – used it. Video forced me to think: what could I do with video that I hadn't done, couldn't do, with photographs and film? So I focused on simultaneous feedback: with video you could see what you were doing, at the time you were doing it – you could change what you were doing, you could correct and improve what you were doing. Video was a medium for rehearsal: the piece could be a tryout, a trial, a learning exercise.

What is the relationship between the video and the performance?
I didn't videotape, or film, performances, because I didn't want the videotape or film to *stand in* for the performance, I didn't want the videotape/film to *become* the piece. The performance was over, the time was gone. Photographing a performance was okay, because photographs were clearly only *instants* of a performance, it's obvious to the viewer that you're not getting the whole thing, you're not getting the real thing, you're getting only a *sign* of the performance. Once a performance was over, it should be transmitted only by reportage and rumor – something like the Second World War, say.

Does the video documentation alter the perception of the performance?
There were three exceptions to what I said above, all in 1971: *Pull*, when somebody shot the performance and I let it go; *Claim*, where a live camera and monitor were part of the performance, it was people's introduction to the performance space – since video equipment had to be there anyway, tapes were inserted, the footage gathered later and edited as a video; and *Pryings*, where a monitor on stage showed in close-up the face of a woman whose eyes I was trying to pry open – the close-up tape was released as a video, it was only a part of the performance, probably the best part, it was the goal of the performance – it was like making a videotape *within* the performance.

Could you comment on the significance the audience plays?
By the time of the last tapes I made, in 73-74, I was thinking of video as face-to-face contact, person-to-person relationship. A video monitor is approximately the size of a person's head: my

head then, on screen, was in relation to your head, the viewer's head, off-screen - I began a videotape with the question: where am I in relation to you? Could I be at the head of a table, with you-the-viewer at the foot (*Undertone*, 1973)? Could I be lying on the floor, looking up at you (*Theme Song*, 1973)? A video existed because I *assumed* a viewer.

You began your career as a poet. How did you employ narrative in your early video works?
My poems depended more on sentence-structure than on narrative. (But then again, subject-verb-object is already a narrative…) A poem didn't narrate an event in some other place, in some other time; it was travel, first on the writer's part and then on the reader's, from left margin to right margin, from top of the page to bottom. (But then again, travel is narrative, like a picaresque novel…) The early video set up a premise that then I had to react to, like a test: there's a tuft of hair on the back of my neck, I can consider that an imperfection on my body - so now I'll use the video monitor as a mirror and reach back to burn it off (*Corrections*, 1970). I probably thought I was doing nonnarrative, antinarrative; the premise set up a beginning, but my goal didn't necessarily lead to an end - the event ended, simply, when the tape ended.

How do your projects with sound and the voice relate to your other video and performance work?
The films I did were Super-8, and the convention of Super-8 then was: silent films (so I could reinvent film for myself, as if from the beginning). Video introduced me to sound. On the one hand, the video image was too fuzzy, too many dots, so you had to resort to sound to be understood; on the other hand, once I dealt with video as a face-to-face space, then sound was more important than sight - in a close-up space, vision blurs, and you have to make do with other senses. The installations I did from 1972 to 1979 always used sound and very rarely video; video was too much a *point* in the space - remember, the convention of the time was monitor, and not video projection - video was too much *sculpture*, whereas sound was an environment, an atmosphere, sound was air. It was sound, probably, that led me eventually away from art and into architecture: architecture has nothing to do with sculpture and everything to do with music - both architecture and music are the structuring and restructuring of a surrounding, an environment.

What or who inspired your work during the 70s?
Let's limit the question to the early 70s, when I was doing video: Godard's movies of the 60's; Bob Rafelson's *The King of Marvin Gardens*; Erving Goffman, Ray Birdwhistle, Edward Hall; Jerzy

Grotowski (though I never saw a play); Van Morrison, Kris Kristofferson's *Me And Bobbie McGee*, the Velvet Underground; the Vietnam War and demonstrations against it.

What roles if any does gender play in your work?
I was using my own person, my own body - my space was the space of my body - and that body was male, I couldn't take it back, I couldn't run away from it. So I could apply stress to my body; the body might change because of that stress: my body could change to female - or at least I could go through the process of wanting it to change, the action was futile, the change could never happen (a film, *Conversions*, 1971). Or I could live up to maleness, play out maleness, so that it couldn't stand the strain, it whimpered and - I hope - petered out (*Remote Control*, 1971; *Command Performance*, 1974).

Why did you decide to concentrate on your body? What role does endurance play?
I hope I didn't use mythology, or archetypes; I hope I used - still use - conventions, that could be played with and turned inside-out and upside-down. I did use American mythology, possibly because I knew that, in spite of my Italian name, I was an American and I had to redefine for myself Americanness, and certainly because of the American bicentennial year; it was a love/hate mythology, a cartoon mythology. There's another way to answer this question: because I used my own person in pieces, anybody who knew a piece of mine knew what I looked like - I thought the pieces dealt with a *person*, like any other person, but photographing/filming/videotaping turned "person" into "art-star," "culture hero" - I had mythologized myself, and that's one reason why I had to stop doing live performance. I said earlier that the only way to transmit performance, after it was done, was through reportage and rumor. The medium of conceptual art was rumor; since there was so little actually "there," the medium of the work became viewers, people, and people talk. Rumor changes facts, "distorts" facts, and there's nothing wrong with that - distribution is change. But rumor also make a thing bigger than it is, rumor mythologizes.
When I stopped writing and changed context, I was an outsider, I didn't have any skills - couldn't draw, couldn't paint, couldn't make anything. I had to start with something I could at least claim I knew: so I started with my body. Put it another way: when I stopped writing, I could choose a medium that would act as a replacement for the page - but, if I had gotten to the point where the page was no longer useful, then I could assume that any medium that replaced the page would eventually no longer be useful, and I would have to drop it - so, instead of focusing on a medium, a ground to work on, I would focus

instead on the *instrument* that used that ground. I would focus on myself as instrument who then could choose whatever ground happened to be available. Put it yet another way: minimal art was my father-art, but I had to kill the father, so that I would have something to do, somewhere to go – so I made myself think that, because a minimal sculpture appeared with no sign of the maker, it appeared as if from nowhere, like the black monolith in [Stanley Kubrick's] *2001: A Space Odyssey* – when something appears from out of nowhere, you have to bow down in front of it, it might be more powerful than you are – so in contradiction to that I had to appear in person, because then I would be held responsible, I couldn't hide behind the scenes, and what I did was the same.

Is there a ritualistic aspect to your body of work?
I hope not. If there's ritual, then there's religion, and I hope what I've done and what I'm doing is the opposite of that. There might be a *replicating* aspect, and that's okay: when something is repeated, it becomes matter, it becomes a fact – when something is repeated, it proliferates like a disease, that spreads over and overtakes the normal.

How did you respond to the unexpected? How important was improvisation?
I assumed the unexpected; it was the unexpected that gave a piece its incidents, all the rest was rote. If the hair at the back of my neck caught on fire, I'd better be ready to rub the fire out (*Corrections, 1971*); if a person came downstairs toward the basement, my self-hypnotism had to make me ready to kill (*CLAIM, 1971*). But I didn't think of these as "improvisations"; they were simply being on guard, being on the alert, living as if in a minefield. Improvisation, in terms of my work of the 70s, meant talk. In most of my videotapes, I set up beforehand a general structure of talking, and then the actual talk was improvised – I was trying not to be an actor, I wanted to think/talk on my feet and from the hip. But in retrospect, the attempt was futile: since it was a prerecorded tape, no one could tell whether I was improvising or not – I was an actor, whether or not I wanted to present myself as one. Improvisation was important only in live performance. The event of performing was the event of a stand-up comic: the lights go on, and *you* have to go on, there's no turning back now. Performing meant performing a contract: you said you were going to do it, and now you had to carry out your promise. But improvisation made no sense in video, because improvisation demands stage fright; improvisation makes sense only when other people are there, who can watch you fail, who can *make* you fail.

Interview with Joan Jonas
by Klaus Biesenbach

When and why did you begin making videos?
My first public performance was in 1968. Later it was translated into a film called *Wind*. It was shot outdoors on the beach (with camera and co-editing by Peter Campus). In 1970 after visiting Japan I bought my first Portapak (video camera and recorder) I wanted to extend my work, to translate it into a medium that would reflect but also alter the original. This came from my interest in the history of film – it was simply the next step. Unlike film, video allowed instant simultaneous sequences. Like performance, video was relatively unexplored territory.

Can you talk a little bit about your process, what sort of preparation goes into your performances? What role does endurance play?
I begin in different ways with props, and/or material and a specific space. I also construct a space or set. In 1968, inspired by Jorge Luis Borges, I made a mirror costume and quoted all references to mirrors in "Labyrinths," while a consideration of the performance space (a large gymnasium) and the peculiarities of the mirror costume generated my movements. I step in and out of the performative area and ideas come from just looking from the point of view of the audience. In thinking of illusion and space I would imagine early Renaissance painting or frescos in Pompeii, for instance. In the *Mirror Pieces* (1969-70) performers carrying 5' x 18" mirrors moved in choreographed patterns. We improvised until I decided on specific patterns and use of time. These mirrors reflected and fragmented space, bodies, and audience. I was interested in the perception of space and how to alter the image through a specific medium (i.e., mirrors, closed circuit television, deep landscape, and text or story).
Organic Honey's Visual Telepathy/Vertical Roll (1972-73) (other works from same time include *Duet* and *Left Side Right Side*) evolved as I continuously investigated my own image in the monitor of the closed circuit video system. I played with costume, mask, and objects in relation to the video camera. At that time I imagined I was an electronic sorceress.

What is the relationship between the video and the performance?
I developed a structure in relation to content that evolved from interacting with the particular relation to camera and monitor and projector. All moves were for the camera.
Usually a performance takes about a year to develop. However I do not work with endurance as a concept as Marina and Ulay did.

When I began to work with video I called it film. I was making videos, but I was referring to film all the time. I was entranced by the early Russian films: Dziga Vertov, Sergei Eisenstein. And early French films: Jean Vigo, Marcel Carné's *Children of Paradise*. Early black-and-white films where the narrative was dreamlike, poetic. *Children of Paradise*, for instance, portrays the essence of the theatrical magic in the way the performer on stage relates to the audience in the highest balconies through the body.

I began by making a simple set. There was a table with objects: a mirror, a doll, a water-filled glass jar into which I'd drop pennies. There was a chair, cameras, and monitors, large mirrors, blackboards. Sol LeWitt asked me to do something for his students, and moving this set to the 112 Greene Street Gallery, I got a camer-aperson to come in. We performed sequences involving the fashioning of images for the camera. It was all there, it was just a question of putting the viewer in a certain position to watch it. From the beginning I was interested in the discrepancy between the camera's view of the sub-ject - seen in the monitor, or a projection, which was a detail of the whole - and the spec-tator's. The video camera framed details of the live performance, juxtaposing a parallel narra-tive - the part to the whole. Such simultaneity allowed me to make more complex statements.

I was also involved with feminism and what it means to be a woman. The women's movement pro-foundly affected me; it led me, and all the peo-ple around me, to see things more clearly. There is always a woman in my work, and her role is questioned. Video provided a channel for explor-ing the possibilities of female imagery. In *Organic Honey's Visual Telepathy/Vertical Roll* I created an alter ego, my opposite, and called her Organic Honey. I stepped outside of myself and played with a reflection. The monitor was an ongoing mirror. In *Left Side Right Side* (1972) I explored how one perceives left and right in the video monitor as opposed to a mirror. A mirror held mid-face doubled each side mixing left and right, emphasizing the difference.

I approached video in the same way as one would with experimental films, working with the actual medium and its peculiar qualities. The vertical roll in video looks like a series of film-strip frames going through the monitor - that's the reference. I also played with the video light, the light emitted from the monitor, as a source of illumination for other actions. I was refer-ring to the continuous time of the piece in a different way. In *Organic Honey's Visual Telepathy*, I drew my dog Sappho. She had one blue eye and one brown eye. Her image was a kind of leitmotif for *Organic Honey*, the animal spirit that represents a force or instinct. Then I did

drawings for the video monitor. I drew "around" the vertical roll and used the vertical roll to bring the parts of the image together. I drew the top half of the dog's head on the bottom of the paper, the bottom on the top; then with the roll the two halves came together. I also put my masked face in place of the top half of the dogs, turning me into half-woman, half-dog.

Does the video documentation alter the perception of the performance?
Yes definitely. One can never experience the original live event in the same way. The documen-tation is just a record. At first I was reluctant to even do it but recently I edited the footage of *Organic Honey* shot at a performance at Leo Castelli Gallery in 1973. Almost thirty years later I am able to see more objectively. Most of my autonomous video works are translations and developments of performances or of ideas found through the process of performing. Some were made quite separately. I move between performance and video continuously.

Could you comment on the significance of the audience?
The audience is necessary. In the Mirror works they became part of the picture they saw reflect-ed in the mirrors. I imagine how the audience will perceive images in the distance, for instance, as in the "Jones Beach Piece." They were standing a quarter of a mile from the action. This gave me a certain freedom of move-ment. I kept a distance indoors also, relating indirectly to the audience through the closed circuit video. Drawings made in performance are different from ones made privately. I am inter-ested in how the presence of an audience affects an action.

Why focus on your body?
I don't necessarily think of my work as focussing on my body, but my body is the vehicle for the work. At first I treated my body as material to move, to be moved or to be carried by others stiff like a mirror - to be moved by or to move props, to be part of the picture, to make the picture. In the video pieces the body was a sum of its parts to be fragmented and seen in close-up, never whole. As a performer I could change rolls, identities through disguise, costume, and use of masks. I made sequences, images for a poetic narrative. Video allowed us to see our-selves in the moment, which led to a development of performance strategies. I was interested in the narcissistic aspect.

I find my language partly through simply stepping into the performing space and playing in relation to all the various elements (sound/music, object/prop, story, and so on).

What or who inspired your work during this period?
All the films I saw at Anthology Film Archives during the 60s and 70s. Happenings and the collaborations of dancers and visual artists in the Judson Church. The work of Jack Smith, the Noh and Kabuki theater I saw during the visit to Japan in 1970, the work of American poets called Imagists and James Joyce, Borges and of course the situation in downtown New York at the time, where traditional boundaries between the forms of painting, sculpture, music, film, etc. were questioned.

What roles if any does gender play in your work?
I am interested in specific female roles or parts and how that relates to the culture. This is a continuous thread.

What role does mythology and rumor play?
Mythology in a traditional or historical sense is present in all of my work, although it is not visible. In switching to a time based medium I referred to traditions or devices in literature, film, poetry and theater, and even the iconography of painting.
For instance in James Joyce's *Portrait of the Artist as a Young Man,* the myth of Daedalus is used to represent the situation of the main character. My early work is more or less silent and black and white – I used stories and myths to construct image sequences that represented something in my particular consciousness that was personal but abstract and not autobiographical. I had to construct an imaginary world – imaginary personas. Later in 1976 I saw the films that Maya Deren shot in Haiti. The filmed drawing sequence in the video performance/installation *Mirage* (1976/94) came from seeing repeated actions unedited, of sand drawings. I translated this into chalk, drawing and erasing my own set of signs.

How does video as a time-based medium relate to your preference for repetitive actions?
Repetition was always there as I also based pieces on musical forms. However, referring to film, working in video, I used the language of montage, of the cut, the edit to construct my work. And in *Vertical Roll* the frames of the vertical roll as I performed actions in and around and in relation were a repetitive element. I am interested in how an action changes by repeating – in how one's perception is altered by repetition.

How did you respond to the unexpected? How important was improvisation?
I used the unexpected as discovery. No such thing as mistakes. This was part of a dialogue with the audience. I used improvisation only in research/rehearsal. It is essential to development and discovery. My performances are usually totally choreographed beforehand. However *I Want to Live in the Country* (1976) (a videotape, never a performance) was made entirely by improvising in a television studio with props and movements in a video setup with two cameras. Occasionally I find a system or device which allows for moving with props like *Moving with No Pattern* (1998). This came from a student workshop. In my teaching I set up improvisational workshops with sound and video.

How has technology affected the current output of art production? And how has it shaped your artistic approach?
The medium is a tool. The camera is equivalent to a pencil. Lately new technologies make things easier and faster. I can do everything in my studio. I can concentrate on the editing process. My studio is a place of production. My work is not better, it is different.
Anyone with a computer and a camera can make a film, can document a subject. This is interesting and empty.

How did the medium itself inform and influence the work?
I never saw a major difference between a poem, a sculpture, a film, or a dance. A gesture has the same weight as a drawing: draw erase, draw erase – memory. My ideas of form and content come from an interaction of these forms.

Is there a ritualistic aspect to your body of work?
In switching from sculpture and art history to performance I wanted to refer to sources outside the art world. In the 60s I went to Crete and witnessed a three-day wedding in the mountains during which the men sang impromptu greetings as guests rode from village to village. Later I visited the southwest and saw the Hopi Snake Dance. Both experiences were profound. I saw how ritual and performance existed as part of a life cycle. These experiences were inspirations for my work, although I was careful to translate into my own language, not to borrow. Later I did actually use a drawing ritual from a tribe in New Guinea as part of a blackboard sequence in *Organic Honey.* It is called "Endless drawing" and was perfect for drawing in performance. I wanted to find my own rituals of the everyday for an audience that was then composed almost entirely of a familiar community.

What are the sources for your choice of narrative and props?
I used what was at hand in the *Organic Honey* pieces. Props were passed down from family and

found. I visit flea markets. I made a drawing for the camera, tracing outlines of a sequence: an old doll, a stone, a mirror, a hammer – building layers of lines suggesting a poetic narrative. I see an object that can be used inappropriately and repeatedly in different ways. Houdini escaped from a wheel, which gave me the idea to make a six-foot metal wheel to roll around in (*Jones Beach*, 1970). Later it hung from the ceiling, spinning to reggae music. For this work, *Funnel* (1974), I began with the form of a cone. I wanted to explore the implications. I made a set out of paper that receded and filled it with paper cones of all sizes. A video monitor in the set reflected this grouping. Then for *Twilight* (1975) and *Mirage* (1976), I had six nine-foot metal cones fabricated and used them in as many ways as possible – to sing and shout through, to bang, to look through, and so on. Narrative models were early film, poetry (in terms of structure), the Noh Theater, rituals, magic shows, the circus. Later I worked with fairy tales, news stories, and sagas.

In what ways has the medium evolved? Is single channel video important today?
In terms of poetic narrative in the work of younger artists such as Eija-Liisa Ahtila the work goes beyond the one-shot/one-idea projected image as painting syndrome so prevalent in work of the last ten years, and relates to film making using possibilities of video directly relating to the content of the work. And Pipilotti Rist is also one who finds ingenious solutions to the challenges of display.
I find it very interesting that young artists are using information that has sifted down through the past 35 years involving performance art, conceptual art, and all forms of media. These and other young artists are going into the world and working with the everyday or popular culture in relation to particular, and/or personal issues, while discovering, recycling, and inventing various images. In documentary style, they record specific events as they relate to their perception of how to position themselves in relation to relatively unexplored subject matter. In this sense the work is political because it asks questions and interacts with the local context in a challenging way by mixing the familiar with the unfamiliar and by transporting different visual languages.
Also there has been a continuous high conceptual standard in the work of people like Gary Hill and Stan Douglas, for instance, who explore more complicated relationships of media structure and content. Single channel video is only important if it represents such concern with invention.

For the Love of Scan Lines
Barbara London

"Video art" began in the mid-1960s, when portable video equipment – the Portapak – became available on the market. Until that time the medium had been restricted to well-lit television studios, with their heavy two-inch-video apparatus and teams of engineers. Not that users had an easy time with the early version of the Portapak: it consisted of a bulky recording deck, a battery pack, and a cumbersome camera, and the tape, on open reels, often got snagged. Still, artists found the Portapak affordable, and the ability to record in ambient light made the medium attractive.
Artists accustomed to painting by themselves in a studio found they could carry on their solitary routine with the new video equipment. They pointed the camera at themselves, composed scenes, and monitored the live images as they were recorded. The artist was producer, cameraman, and performer rolled into one.
Video editing of these first productions was next to impossible. Artists accepted the limitations of the medium, and in keeping with John Cage's slogan "Go with whatever happens," they adopted "No editing" as an aesthetic. Consequently, many early works run for the full length of a thirty- or sixty-minute tape.
Bruce Nauman's videos of the 1960s feature repetitive processes performed for the camera. *Lip Sync* (1969) records a single nonstop action repeated over and over on the one-hour tape: Nauman, outfitted with earphones, tries to repeat what he hears – his just articulated phrase "Lip sync." Evidently, his aural and vocal faculties are disconcertingly out of sync. Nauman's exertion induces physical distress in the artist and in the sympathetic viewer.
William Wegman's *Selected Works: Reel #3* (1973) takes a different tack: the artist works in his painting studio, on his own with a star performer – the weimaraner dog Man Ray. The humorous sketches enacted by Wegman's canine alter ego call to mind the zany antics of Ernie Kovacs, the funnyman of the golden age of television.

Another art form that came to prominence in the 1960s was performance. Although video and performance forged individual identities, they also worked well in tandem. Video's ability to arrest and extend time and space blurred the boundaries of live performance: the form was no longer constrained to a one-time action limited in space. The enhanced palette that video and performance brought to each other stimulated painters, sculptors, musicians, and dancers to explore this cross-disciplinary form.

Early in her performance career, Joan Jonas began to use mirrors to construct illusionary spaces. She also often performed with a live video camera, which she linked to monitors on stage. The setup allowed Jonas to reveal close-up details of her performance while maintaining a theatrical distance from the viewer.

Jonas typically develops a work by presenting it several times, reshaping and enriching each performance. At the end of this evolutionary process she generates a video that encapsulates the performances yet stands alone as an original work. Jonas's performance/video *Organic Honey's Visual Telepathy* (1972) includes a continuous series of close-ups explicitly choreographed for the video camera. The details of the live action are fed to an array of monitors onstage, which the audience perceives as a nonnarrative play within a play. Clearly, a video/performance play within a play has means unavailable to its theatrical equivalent.

Richard Serra's 1973 video *Surprise Attack* operates largely outside the video frame – only Serra's arms and torso are visible onscreen. While he declaims from Thomas C. Schelling's *The Strategy of Conflict,* he vigorously slams a lead rod from one hand to another. The close-up view seems to expand beyond the box of the video monitor to include the artist's whole body in action. In painterly terms, Serra has extended the painting on the canvas beyond the frame.

The effect of context on interpretation is an abiding concern of conceptual artists. The tape *John Baldessari Sings Sol LeWitt* (1973) opens with Baldessari facing the camera. In a deadpan voice he says, "I'd like to sing for you some of the sentences Sol LeWitt has written on conceptual art." Then, to the tune of "Tea for Two," he sings LeWitt's text, which begins, "Formal art is essentially rational." The song plods along for about twenty minutes – as long as it takes to outline LeWitt's notion of conceptual art.

Vito Acconci is faithful to the tradition of artists who refuse to acknowledge any limitations. Everyone except Acconci agrees on a fundamental distinction between video and performance – the video on a monitor is not alive, right? *Command Performance* (1972) sets out to prove otherwise. The videotape presents Acconci as a talking head available for conversation – his head is the same size as the viewer's. He cajoles, entreats, and charms passerbys, and soon enough has them talking back to him. The realization that they are chatting with a video image chagrins some viewers, but falling for Acconci's ruse is no worse than saying "Thank you" to an electronically generated telephone voice.

Bill Viola developed his ideas about actual and imagined time in a series of short works centered on a particular location, sound, or action. *Space between the Teeth* (1976) features Viola as subject/performer full-face on a monitor, staring intensely at the camera. As his anxiety rises, the tension is transferred to the camera, which slowly dollies back to long-shot as if it were pulling an elastic band taut. Finally, Viola releases an agonizing scream, freeing the camera to dolly/zoom with amazing speed right into his larynx.

Mainstream television broadcasters often look to artists for ideas, but on occasion creativity flows from the commercial world to video. Peter Campus, a professional filmmaker, devised a riveting and much copied illusion in which he appears to tear a hole in his back and walk through himself. The video, *Three Transitions* (1973), was produced by Public Television's WGBH (Boston) in an artists' lab furnished with a professional crew.

Another work to come out of WGBH was Nam June Paik's *Global Groove* (1973). The video strings together Pepsi commercials, the modern dancer Merce Cunningham, the poet Allen Ginsberg, a tra-

ditional Korean dancer, and an ingenue tap dancer from *A Chorus Line.* The arrangement of images seems haphazard, and indeed they are unconnected except for the facets they reflect of the "global village." When Paik made the video, the idea of a world culture was seen in a positive light. The mantra "We are all one" was groovy.

In retrospect, it is not surprising that video was particularly attractive to women artists: the field was new and wide open, without an established hierarchy or old-boy network to exclude women. Martha Rosler's *Semiotics of the Kitchen* (1973) is a hilarious parody of the popular TV cooking show with chef Julia Child. Instead of a recipe, Rosler presents her impression of everyday kitchenware. She begins by enunciating "A" as she dons an apron, then proceeds letter by letter: she illustrates E by beating the air every which way with an eggbeater; for K, she raises a knife, and segues into a series of vehement stabbing gestures. By the end of the alphabet the kitchen cupboard resembles a cabinet of torture instruments. Kitchenware, Rosler suggests, is a tool of repression that channels women into traditional roles.

Wonder Woman, the superhero of comic book and television fame, is commonly seen as a strong role model for women. Dara Birnbaum, however, does not consider this superhero wonderful: her image was conjured up by men, who also outfitted her with a silly superhero accessory – a metal bracelet that can deflect bullets. Birnbaum's video *Technology/Transformation: Wonder Woman* (1978-79) is a patchwork of clips from the TV show. The voice on the music track of Birnbaum's tape taunts Wonder Woman to "shake thy wonder maker." Well, what makes a woman wonderful?

The provenance of Tony Oursler's *Weak Bullet* (1980) can easily be determined: it originated as a stream of consciousness from the hallucinogenic 1960s and '70s. In those heady years, drug visions branded the memory of mind explorers. Everyday life rarely packs the wallop of such experiences. Readers of Carlos Castaneda's series of books could readily believe the teaching of their drugmeister protagonist, Don Juan, that physical existence is not the primary reality and quotidian trials are mere interruptions of one's true life within the world of dreams. In *Weak Bullet,* Oursler inhabits a grisly underworld, as if he were on a bad acid trip and suffering seizures.

A streak of desperation marked the art world of the 1970s. Perhaps the distress caused by the Vietnam War, or by the demise of the revolutions of the 1960s, left artists rudderless. Like many of their contemporaries, Marina Abramović and Ulay turned to nihilism, which they directed at their own person. In performance, they psyched themselves up to push themselves to the ultimate end – their death. On more than one occasion they were rescued by a viewer. In *Breathing In Breathing Out* (1977), Abramović and Ulay breathed only each other's exhaled breath until they passed out.

Paul McCarthy used to perform before a live audience, but the privacy of video recording provides a more appropriate stage for his disquieting revelations. McCarthy trades in bad taste. Many of his personae are animated by a juvenile fascination with blood and semen (ketchup and mayonnaise). His characters also gleefully play with brown mustard.

Heidi (1992), a collaboration between McCarthy and Mike Kelley, purports to recount the children's tale of a virginal maiden. The artists' Heidi is a large doll, three feet tall, with the face of Madonna (the pop star version). Wearing masks, McCarthy and Kelley engage Heidi/Madonna and two dolls in a sadomasochistic orgy that surpasses any of the escapades attributed to Madonna herself.

Video by its nature reaches into many areas. Over the years, artists from many different disciplines have come on board, producing a wide variety of video works. Today video is mainstream, but to gain acceptance it had to overcome several hurdles. One relatively unheralded advance, for example, was the invention of the video cassette, which enabled museums to program video decks rather than hire someone to stand in the gallery and rewind reel-to-reel tape.

Many years passed before guiding principles for the acquisition of videos were clarified.

Following the tradition of the unique objects of painting and sculpture, some artists offered tapes as limited editions; others followed the unlimited-edition model of experimental filmmakers, making videotapes accessible at affordable prices to universities and libraries as well as to collectors and museums.

The Museum of Modern Art purchased its first videos twenty-five years ago through the Department of Prints and Illustrated Books. Although the acquisitions committee was accustomed to purchasing limited-edition prints and books, they opted to acquire only "unlimited" tapes. Eventually the videotape collection was merged with the Museum's film archives.

In recent years the issue of limited-edition videos has resurfaced. Artists are creating "single channel installations" with add-on props and viewing conditions that specify the gallery's dimension and the luminance and size of the projected image. The works are dealt with as editions of installations, rather than simply as videotapes for intimate TV viewing.

Collectors are undeterred. Perhaps they have been infected by the irrepressible experimental nature of video: they find the complexities of acquiring videos stimulating. Pam and Dick Kramlich have assembled a premier video collection in San Francisco, and they are building a home nearby to live in and share with their acquisitions. Unlike a painting, which requires only a patch of wall, or a sculpture, which might fit in a niche, video does not integrate passively into a personal environment.

Video is central to the architecture of the Kramlichs' home. In addition to state-of-the-art exhibition areas, considerable space is reserved for a comprehensive library of video catalogues and ephemera. A research center and a climate-controlled storage area underline a commitment to preserving a personal vision of video – a snapshot of video history from a contemporary perspective. The Kramlich Collection limns the boundaries of video's rowdy beginnings and the many crosscurrents that have made it an art of our times.

Visibility and the Electronic Mirror

Christopher Eamon

In Bruce Nauman's 1968 videotape entitled *Wall-Floor Positions*, the artist is seen contorting his body between the floor and the wall of his studio. With one leg and an arm planted on the floor and the other leg and arm pressed into the wall at the edge of the image, he begins to move his body, slowly and strenuously altering his position such that an arm replaces the position of his foot, or a leg replaces his arm outstretched across the wall. He does so until he has completely inverted himself several times and has covered, within the sixty-minute running time of the tape, the entire image area.

Throughout this continuous action Nauman rarely misses the edge of the image's frame. He concentrates intently on his movement, never looking up at the camera, but always somewhere off-screen to his right. How does he locate the edge of the frame each time? How does he know where to place himself when he is upside-down stretching outward like a spider? He must be watching something off-screen, and, if so, given how the use of video unfolds in the late 1960s, it is altogether likely that the object of his gaze was the live image of his own body on a video monitor. If the reference for Nauman's movement can be located within the feedback loop of closed-circuit video, he can be seen also to address a specific condition of his body appearing as a video image. The position of his body within the frame is contingent on its being mirrored in real time by an absent device.

Nauman's use of video in many of h__ fourteen performance videos points to how ____ ___ dium simultaneously shows live tha⁺ ____ ___ing recorded. This capacity is ____ ₂₄ ____ ⁺hat the medium transcends do____ ____ 's at least two points o͏ᶠ practices of the la¹ performance as a⌐ creation of o⊢ mirror as a¹ At the s⌐ mance-¹ tra⌐ ⌐

when video is conceived as a mirror it has evocative implications for notions of audience, viewer, and participant. The emergence of video as an artistic medium can be shown to coincide with a fascination with mirroring in the late-1960s, which corresponds with a displacement within conventional modes of spectatorship. Performance video changed the way performer and audience would interact.

The early performance-related videotapes of Bruce Nauman, Vito Acconci, Joan Jonas, Peter Campus, and Dan Graham took part in a broader shift in artistic practice that had been occurring for almost a decade. By the late 1960s, emphasis had shifted firmly away from painting and sculpture to performance. Allan Kaprow, Robert Whitman, Claes Oldenburg and others had moved Cage-inspired Happenings into the public sphere from around 1959 onward. The action-oriented Fluxus movement had formed a loose association by 1961, and by around 1966-68, the so-called de-materialization of the art object through performance had begun to permeate even institutional boundaries. Influenced by the Judson Dance Theatre's embrace of amateur and everyday movement (1962), especially in the dance works of Yvonne Rainer, artists asserted process over completed artworks and proposed their own physical endurance as content. This along with an incredible degree of cross-fertilization among poetry, film, theater, dance, and the visual arts provide a substantive framework for the early use of video as an artistic medium.

It would be a mistake to confuse artists' work in film completely with video, even though their use of film and video overlapped at times. Many of the artists who eventually explored video such as Jonas, Acconci, and Nauman, initially used Super 8 and 16mm film to record their actions. Jonas' *Wind* (1968), Nauman's studio films such as *Stamping in the Studio* (1968), and Acconci's early *Three Adaptation Studies* (1970) were all originally shot on film. Acconci and Nauman routinely utilized photographs and audiotape to record their actions as well. Later, each of these artists used the video camera contemporane-ly with film in ways similar to, and, at markably different from film, creating lasting and influential examples

specific reference
ecording of

events. Nauman referred to his ability to revise works in video, which could not be previously done in film: "With the videotapes I had the equipment in the studio for almost a year, I could make test tapes and look at them, *watch myself on the monitor*, or have somebody else there to help"[1] [my italics]. In works such as the aforementioned *Wall Floor Positions* and in Acconci's *Centers* (1971), *Corrections* (1970) and a host of others, artists exploited the "liveness" of video to look at their own image (becoming both subject and object of the camera) in order to position themselves with respect to the frame of the camera.

In *Centers*, Acconci appears in a headshot, finger raised and pointing through the camera to an implied viewer. He attempts to hold his arm directly raised in front of him and maintain the tip of his finger in the center of the image for twenty minutes. This activity proves impossible, especially as time progresses. His finger is rarely centered directly in the screen. Possibly due to errors of parallax, or muscle fatigue, he waivers just below and to the right of it. In any case, his failure to center the gaze reflects on the artist's self-awareness, since he was pointing at himself the entire time. Acconci writes:

"Pointing at my own image on the video monitor: my attempt is to keep my finger constantly in the center of the screen - I keep narrowing my focus into my finger. The result (the TV image) turns the activity around: pointing away from myself, at an outside viewer - I end up widening my focus onto passing viewers (I'm looking straight out by looking straight in)."[2]

Initially, the artist's "focus" is himself as reflected in the video image positioned across from him, but eventually, through a temporal remove, his focus is an implied audience, and one that is not static: "I end up widening my focus onto *passing* viewers."

Like Nauman in *Wall Floor Positions* where the frame of the image in part constitutes the work of art, Acconci looks to the mirror image of the video apparatus to correct his position. In *Corrections* (1970), and *Passes* (1970), the artist's performed activity is programmed, as it were, through his ability to see what can't normally be seen in the video mirror of an off-screen monitor. In *Corrections*, the artist's sim-

ple actions initially seems straight forward: he burns the hair off his back with lit matches in short, repeated actions until it is completely gone. Acconci's expanded sight is accomplished through a monitor positioned below the camera's point of view.

Nauman and Acconci, whose use of film and video overlapped in a period beginning in 1970, made quick use of video's immediacy to review and remake what they considered unsatisfactory. And, in both cases, the artists used actual mirrors in place of video monitors in their work, Acconci in late 1968 to 1969, and Nauman in 1970. In Acconci's early and emblematic Super 8 film *See Through* (1970), the artist boxes with himself in a mirror. In an effort to beat himself or "take himself on," the artist and his double spar until the mirror is shattered with a few final blows. The fact that the artist must face the mirror in this film highlights an issue of visibility in electronic technology. He takes on an unmediated double, but ultimately needs to shatter this image, as he put it, to "get out of a closed circle." Acconci's desire to break out of the viewer/viewed circle is later achieved through the transmission effects of the video mirror: its removal from the site of the action. His use of the video mirror also reflects his desire to counter the conventional setup of performer and audience, a desire that underscores a more general impetus for artists using mirrors in the late 1960s.

The direct antecedent of *See Through*, one of the *Relationship Studies* subtitled *Shadow-Play* (1970), features Acconci boxing with his own shadow cast on a facing wall. When compared to *Recording Studio from Air Time* (1973), *See Through, Shadow-Play,* and *Centers* can be cast as allegories for three moments in the history of representation: Plato's parable of the cave, the discovery of perspectival space and optics in the Enlightenment, and, finally, the era of electronic imaging. Indeed, in the films *Shadow-Play* and *See Through*, the relationship between actor and his double is purely indexical: he occupies the same space as his double at some level. However, the advent of the video camera allows the artist to see himself as the audience does at the same time that he performs for the audience. The result compounds the doubling effect of the mirror, bringing the artist into a seemingly direct relationship with the audience. The video mirror itself is no longer visible to viewers and has been erased in the process. Because the camera is absent, the circuit that runs from performer, to self, to audience is broken. Since camera and monitor, object and image, are no longer continuous in space, parallel in terms of scale, nor obedient to the rules of perspective, the special feature of the video mirror is to extend vision while hiding itself.

Indeed, Nauman envisioned video's capacity to reimagine the relationship between viewer and viewed early on, in *Video Corridor for San Francisco (Come Piece)* (1969). In fact, this early example of a corridor piece contains no physical corridor, only two closed-circuit video cameras and two monitors positioned within a space such that viewers traversing the gallery catch their own image turned sideways, upside-down, or partially masked by a covering on the camera lens. For Nauman, the relationship between camera and monitor already constituted a type of corridor. The linearity of that space was disturbed. Nauman explains, "You can walk in and see yourself from the back, but it's hard to stay in the picture because you can't line anything up, especially if the camera is not pointing at the mirror."[3] And, unlike with a conventional mirror, if the camera were behind you, your image would recede as you got closer to it.

Nauman rarely used actual mirrors in his work, though he had already explored a number of mediums by 1969. While Nauman had used the camera to make approximately twenty-seven films and videos, the first time a video monitor appeared in one of his structures was in *Live Taped Video Corridor* (1970), which had morphed out of a corridor used first as a prop for his videotapes and was later recreated for "Anti-Illusion" at the Whitney Museum of American Art in 1969. (The 1969 video *Bouncing in the Corner No. 2* resulted from him taping an action performed in this corridor when it was first built in his Southampton studio). In the later *Live Taped Video Corridor*, two monitors are set one atop another at the far end of the corridor. The image from a live camera with its lens focused midway down the corridor appears on the top monitor, while a taped image taken from a camera in the same position appears on the lower one. A person walking down the corridor would see himself from behind on the top monitor, greatly

reduced in scale, when he reached the midway point of the construction. Here, we have a case of the video corridor/mirror distorting the relationship of viewer to the artwork.

In May of the same year Nauman created another corridor for the gallery at San Jose State College where he replaced the video monitor with a mirror at the apex of the hallway. Referring to *Corridor Installation with Mirror - San Jose Installation* (1970), Nauman remarks, "...in this piece the mirror takes the place of any video element. In most of the pieces with closed-circuit video, the closed circuit functions as a kind of electronic mirror."[4] Nauman clearly saw the two types of mirroring, optical and electronic, as related if not substitutable.

The placement of the mirror in his San Jose *Corridor* allowed it to reflect what was taking place on the other side of the v-shaped structure. Nauman recalls, "The mirror allows you to see some place that you didn't think you could see."[5] The viewer, who optimally sees himself only from the neck down as he passes the mirror, becomes a participant, indeed a performer, in the corridor, just as Nauman had in several of his videotapes, but he or she also becomes a headless viewer/participant endowed with the capacity to see that which could not otherwise be seen. This headless entity, endowed with an expanded capacity for sight, is a kind of trope for the medium of video itself. In *Corridor Installation with Mirror*, the old physical mirror is a figure for the way the new electronic mirror works. Its expanded sight is almost always accompanied with the power to dislocate the subject within its circuit or loop.

By the early 1960s many artists had begun to explore the possibility of involving the viewer more directly in their work as a participant by creating the foundations for what has become known as interactivity. Simultaneously and paradoxically, the audience began to disappear from the act of performance. By the mid-1970s Rosalind Krauss was tempted to make what she acknowledges is a generalization: "The medium of video is narcissism," she wrote, seeing in video an endemic self-regard, the collapse of subject and object within the video mirror, and the negative effects of repetition in collapsing temporality into the present.[6] Whether these points hold for Nauman and Acconci is questionable as they used video to map the space of the closed-circuit loop, to test its boundaries and develop it as a tool for a new type of performance and a new type of audience.

The structure they interrogated was not the conventional, static audience/performer pairing, but, rather, a new type of relationship where the viewer had volition and looked as if he or she wanted to. Acconci referred to this viewer as a passerby. In addressing repetition in his video work, Nauman similarly noted that he never intended for his tapes to be viewed in their entirety. He preferred, rather, to make works that gave viewers a feeling of being able "to come in or leave at any time."[7] Given that spectators do not view the entire work, they are not stuck in the present tense, as Krauss argues, but if anything, given over to mild distraction. Still, questions of spectatorship are central to the new kind of performance. What happened, for instance, to the audience in the transition between Happenings and the concerts of the Judson Dance Theatre and actions performed for cameras beginning around 1966? What happened to the notion of "audience" in Acconci's films and videos from 1969 through 1971? At a certain point, the audience had been central to Acconci's work. In 1972 he claimed that before 1970 his presence had been "...a sort of margin surrounding the audience....Then there was a sort of shift from that, [a] shift from me as say, margin, to me as center point, as focal point."[8] This earlier modality is made actively clear in Acconci's photo series *Twelve Pictures*, taken in May 1969. The artist's act of photographing the audience at The Theatre in New York constitutes both a six-minute-long performance and document. It also reveals the time-based nature of the event, revealing Acconci's movement from left to right across the theatre in order to map the space inhabited by the audience as he pans in front of them.

Regarding performance of the late 1960s, Henry Sayre argues that the imminence of the art object, its "presence" or artistic meaning, was displaced from the object to the audience as a "site" for the creation of meaning.[9] Acconci's earliest performances involving the written and spoken word - as he put it, "the page as a field for action" - provide a case in point for Sayre's idea.[10] After the printed page, where the locus

of meaning is the reader, this locus becomes, for Acconci, the public sphere and, after that, the camera.

Acconci was never primarily interested in a static audience/performer relationship. He wanted to be mobile and he expected the audience to be mobile as well. In describing *Seedbed* (1972), the work that Acconci believed returned him to his marginal position with respect to the audience, he explained, "It really brings back the gallery rather than goes away from it … gallery space as not so much a space with an audience - an audience is bad - as a space with passersby."[11] In this statement we can interpret Acconci as having been opposed to the conventional notion of an observing audience, but he was not opposed to an active one. He embraced the free movement of the observer, which could not be controlled by the artist or by convention.

By 1970, Land Art had already temporally and spatially displaced the audience. Land artists had taken the work of art to new proportions of scale, and to more and more remote locations. Works by Michael Heizer, Robert Morris, and, notably, Robert Smithson required the mobility of the viewer so that they may become part of the work and recognize themselves in it. In Heizer's *Double Negative* (1969) two gigantic slots (each 40 feet deep and 100 feet in length) were carved out of the earth on opposite sides of a deep ravine in the Nevada desert. The experience of the piece is best described by Krauss:

"For, although it is symmetrical and has a center (the mid-point of the ravine separating the two slots), the center is one we cannot occupy. We can only stand in one slotted space and look across to the other. Indeed, it is only by looking at the other that we can form a picture of the space in which we stand. By forcing on us this eccentric position relative to the center of the work, the *Double Negative* suggests an alternative to the picture we have of how we know ourselves. It causes us to meditate on a knowledge of ourselves that is formed outward toward the responses of others as they look back at us. It is a metaphor for the self as it is known through its appearance to the other."[12]

For Krauss, the experience of Heizer's *Double Negative* is like that of a mirror. The late-1960s fascination with mirroring is expressed again and again in Land Art and in the film art of the

decade. The use of the mirror, here, however, tends to constitute the viewer as recognizable and complete in the eyes of the Other. This sort of mirroring is not the same type as is employed in the new, expanded, electronic mirror. As in Nauman's *Corridor Installation with Mirror*, the expanded mirror displays even as it displaces and erases itself.

An important example of mirroring that functions like the electronic mirror is Robert Smithson's series of works given the general title "displacements" that involve photographs of mirrors set in the landscape. Smithson's interests lie in the mapping of remote locations, in quasi-natural sites and of entropy. The most paradigmatic of these, *Yucatan Displacement* (1969), consists of a set of approximately twelve mirrors positioned in the landscape and photographed on site. The resulting "documentation" ($2^{1/4}$-inch-square transparencies) reveals an image within an image, or, the displacement of the Other within a document of a specific location at a specific time. The mirrored squares function to map one place onto another, suggesting a rupture within the indexical continuity of image and object. From the standpoint of photo-documentation, the reflected images of the mirror appear radically Other; since each of the mirrors is itself square, they compound the outline of the $2^{1}4$-inch-square transparencies that constitute the work after the fact. The similarity between the format of the image/transparency and that of the mirrored image reinforces a sense of identity between the two, pushing the mirror into a liminal position between image and nature. The mirrors themselves tend to disappear, as the image reflected in them becomes more and more photographic.

Joan Jonas' *Glass Puzzle* (1973) imagines a more complicated relationship between viewer and viewed. In it, the monitor-camera circuit is capitalized upon and compounded by the reflectivity of the actual television tube. Using two cameras, one to catch the action and the other to record what is being shown on the monitor, Jonas positions her actions so that they not only appear on the screen of the television tube, but are reflected also in its glass surface. The doubling effect of the monitor as both electronic and physical mirror makes the position of the action absolutely ambiguous. The subject of the action

is dissolved within the electronic pulse of the video loop.

The themes of *Glass Puzzle* are transparency, opaqueness, reflectivity and the double, and in many ways it appears to be a highly formal exercise. In others, it represents an obfuscation of the transparency of the mirror, a complicating of the collapse of subject and object taking place in it. But, unlike Nauman's *Corridor Installation with Mirror*, this collapse is not accompanied by expanded powers of sight.

Part 2 of Peter Campus' early and eloquent *Dynamic Field Series* (1971) explores how the edges of the screen are constitutive of the video image, much as in Nauman's *Wall-Floor Positions*. In part 1 of *Dynamic Field Series*, which was shot in the Judson Memorial Church, Campus suspends the camera from a pulley. It records him lying on the wooden floor of the church auditorium; his own likeness recedes and bobs as he raises the camera and enlarges as he once again lowers it. The figure and ground of this image seem to have no structural integrity. Both Campus and the floor sway and rotate. As in *Wall-Floor Positions* the laws of gravity are suspended. There is no upward and downward orientation in this now unmoored image. The apparatus is suspended from the ceiling by a rope that is visibly connected to the hand of the artist. In a conflation of puppet and puppet master, the camera, which captures and holds Campus' image, is visibly connected to its master, but he has no control over the dynamism of the field of vision. He is a cameraman in a state of willed "uncontrol." The type of transparency he espouses is the apparatus that captures him. Campus' final act of anchoring is in fact an unanchoring.

Nauman's early tapes share with *Dynamic Field Series* an exploration of the absolute contingency of the video image. In *Dynamic Field Series*, Campus pushes the interrogation even further in that the very ground of the image is made mobile. This is why he begins with a shot of his feet stomping on the hardwood floors of the church auditorium. The image's solidity, its reality, is undermined as the camera is raised. Campus makes the viewer aware of the presence of the camera that normally goes unnoticed. What is usually erased in the video loop, the presence of the camera, is drawn out by the artist from within the video image itself, just as Nauman's gaze in

Wall-Floor Positions helps to make visible the invisible monitor.

Campus and Nauman each in their way explore the technological conditions of the video image: that the image can be live and the apparatus can be absent. Along with Acconci and Jonas, they embarked on an exploration of a concept of the mirror that was not unlike other concepts that were current in the late 1960s. They went on to draw out the specific nature of video to afford an expanded sight and revealed in their work its ability to make a cut in the fabric of perception by pushing at its limits, by extending or altering our perception of space. At the same time, with the aid of the camera, they re-imagined the conditions of performance. Who the audience was and how it behaved became of central importance. The audience as observer shifted to the audience as passerby: an engaged, mobile participant, yet transitory, beyond the artist/artwork's grasp.

[1] Sharp, Willoughby, *Avalanche*, Winter 1971, p. 30
[2] Acconci, *Avalanche*, Fall 1972
[3] Sharp, p. 24
[4] Sharp, p. 30
[5] Sharp, p. 30
[6] Krauss, Rosalind, "Video: The Aesthetics of Narcissism" in *October*, New York, Spring 1976, p. 51-64
[7] Sharp, p. 29
[8] Béar, Lisa, *Avalanche* (Fall 1972) p. 71
[9] Sayre, Henry, *The Object of Performance*, The University of Chicago Press, Chicago, 1989, p. 6
[10] Acconci, p. 4
[11] Acconci, p. 74
[12] Krauss, Rosalind, "The Double Negative: a New Syntax for Sculpture," in *Passages in Modern Sculpture* The MIT Press, Cambridge, Massachusetts 1977, p. 220

Page 29: Vito Acconci, *12 pictures, May 28, 1969*, 1969. Courtesy Barbara Gladstone Gallery

Marina Abramovič and Ulay

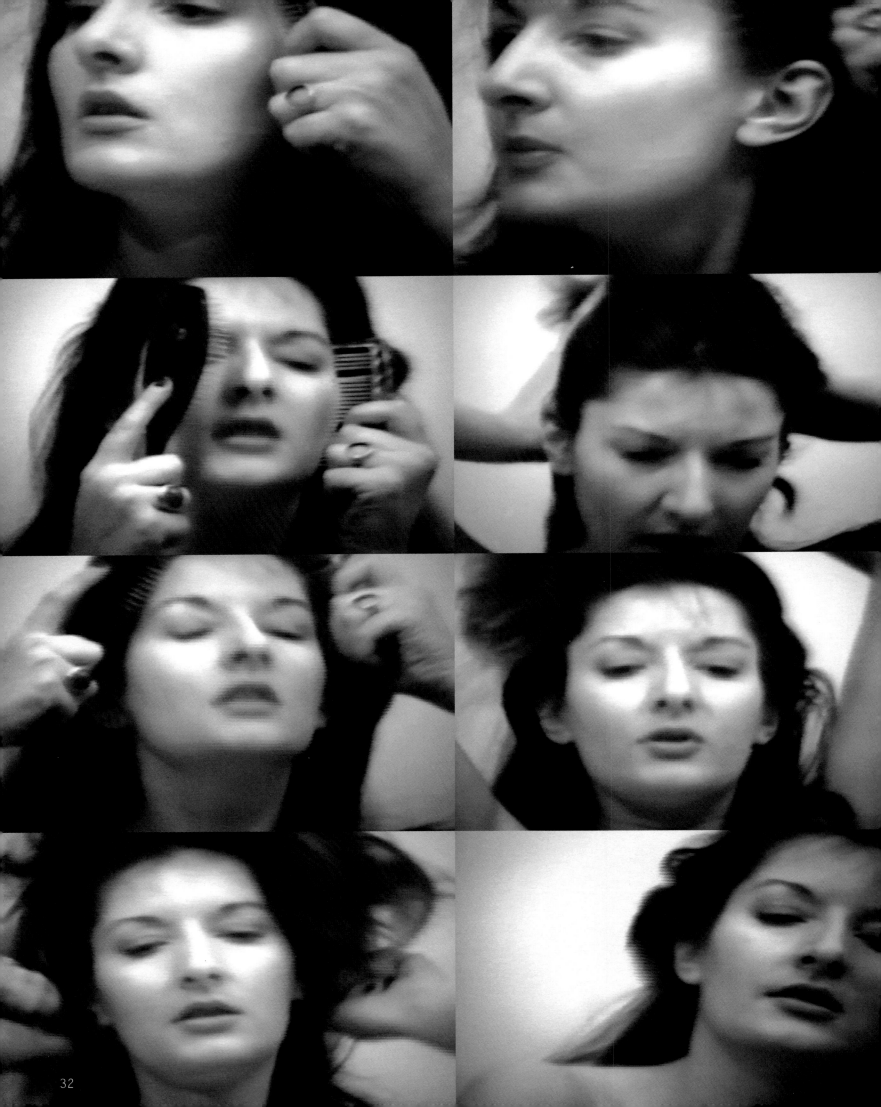

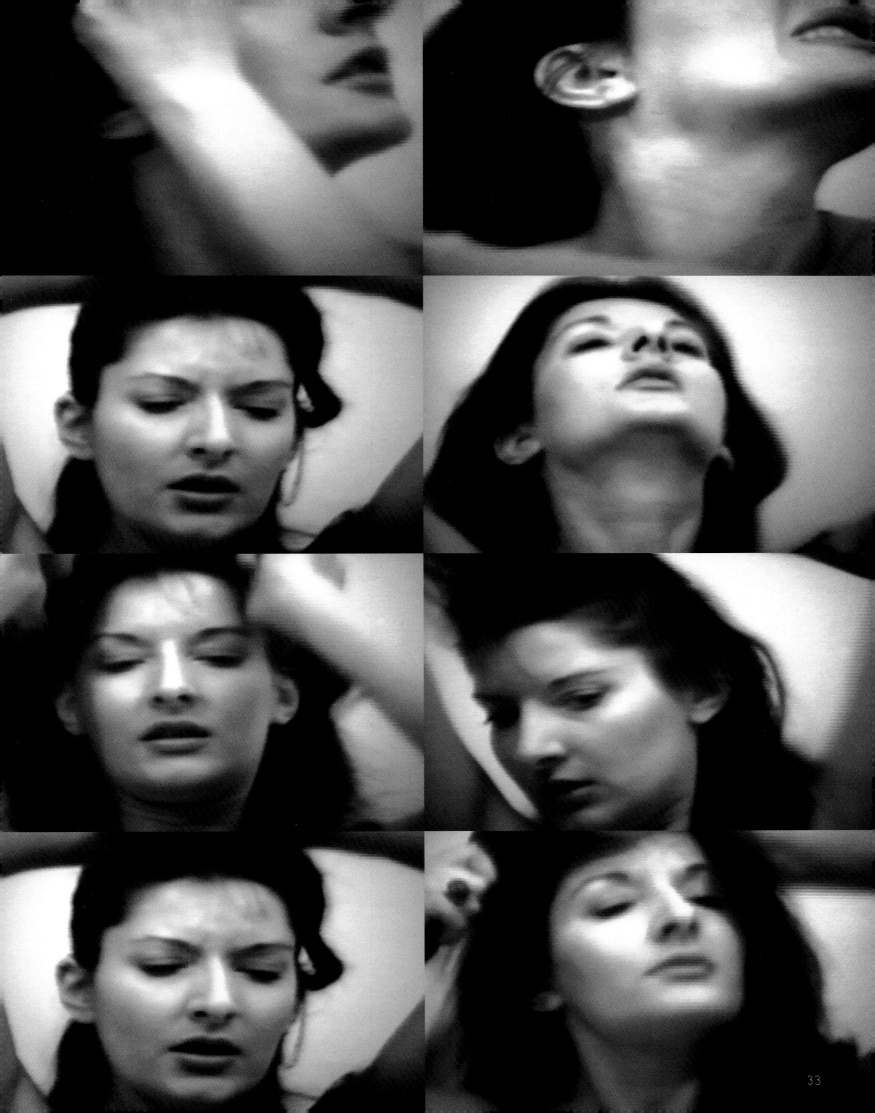

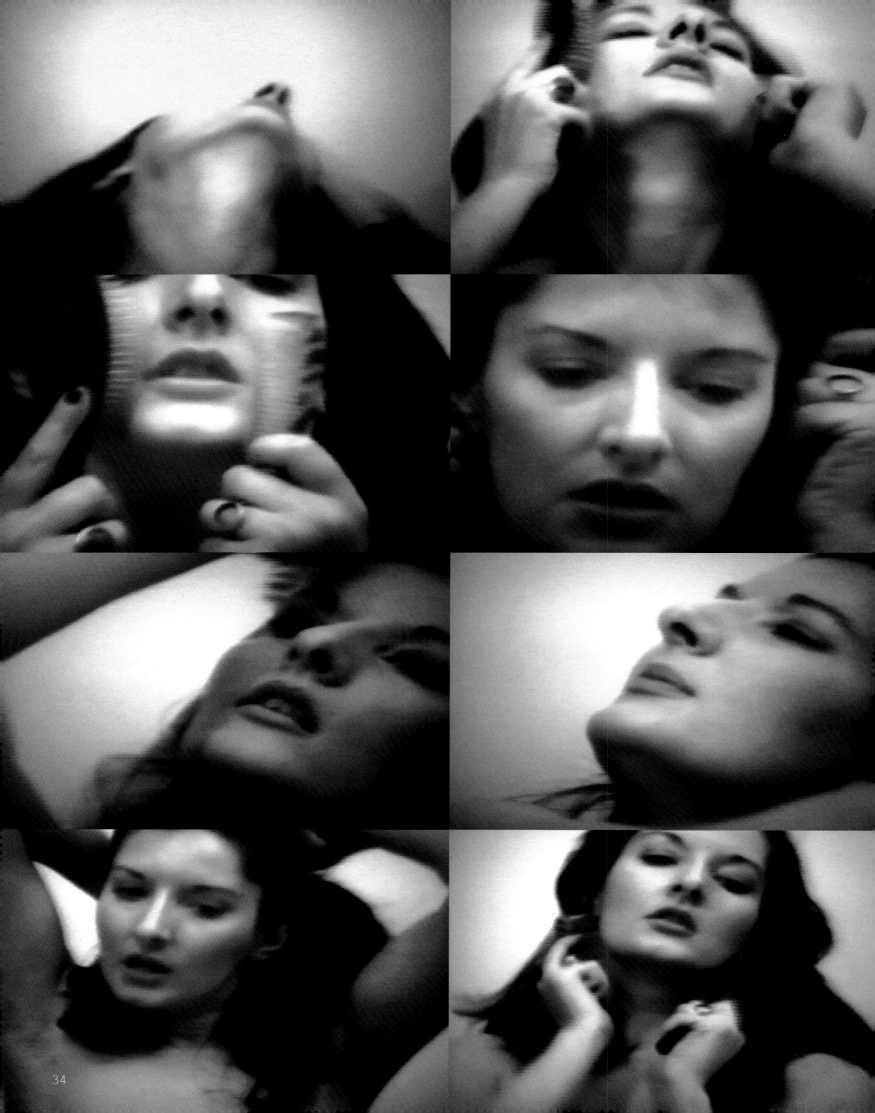

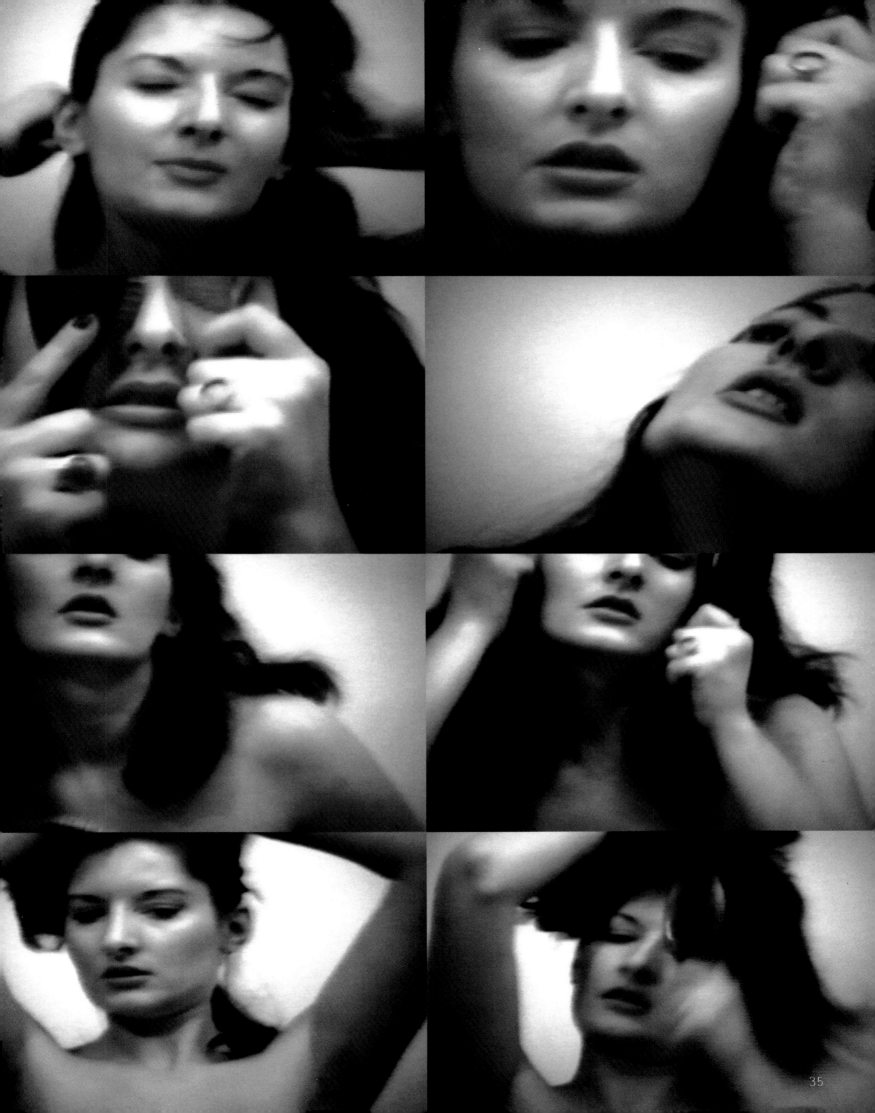

pimple sole blackhead ___ eyeball enamel cracked gangrene

veins legs arms nail sole ___ being parent father mother

spice quasimodo disappear ___ brother sister aunt crease

coffee cucumber cos hierarchy ___ mother cos hierarchy obrenovic

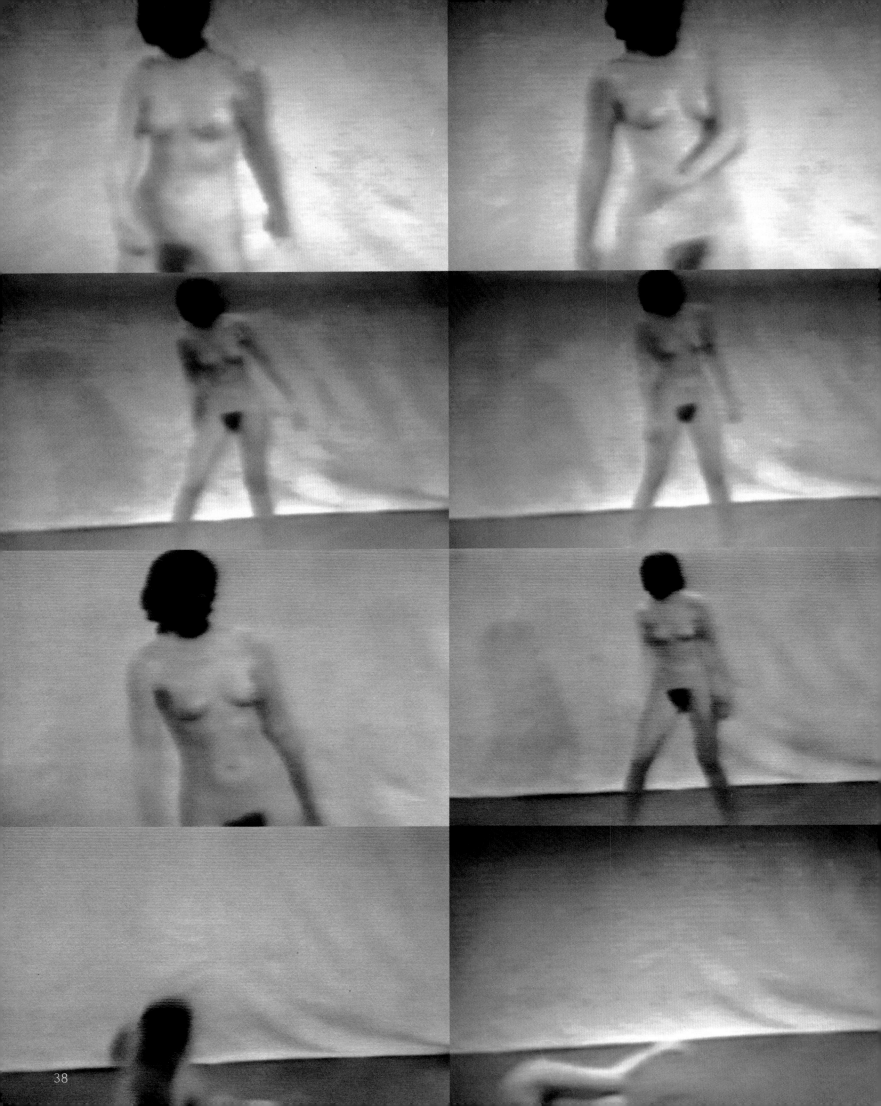

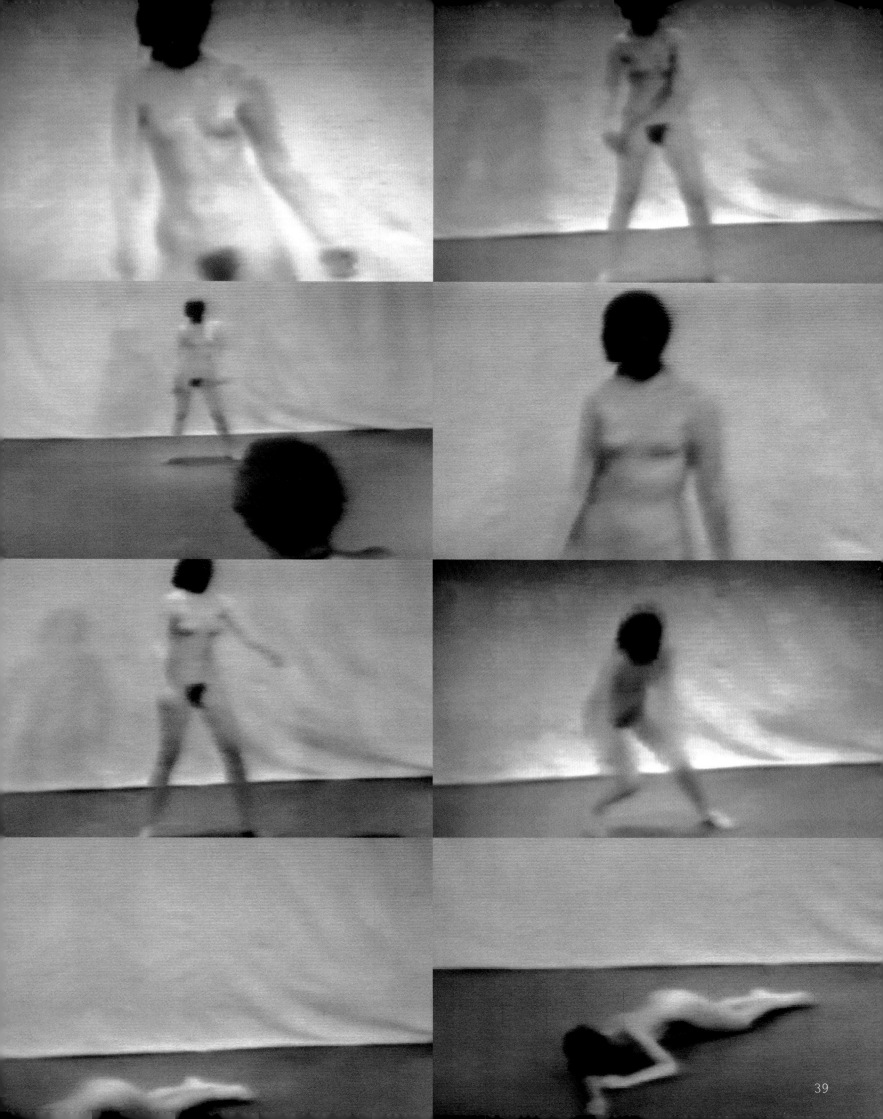

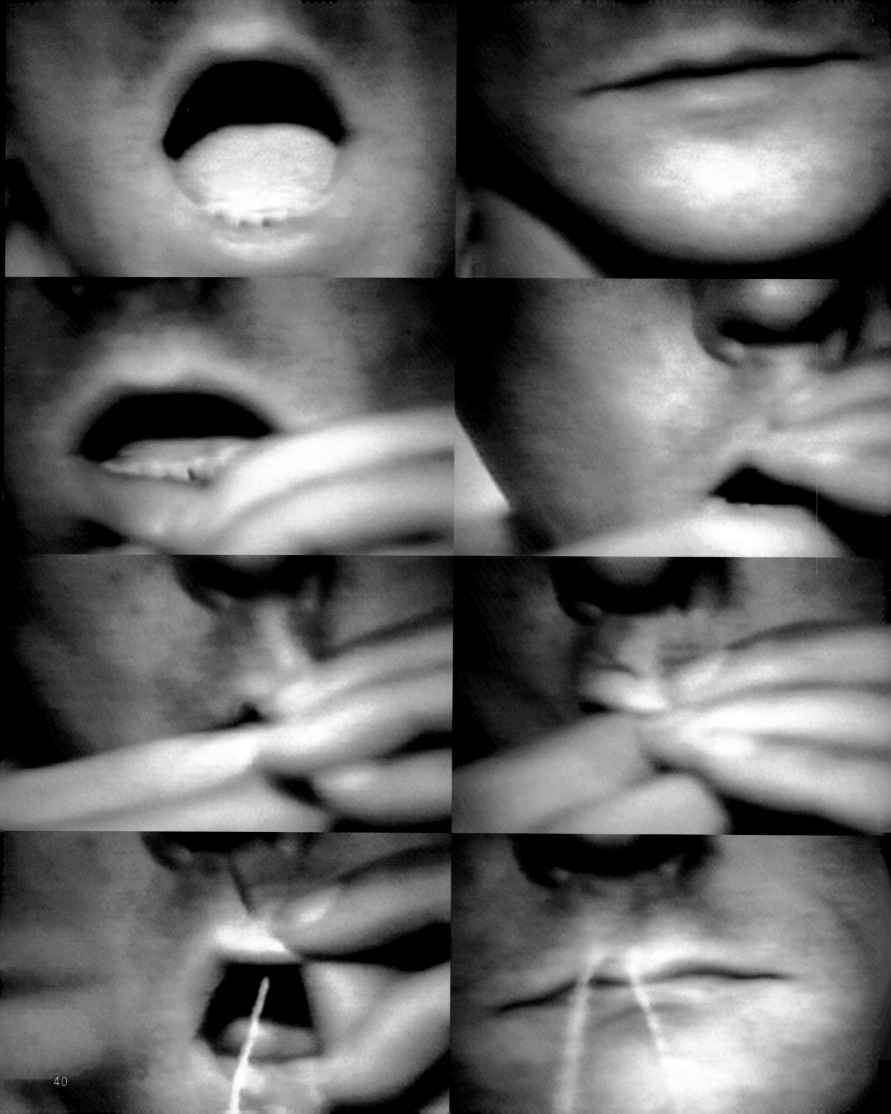

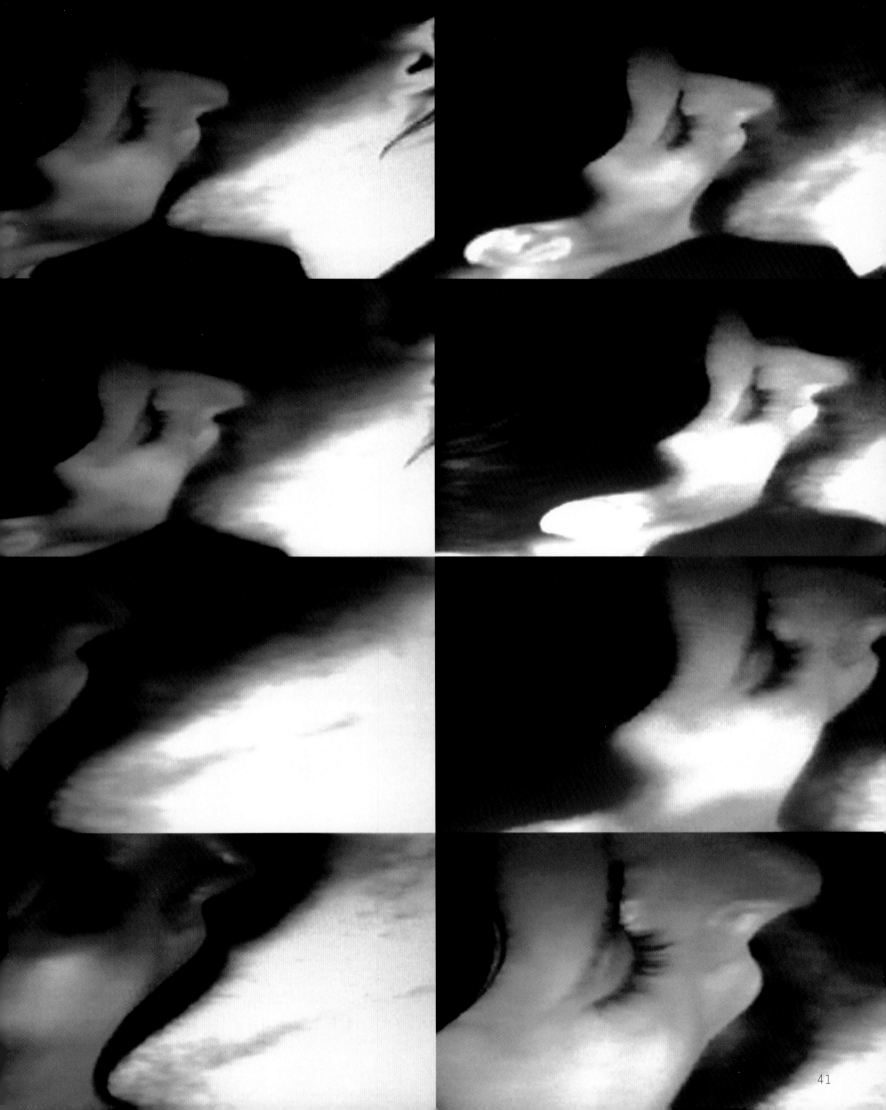

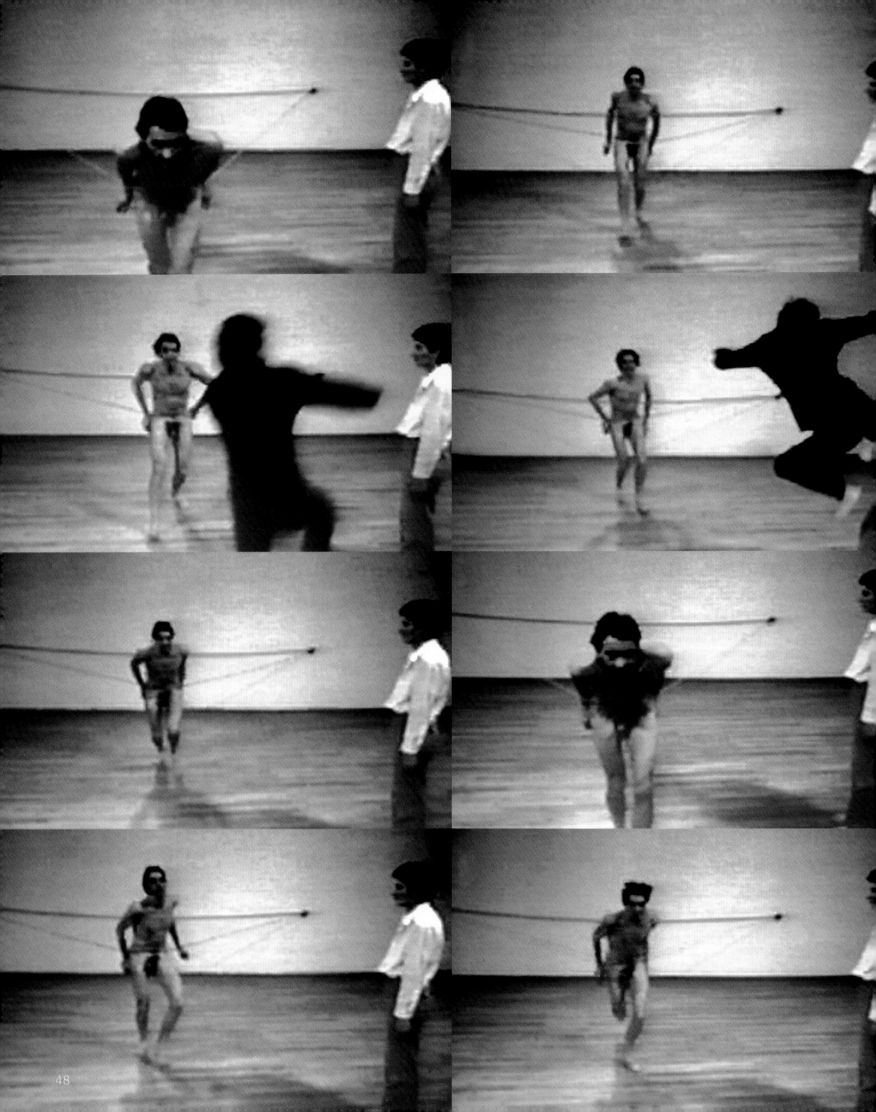

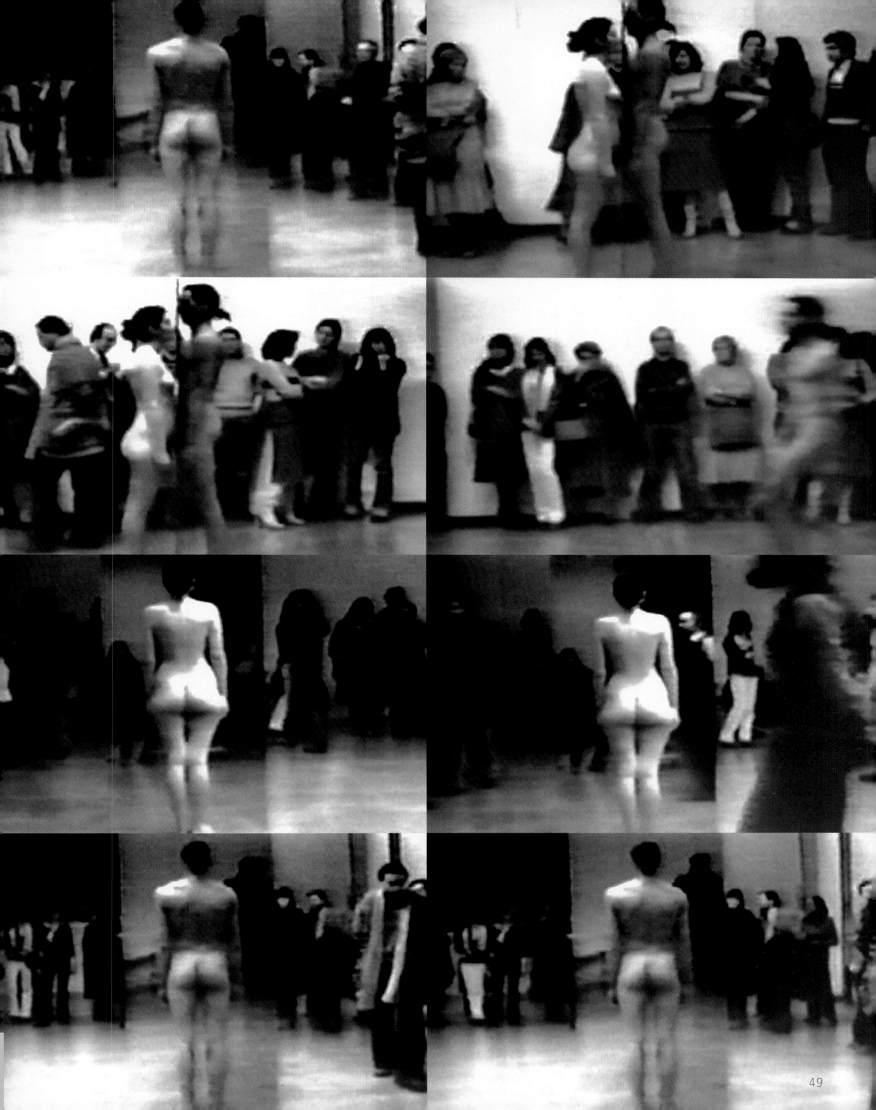

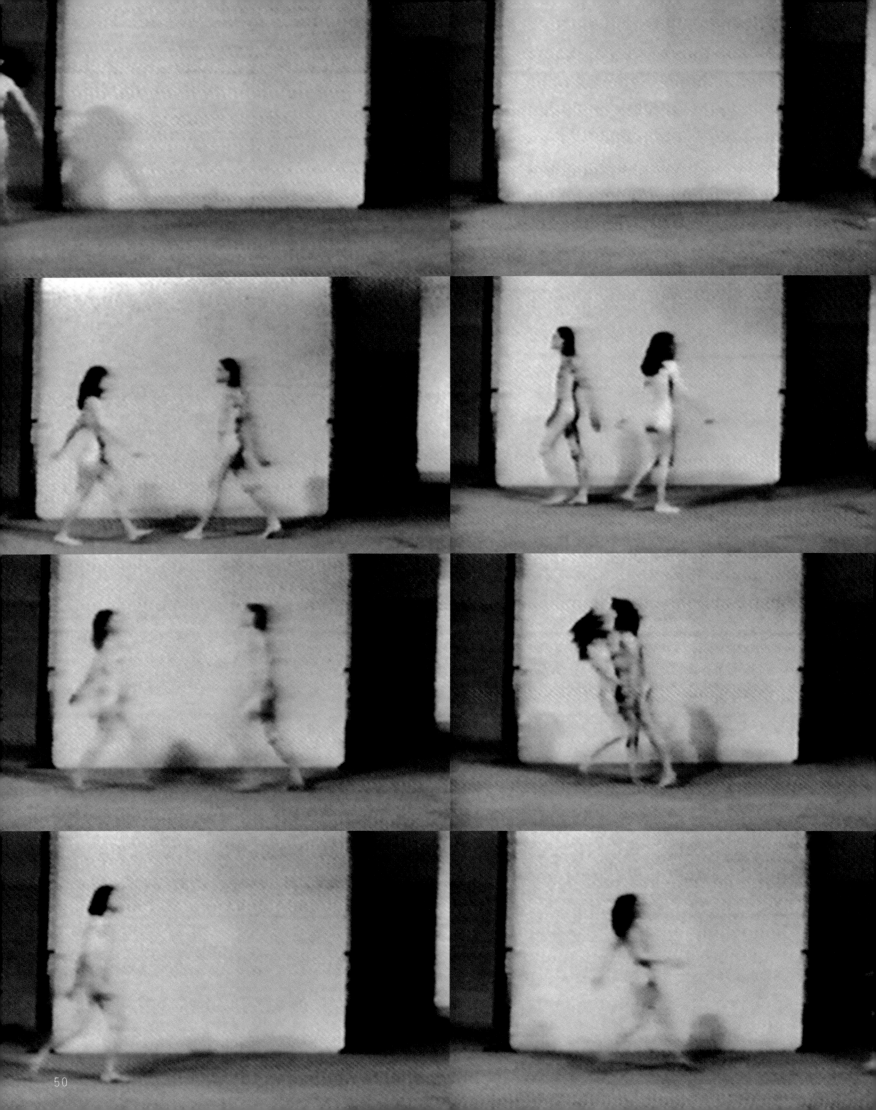

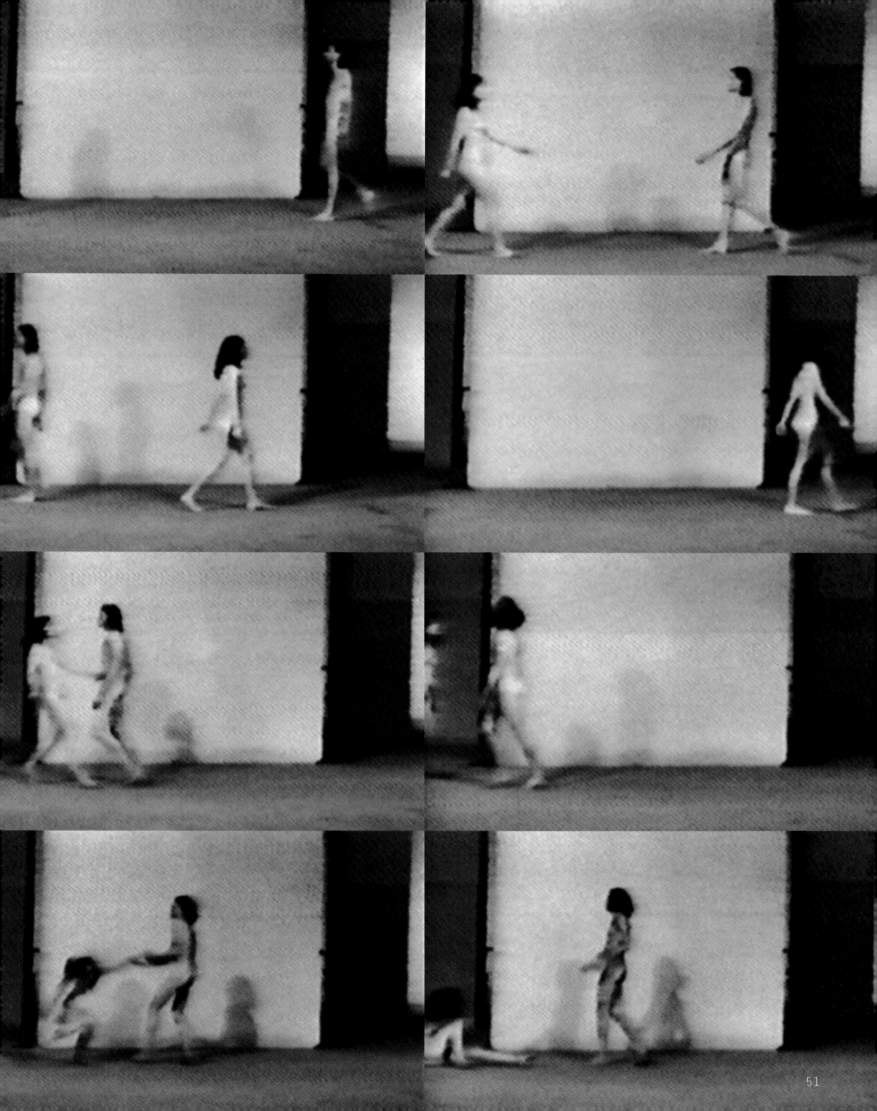

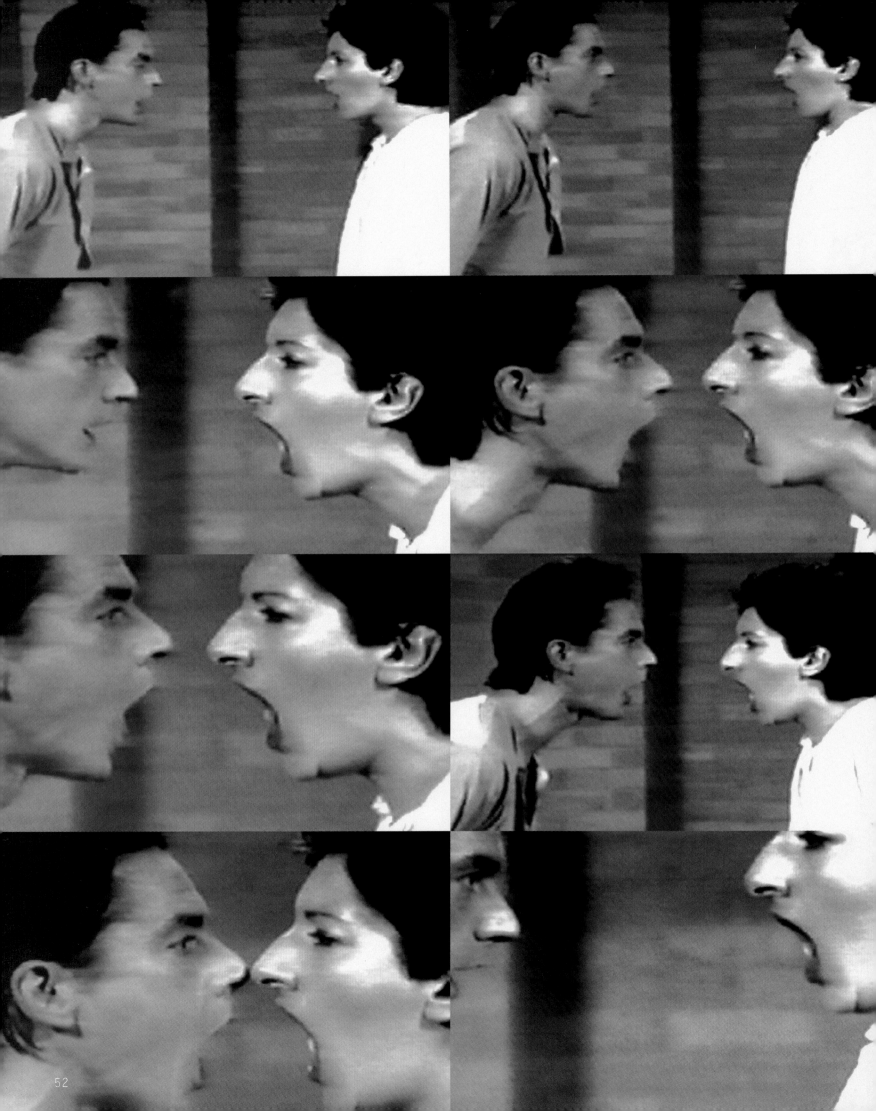

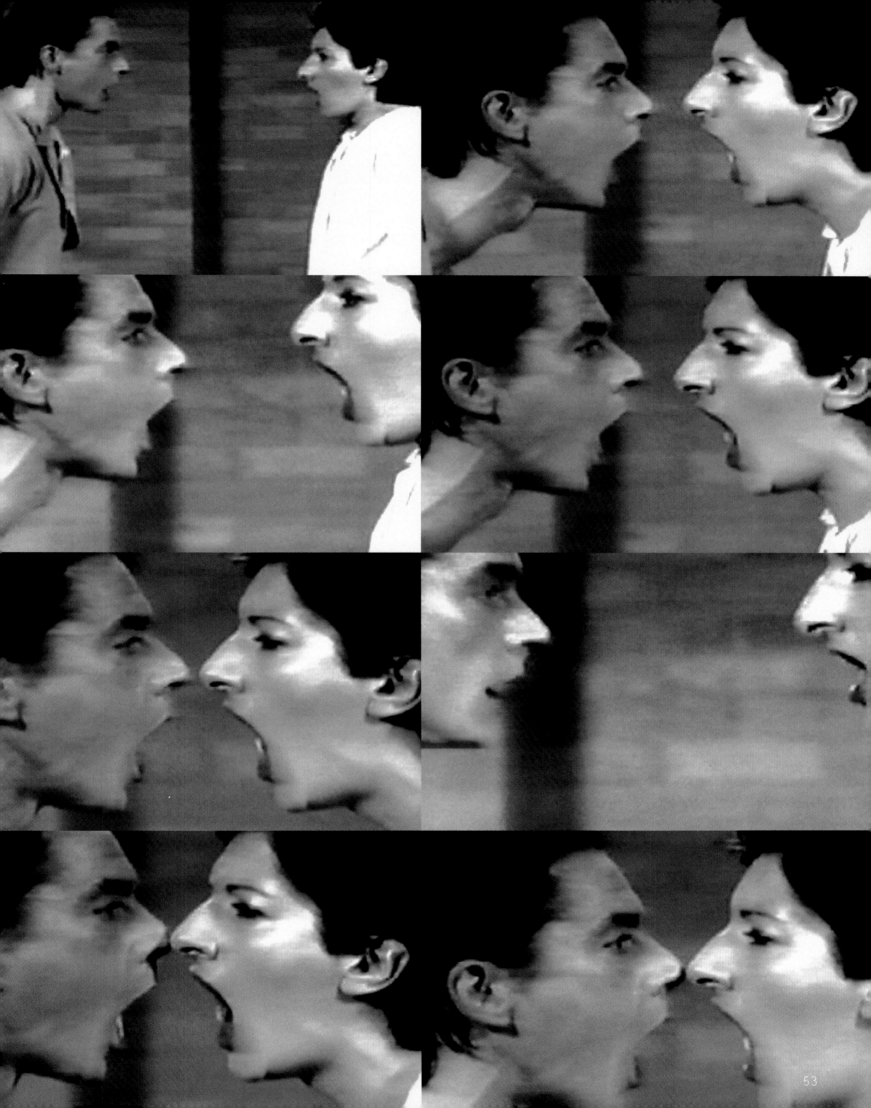

Marina Abramovič (b. 1946) and Ulay (b. 1943)
Selected Single Channel Film and Videos Works

The Television is a Machine, 1973
Performance Anthology, 1975-1980 (Program 1. Four Performances by
Abramovič, 1975-76: *Art must be beautiful, Artist must be beauti-
ful*; *Freeing the Voice*; *Freeing the Memory*; *Freeing the Body*.
Program 2. Action in 14 predetermined sequences by Ulay: *There is
a Criminal Touch to Art*. Program 3. 14 Performances - Relation
Work, 1976-80: *Relation in Space*; *Talking about Similarity*;
Breathing in, Breathing out; *Imponderabilia*; *Expansion in Space*;
Relation in Movement; *Relation in Time*; *Light/Dark*; *Balance
Proof*; *AAA-AAA*; *Incision*; *Kaiserschnitt*; *Charged Space*; *Three*)
Point of Contact, 1980
Nature of Mind, 1980
Timeless Point of View, 1980
Collected Works, 1975-86, (*Performance Anthology*, 1975-1980; *Modus
Vivendi*, 1979-1986, Program 1: *Communist Body/Fascist Body*; *That
Self*; *Anima Mundi*. Program 2: *Positive Zero*; *Night Sea Crossing
Conjunction*; *The Observer* (with Remy Zaugg); *Continental
Videoseries* (1983-1986), Program 1: *City of Angels*, *1983*; *Terra
Degli Dea Madre*, *1984*; *Terminal Garden*, *1986*; Program 2: *China
Ring*)
Crazed Elephant, 1983
Avalokiteshvara, 1983
The World is My Country, 1985
The Lovers, *The Great Wall Walk*, 1988
SSS, 1989
Boat Emptying - Stream Entering, 1989

All images courtesy of Electronic Arts Intermix (EAI), New York

(32-35) *Art must be beautiful, Artist must be beautiful*,
1975-1976, from *Performance Anthology*, 1975-1980, 4:16 hr, b&w,
sound
(36) *Freeing the Voice*, 1975-1976, from *Performance Anthology*,
1975-1980, 4:16 hr, b&w, sound
(37) *Freeing the Memory*, 1975-1976, from *Performance Anthology*,
1975-1980, 4:16 hr, b&w, sound
(38-39) *Freeing the Body*, 1975-1976, from *Performance Anthology*,
1975-1980, 4:16 hr, b&w, sound
(40) *Talking about Similarity*, 1976-1980, from *Performance
Anthology*, 1975-1980, 4:16 hr, b&w, sound
(41) *Breathing in, Breathing out*, 1976-1980, from *Performance
Anthology*, 1975-1980, 4:16 hr, b&w, sound
(42-43) *Imponderabilia*, 1976-1980, from *Performance Anthology*,
1975-1980, 4:16 hr, b&w, sound
(44) *Relation in Time*, 1976-1980, from *Performance Anthology*,
1975-1980, 4:16 hr, b&w, sound
(45) *Light/Dark*, 1976-1980, from *Performance Anthology*, 1975-1980,
4:16 hr, b&w, sound
(46) *Charged Space*, 1976-1980, from *Performance Anthology*,
1975-1980, 4:16 hr, b&w, sound
(47) *Kaiserschnitt*, 1976-1980, from *Performance Anthology*,
1975-1980, 4:16 hr, b&w, sound
(48) *Incision*, 1976-1980, from *Performance Anthology*, 1975-1980,
4:16 hr, b&w, sound
(49) *Balance Proof*, 1976-1980, from *Performance Anthology*,
1975-1980, 4:16 hr, b&w, sound
(50-51) *Relation in Space*, 1976-1980, from *Performance Anthology*,
1975-1980, 4:16 hr, b&w, sound
(52-53) *AAA-AAA*, from Performance Anthology, 1976-1980, from
Performance Anthology, 1975-1980, 4:16 hr, b&w, sound
(54-55) *There is a Criminal Touch to Art*, 1976-1980, from
Performance Anthology, 1975-1980, 4:16 hr, b&w, sound
(56) Top to bottom: *Terminal Garden*, 1986; *Art must be beautiful,
Artist must be beautiful*, 1975-1976, from *Performance Anthology*,
1975-1980; *City of Angels*, 1983; *Balance Proof*, 1976-1980, from
Performance Anthology, 1975-1980
(57) Top: *AAA-AAA*, 1976-1980, from *Performance Anthology*,
1975-1980;
Bottom: *Relation in Time*, 1976-1980, from *Performance Anthology*,
1975-1980

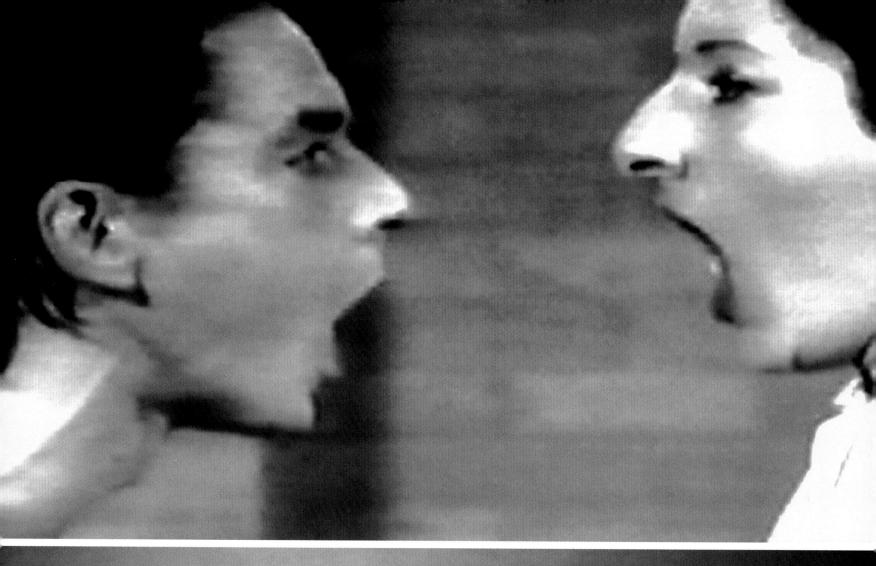
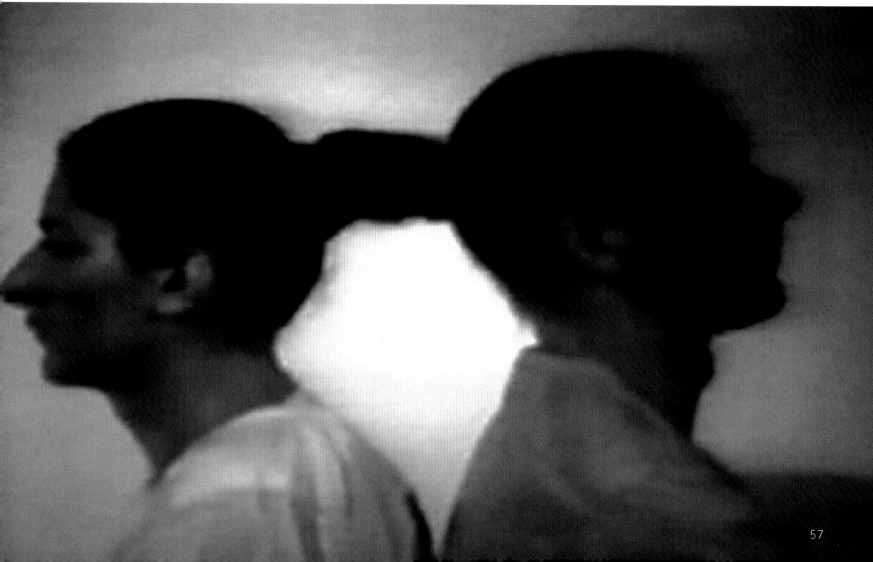

Vito Acconci

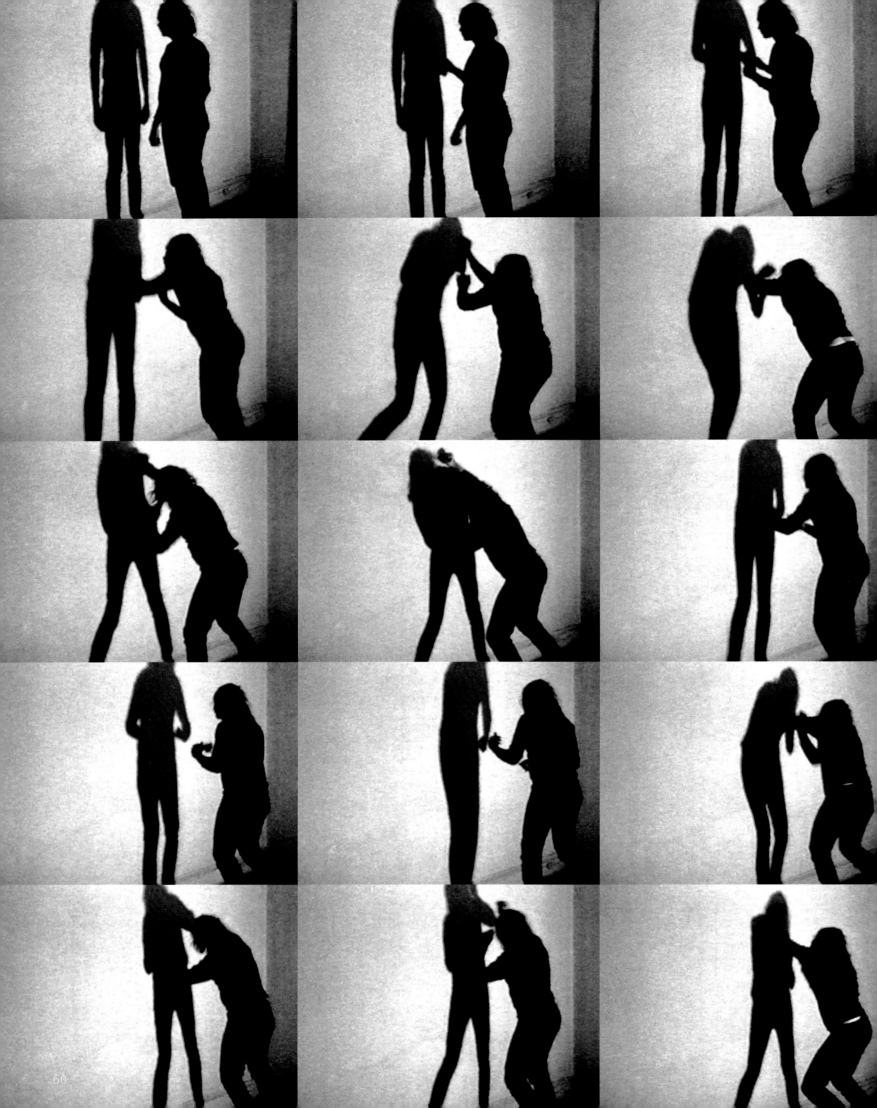

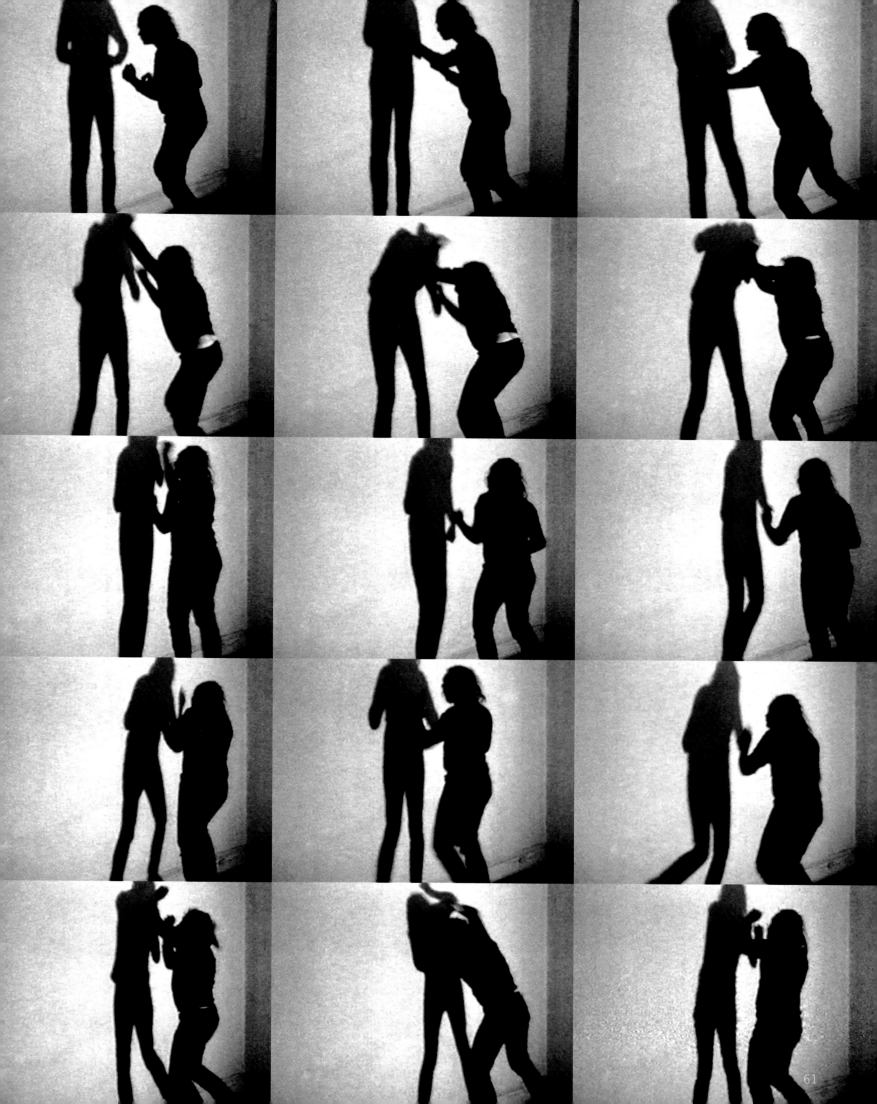

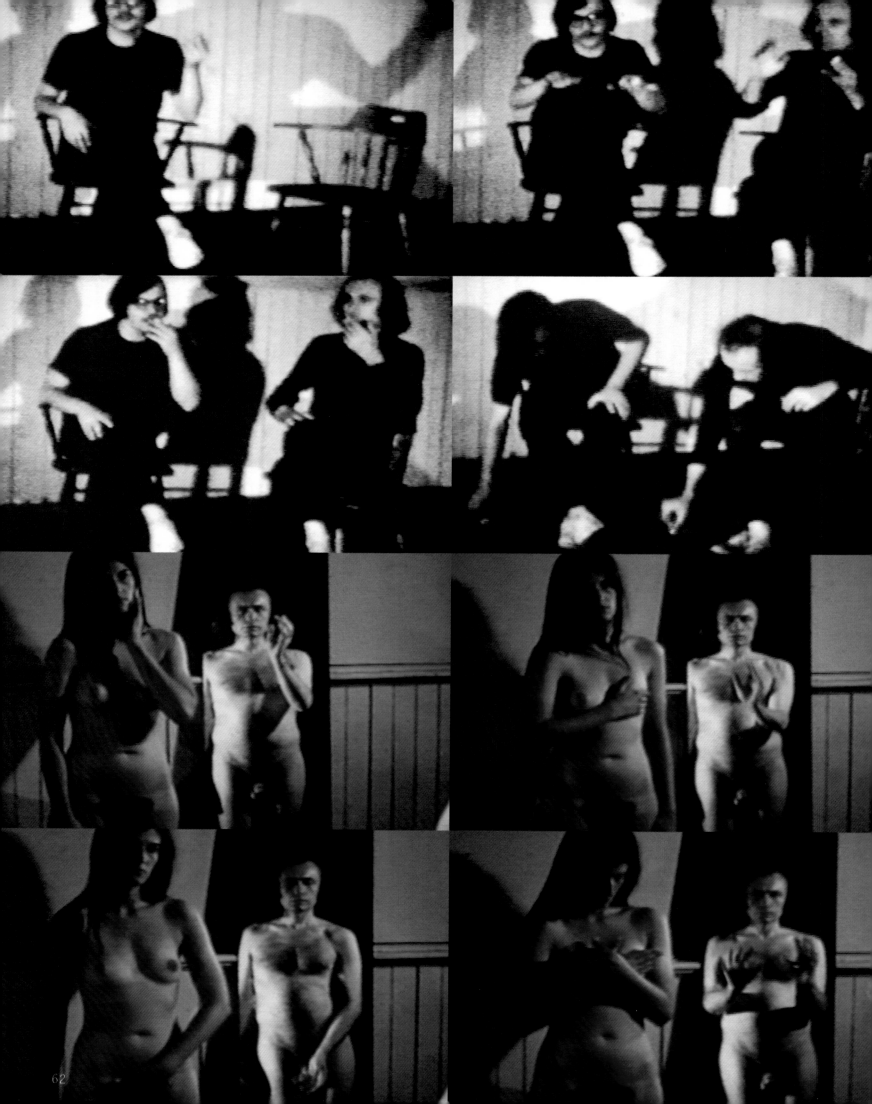

'T THEM OFF
MY BACK.

I'D SAVOR
WORDS:

COME DOWN
HARDER NO

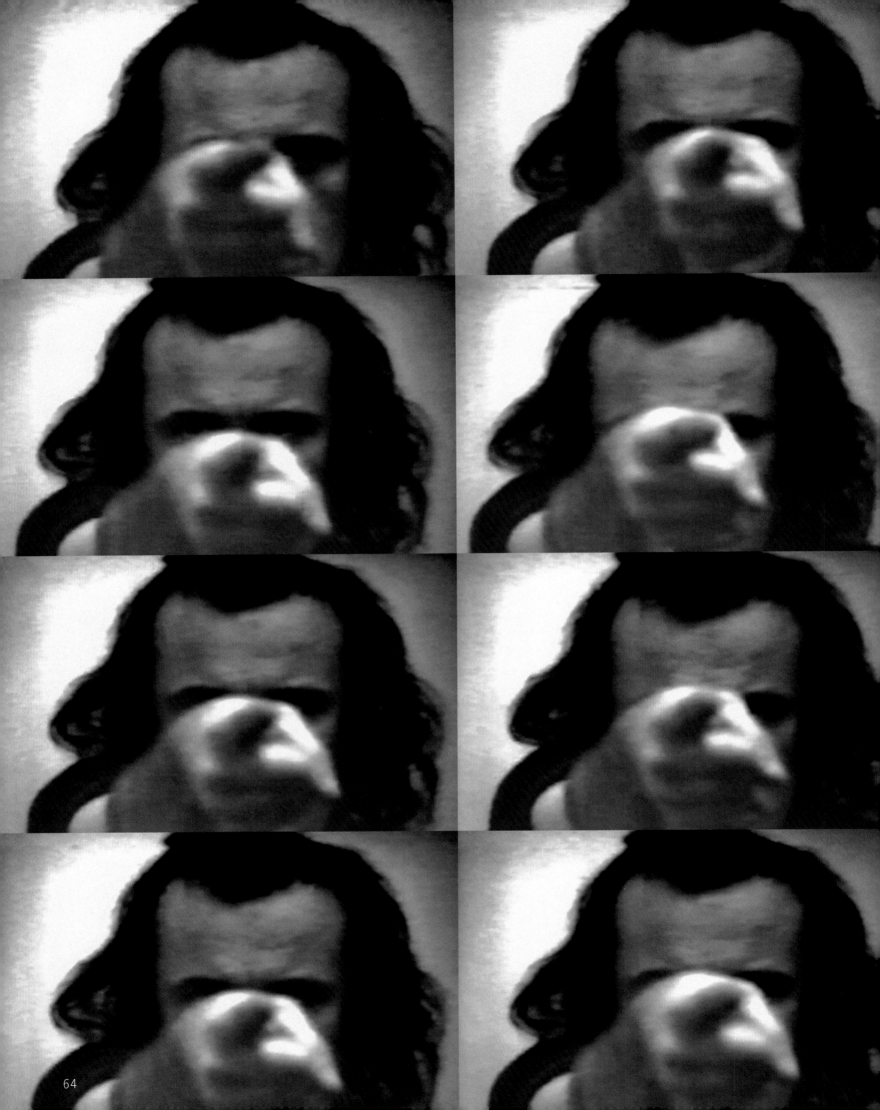

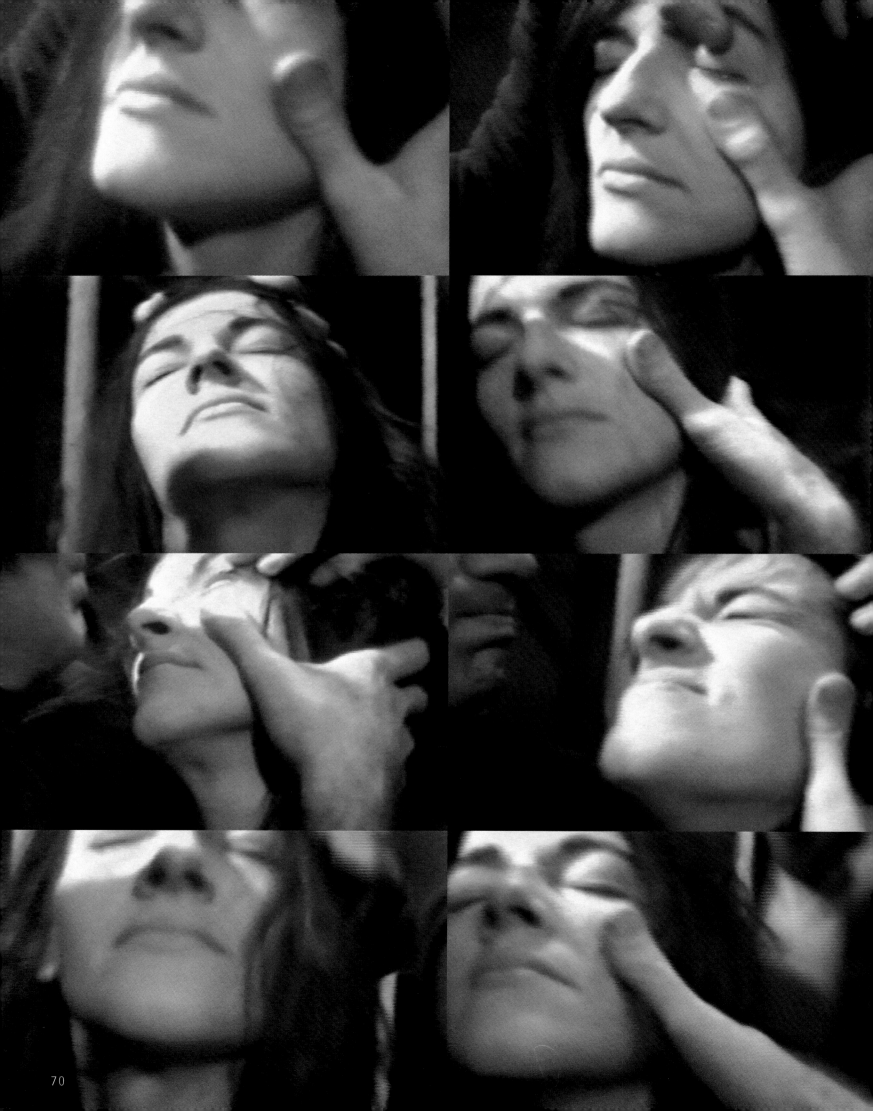

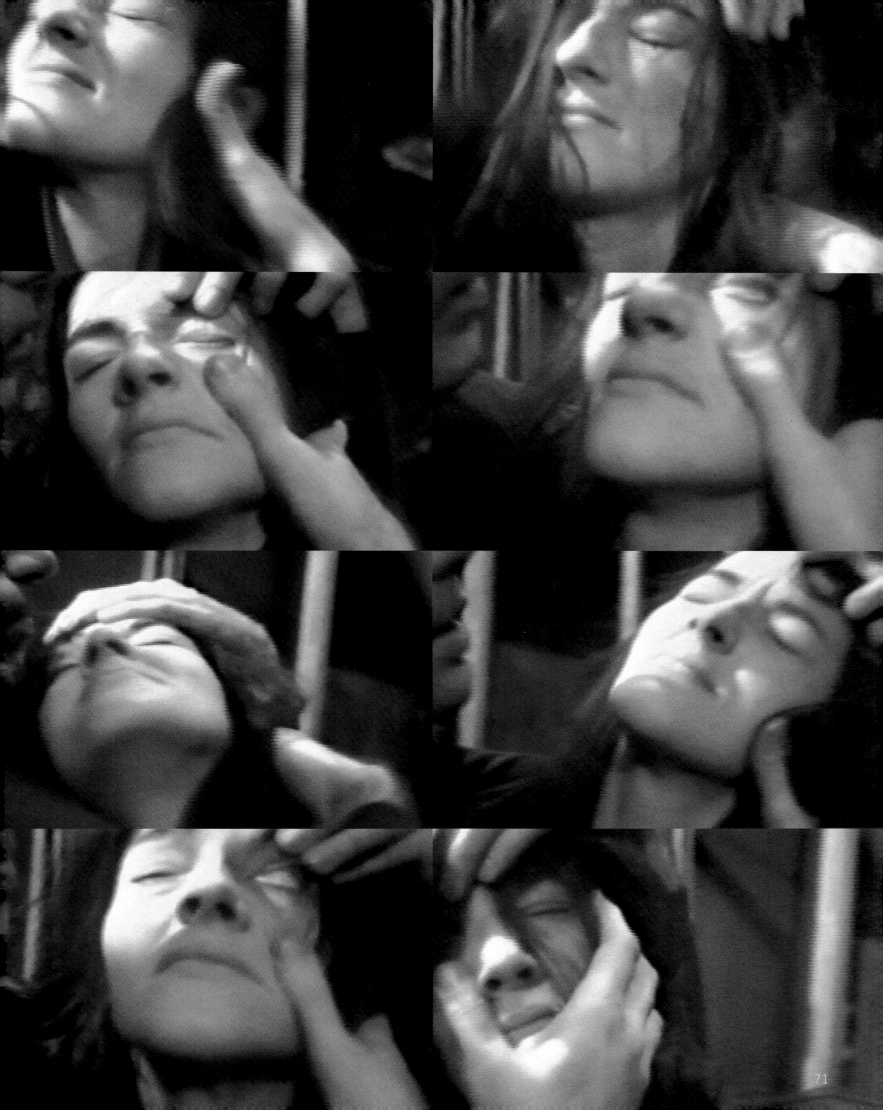

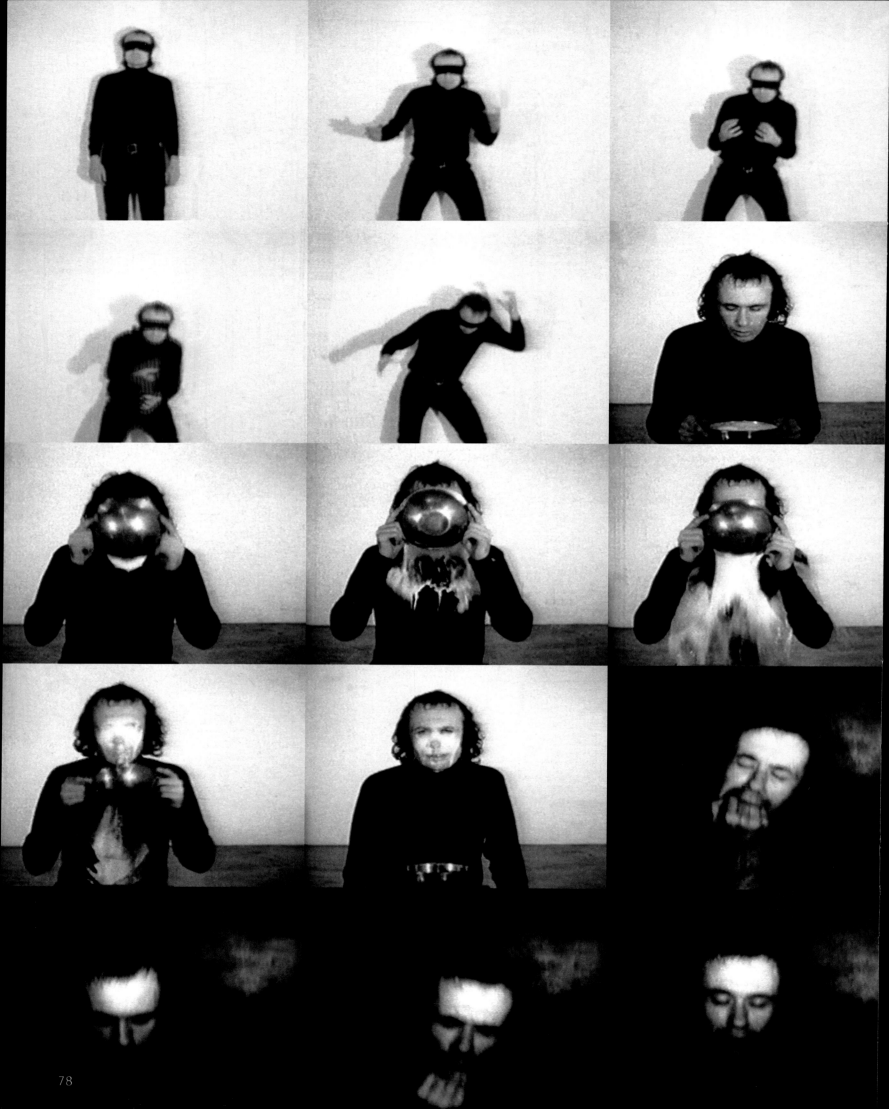

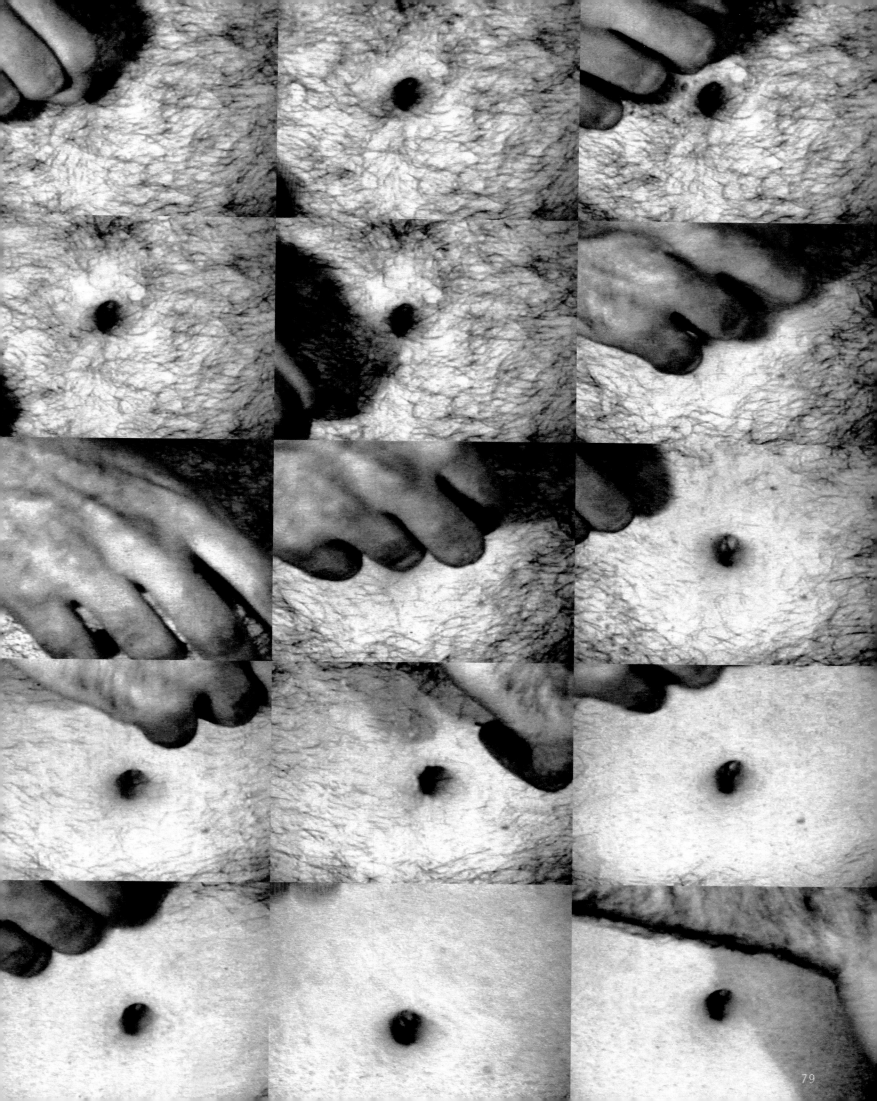

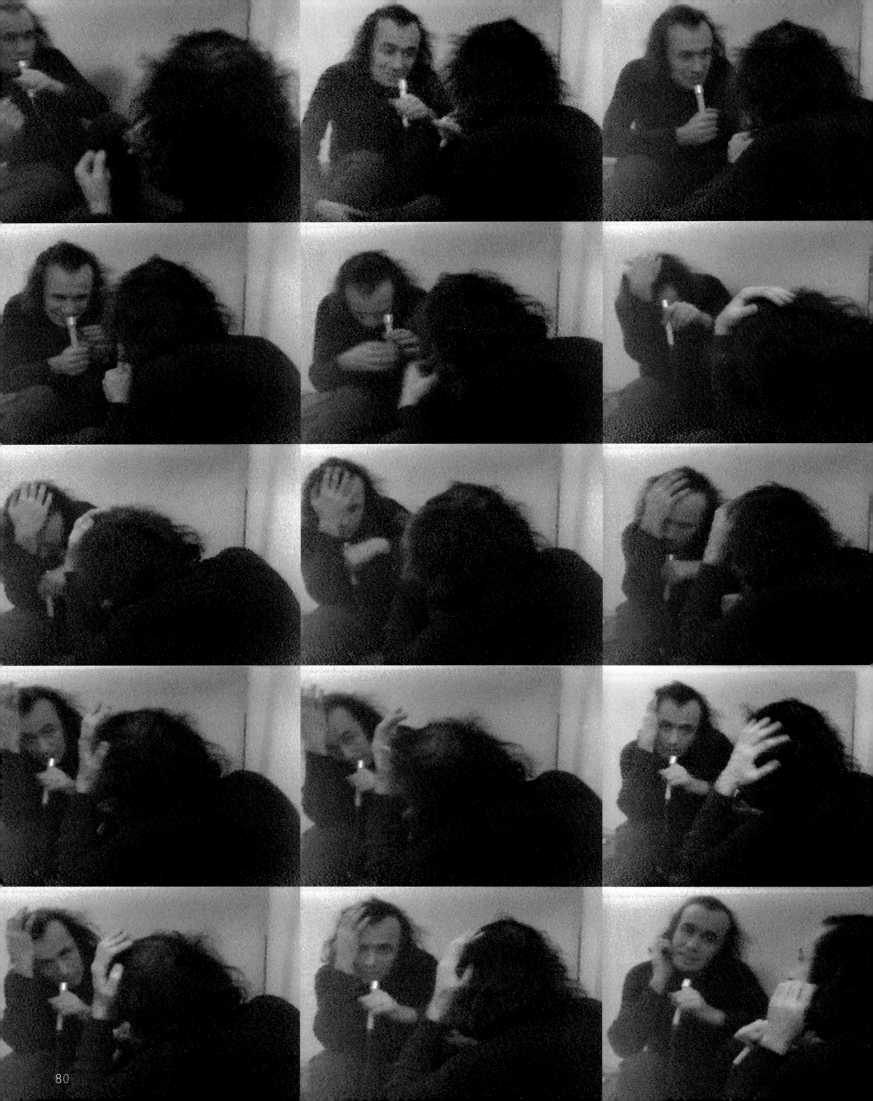

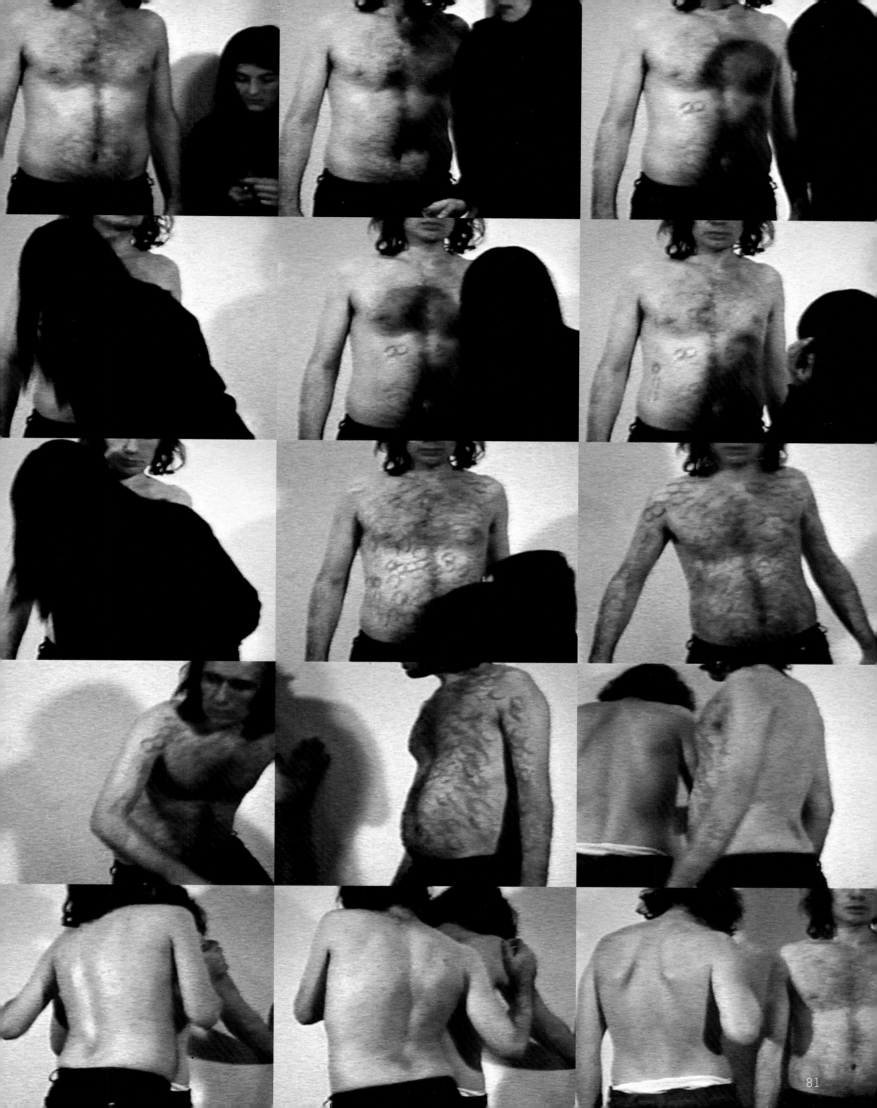

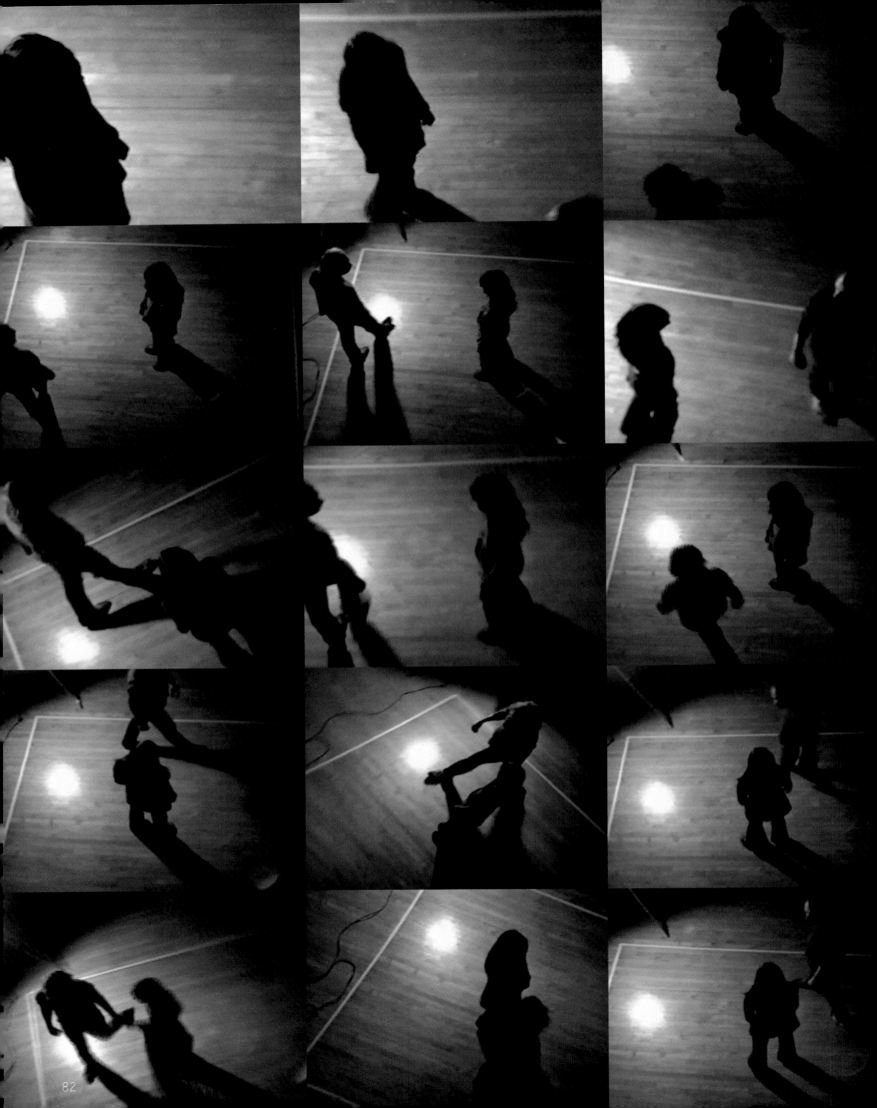

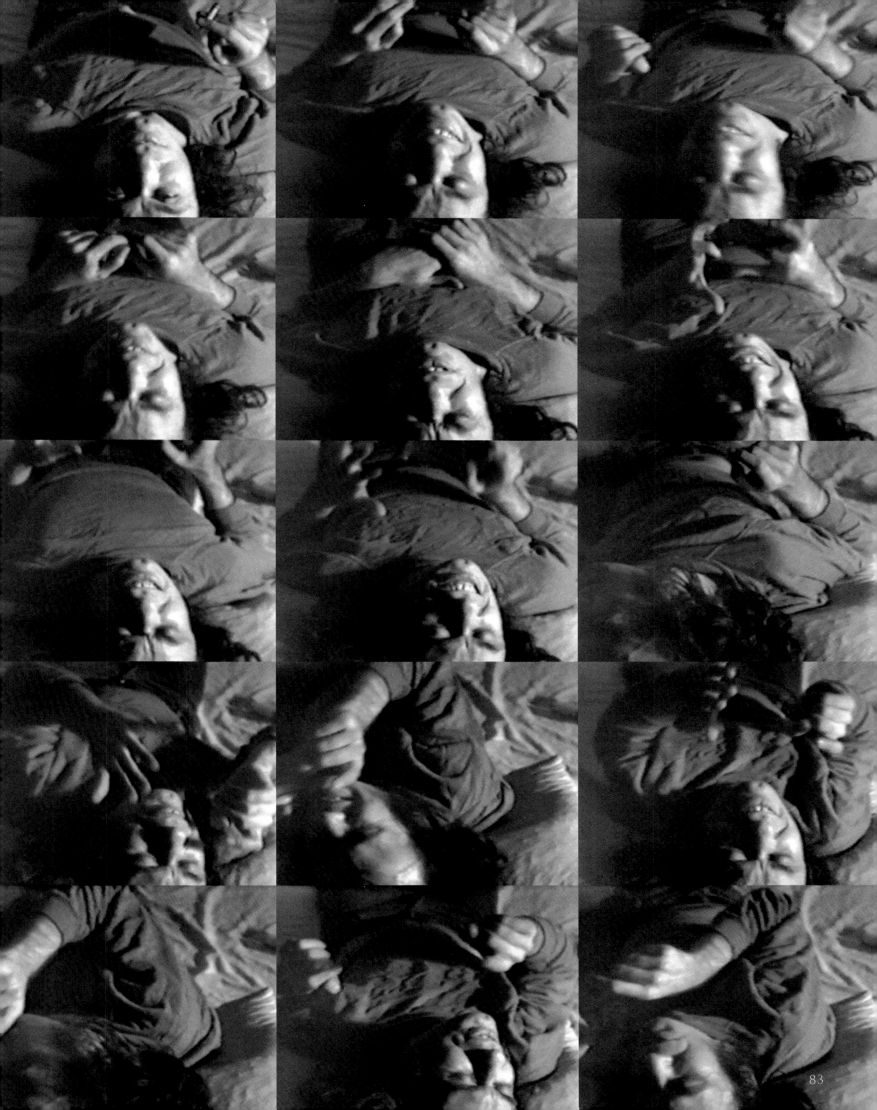

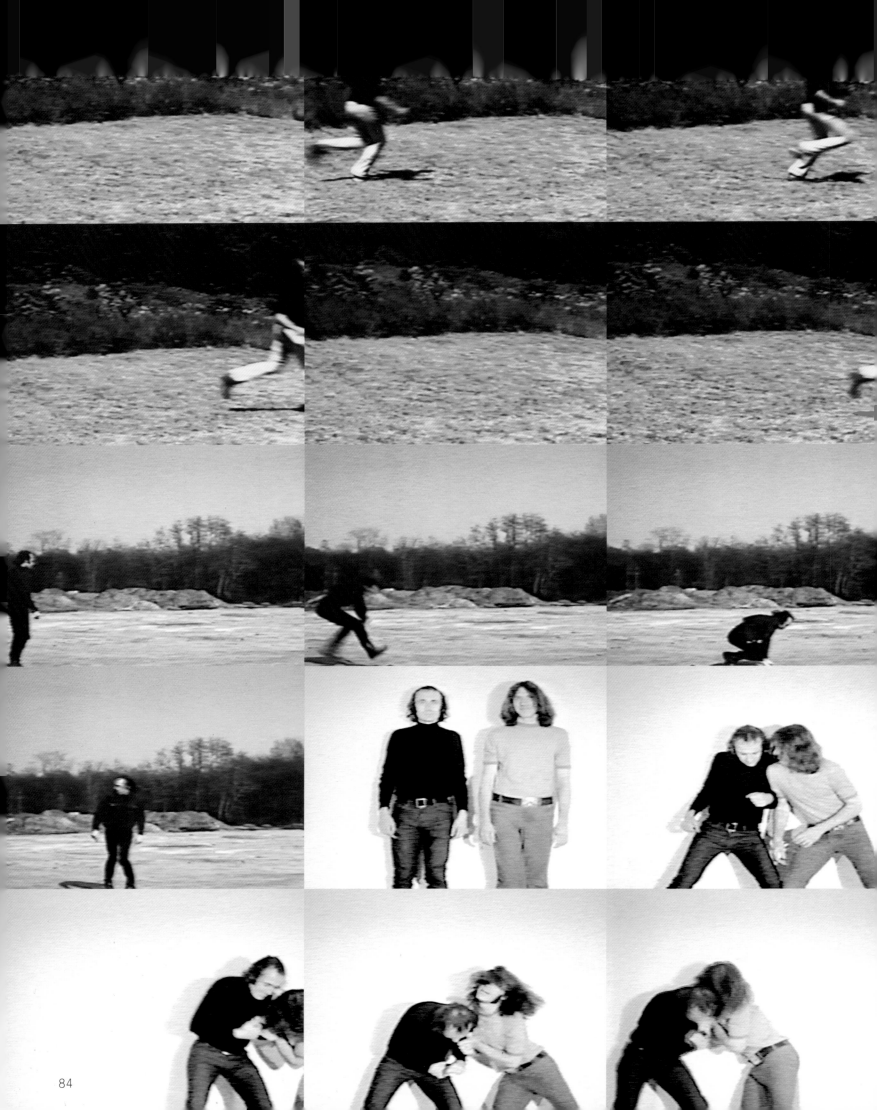

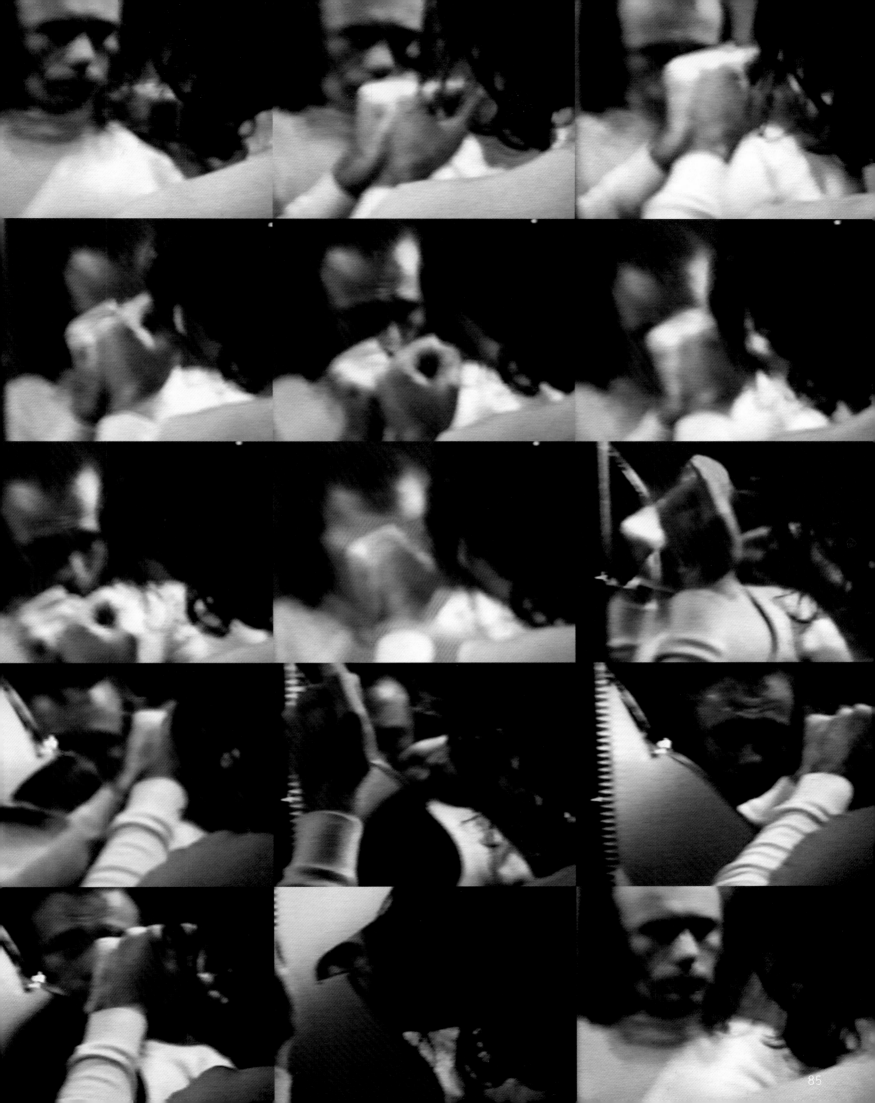

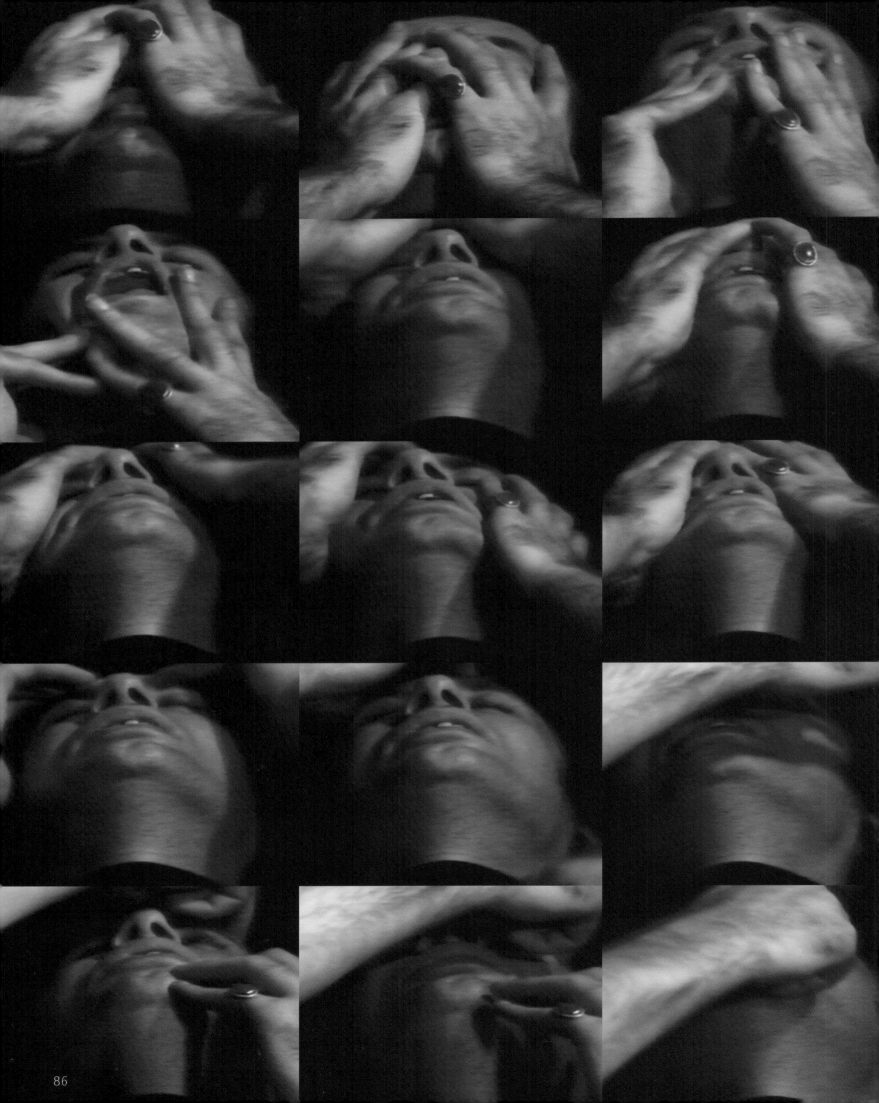

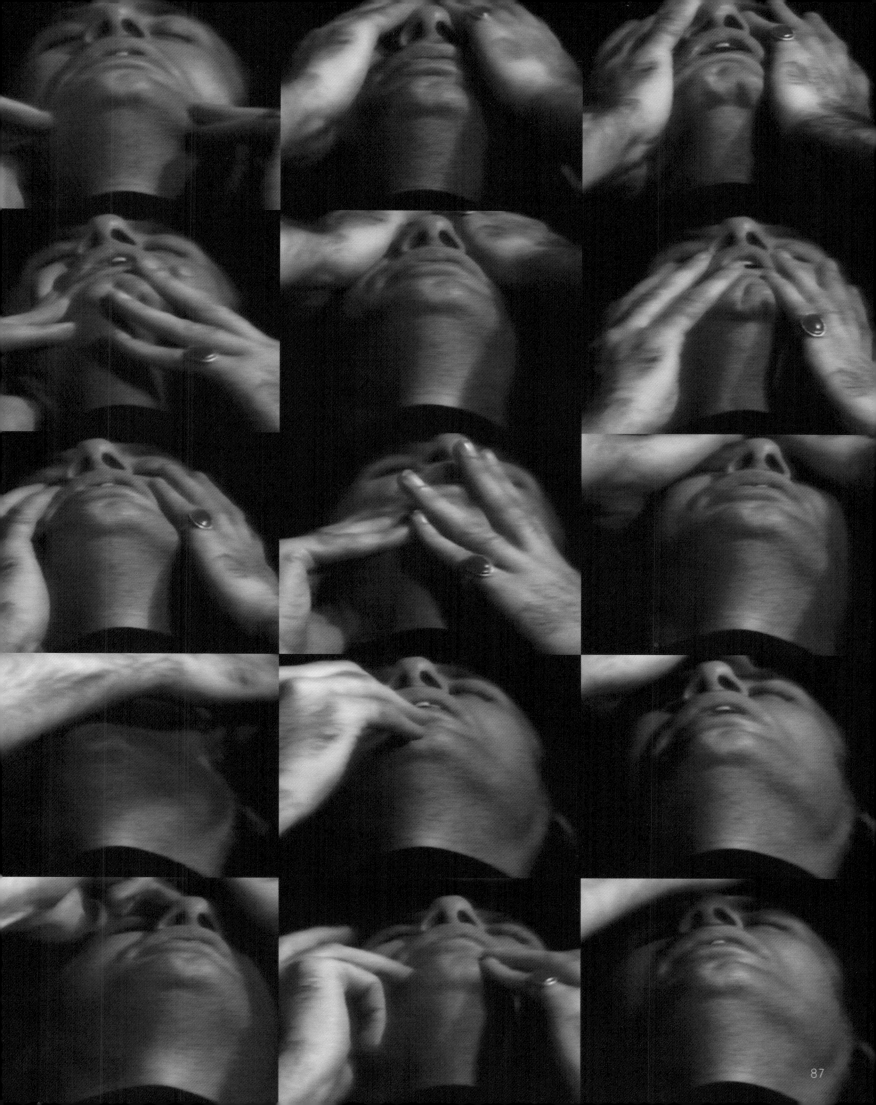

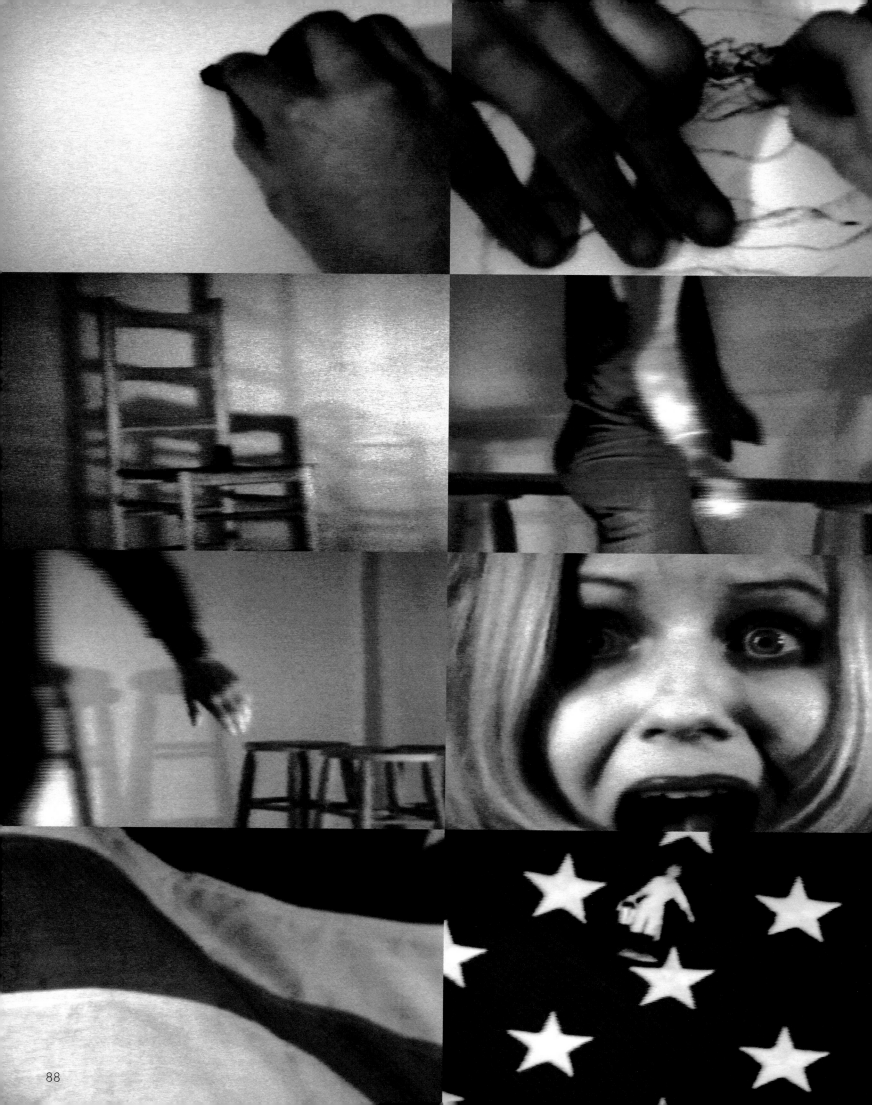

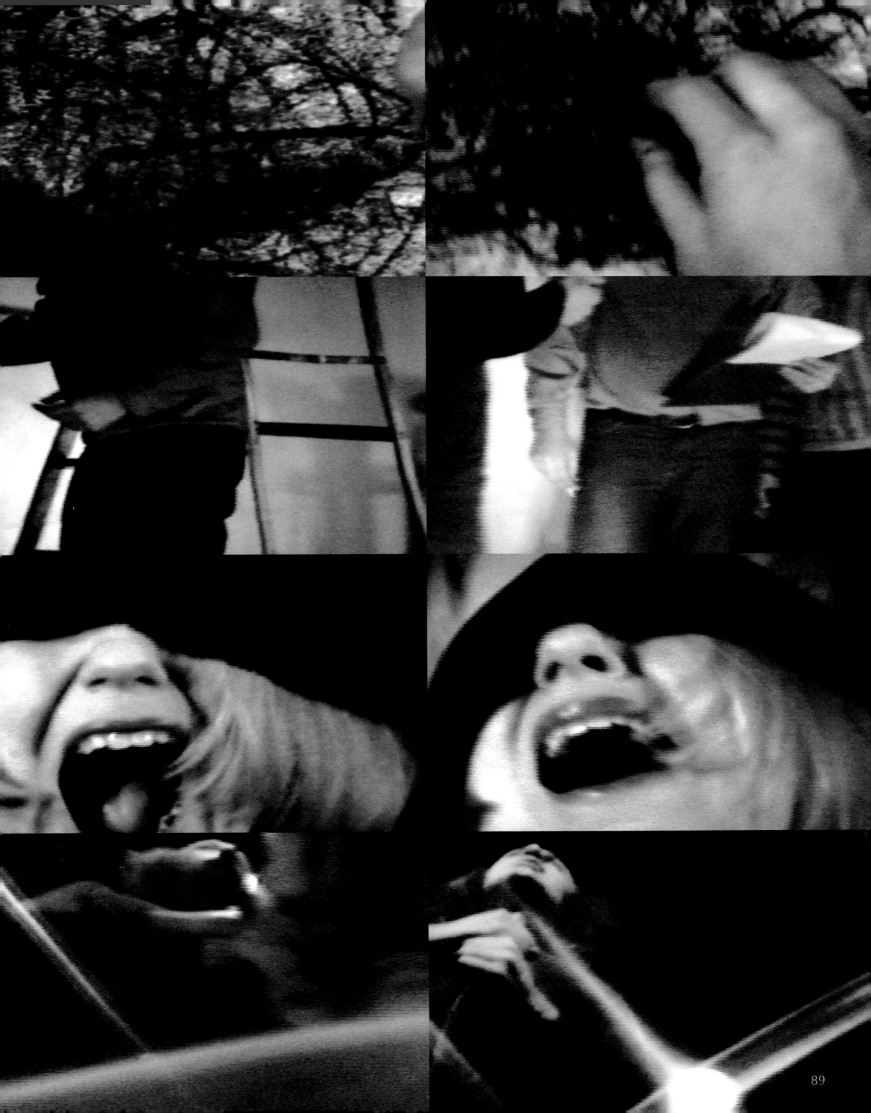

Vito Acconci (b. 1940)
Selected Single Channel Film and Video Works

Running Tape, 1969
Three Frame Studies, 1969
Applications, 1970
Corrections, 1970
Open-Close, 1970
Openings, 1970
Rubbings, 1970
See Through, 1970
Three Adaptation Studies, 1970
Three Relationship Studies, 1970
Two Cover Studies, 1970
Two Takes, 1970
Association Area, 1971
Centers, 1971
Claim Excerpts, 1971
Contacts, 1971
Conversions, 1971
Filler, 1971
Focal Point, 1971
Pick-up, 1971
Pryings, 1971
Pull, 1971
Two Track, 1971
Watch, 1971
Waterways: 4 Saliva Studies, 1971
Zone, 1971
Face to Face, 1972
Hand to Hand, 1972
Face-Off, 1973
Full Circle, 1973
Home Movies, 1973
Recording Studio From Air Time, 1973
Stages, 1973
Theme Song, 1973
Undertone, 1973
Visions of a Disappearance, 1973
Walk-Over, 1973
My Word, 1973-74
Command Performance, 1974
Face of the Earth, 1974
Open Book, 1974
Shoot, 1974
Turn-On, 1974
The Red Tapes, 1976
Election Tape '84, 1984
The City Inside Us, 1993

All images courtesy of Electronic Arts Intermix (EAI), New York

(60-62) *Three Relationship Studies*, 1970, 12:30 min, b&w and color, silent, Super 8 film
(63) *My Word*, 1973-74, 91:30 min, color, silent, Super 8 film
(64) *Centers*, 1971, 22:28 min, b&w, sound
(65) *Corrections*, 1970, 12:00 min, b&w, sound, Super 8 film
(66) *Filler*, 1971, 29:16 min, b&w, sound
(67) *Walk-Over*, 1973, 30:00 min, b&w, sound
(68) *Full Circle*, 1973, 30:00 min, b&w, sound
(69) *Open Book*, 1974, 10:09 min, color, sound
(70-71) *Pryings*, 1971, 17:10 min, b&w, sound
(72) *Face-Off*, 1973, 32:57 min, b&w, sound
(73) *Theme Song*, 1973, 33:15 min, b&w, sound
(74) *Claim Excerpts*, 1971, 62:11 min, b&w, sound
(75) *Undertone*, 1973, 34:12 min, b&w, sound
(76) *Focal Point*, 1971, 32:47 min, b&w, sound
(77) *Home Movies*, 1973, 32:19 min, b&w, sound
(78) *Three Adaptation Studies*, 1970, 8:05 min, b&w, silent, Super 8 film
(79) *Openings*, 1970, 14:00 min, b&w, silent, Super 8 film
(80) *Recording Studio From Air Time*, 1973, 36:49 min, b&w, sound
(81) *Contacts*, 1971, 32:37 min, b&w, sound
(82) *Pull*, 1974, 32:37 min, b&w, sound
(83) *Command Performance*, 1974, 56:40 min, b&w, sound
(84) *Three Frame Studies*, 1969, 10:58 min, b&w and color, silent, Super 8 film
(85) *See Through*, 1970, 5:00 min, color, silent, Super 8 film
(86-87) *Face of the Earth*, 1974, 22:18 min, color, sound
(88-89) *The Red Tapes (1-3)*, 1976, 141:27 min, b&w, sound
(90) Top to bottom: *Waterways: 4 Saliva Studies*, 1971; *Conversions*, 1971; *Focal Point*, 1971; *Home Movies*, 1973
(91) Top row: *Face of the Earth*, 1974; *Centers*, 1971; *Zone*, 1971
Second row: *Two Track*, 1971; *Undertone*, 1973; *See Through*, 1970
Third row: *Shoot*, 1974; *Pick-up*, 1971; *Visions of a Disappearance*, 1973;
Fourth row: *Watch*, 1971; *Face-Off*, 1973; *Two Takes*, 1970; Bottom row: *The Red Tapes*, 1976; *Association Area*, 1971; *Applications*, 1970

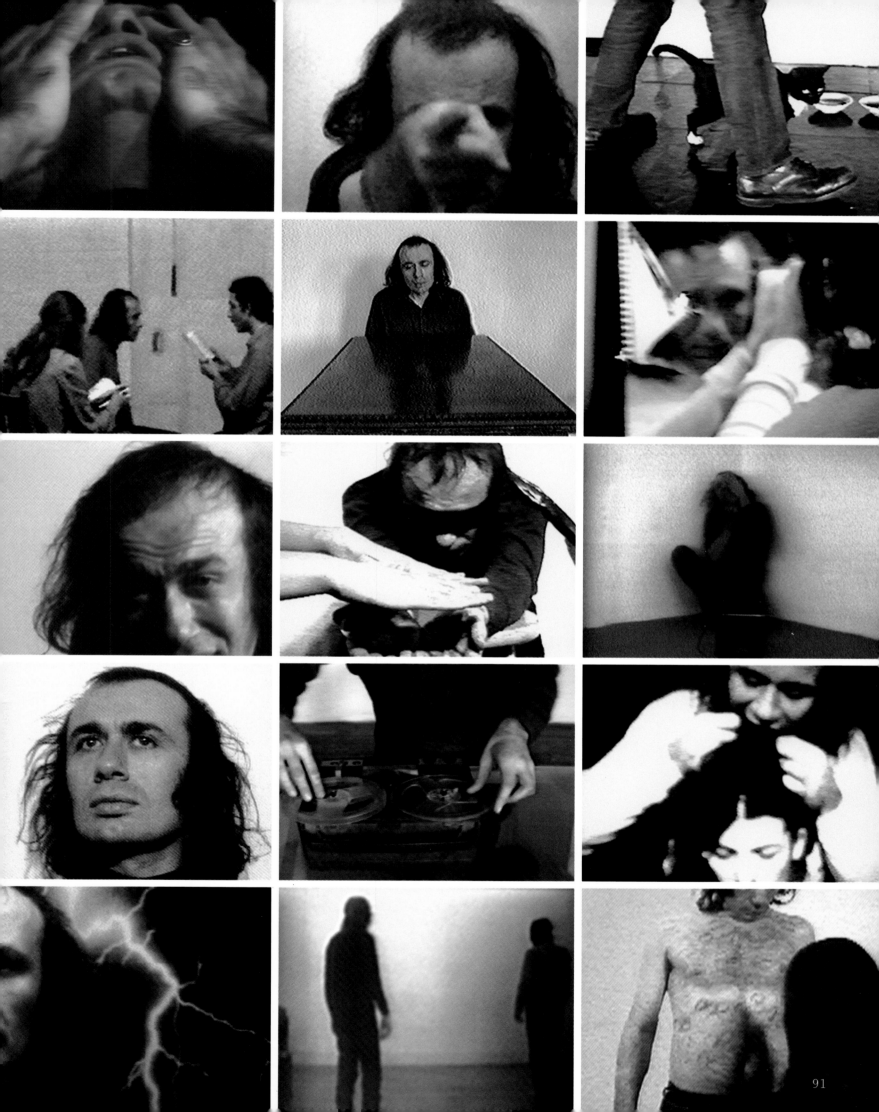

Darren Almond

03:01:03

08:46:19

00:05:04

00:50:18

Darren Almond (b. 1971)
Selected Single Channel Film and Video Works

Schwebebahn, 1995
A Real Time Piece, 1996
H.M.P. Pentonville, 1997
Time And Time Again, 1998
The Guest, 1998
Geisterbahn, 1999
The Great Circle, 2000

Images courtesy of Jay Lopling, London, except when noted.

(94-95) *H.M.P Pentonville*, 1997, 7:50 min, color, sound, film.
Courtesy of the Collection of Pamela and Richard Kramlich
(96) Top to bottom: *Time and Time Again*, 1998; *The Great Circle*,
2001; *A Real Time Piece*, 1996
(97) Top: *Geisterbahn*, 1999
Bottom: *Schwebebahn*, 1995

John Baldessari

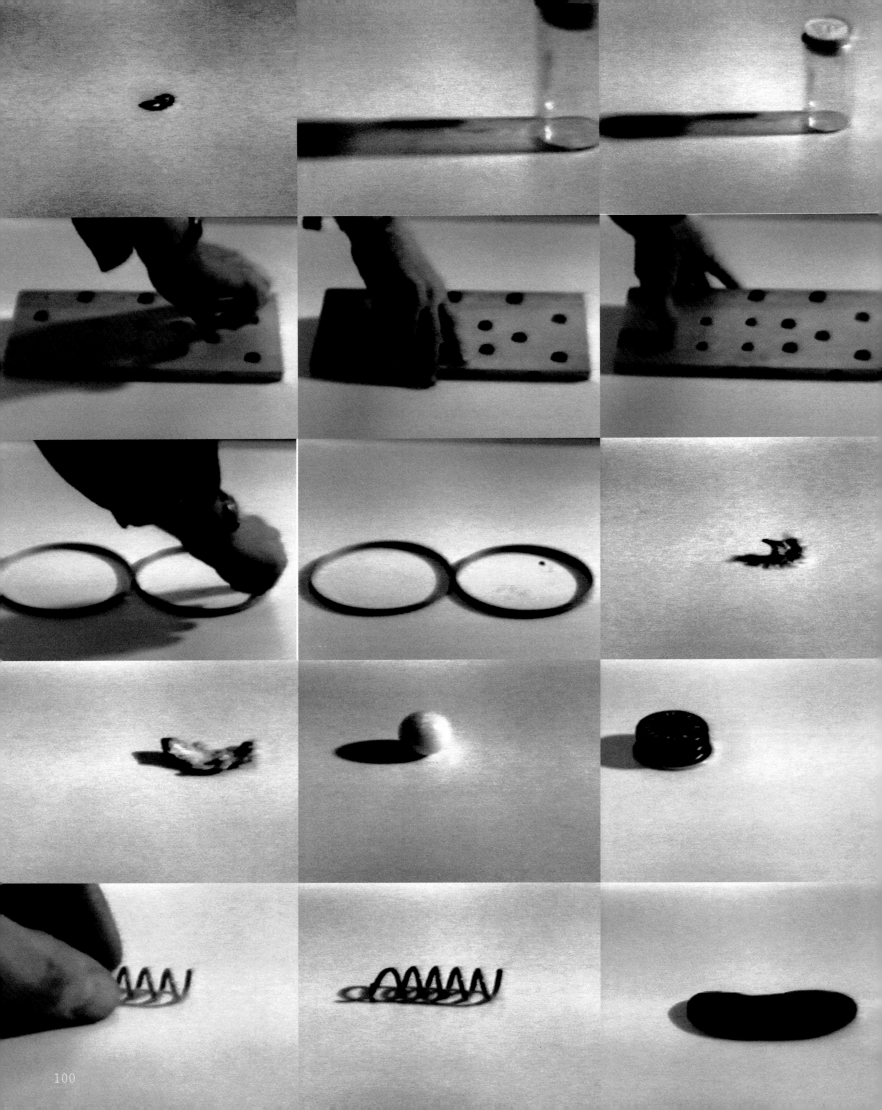

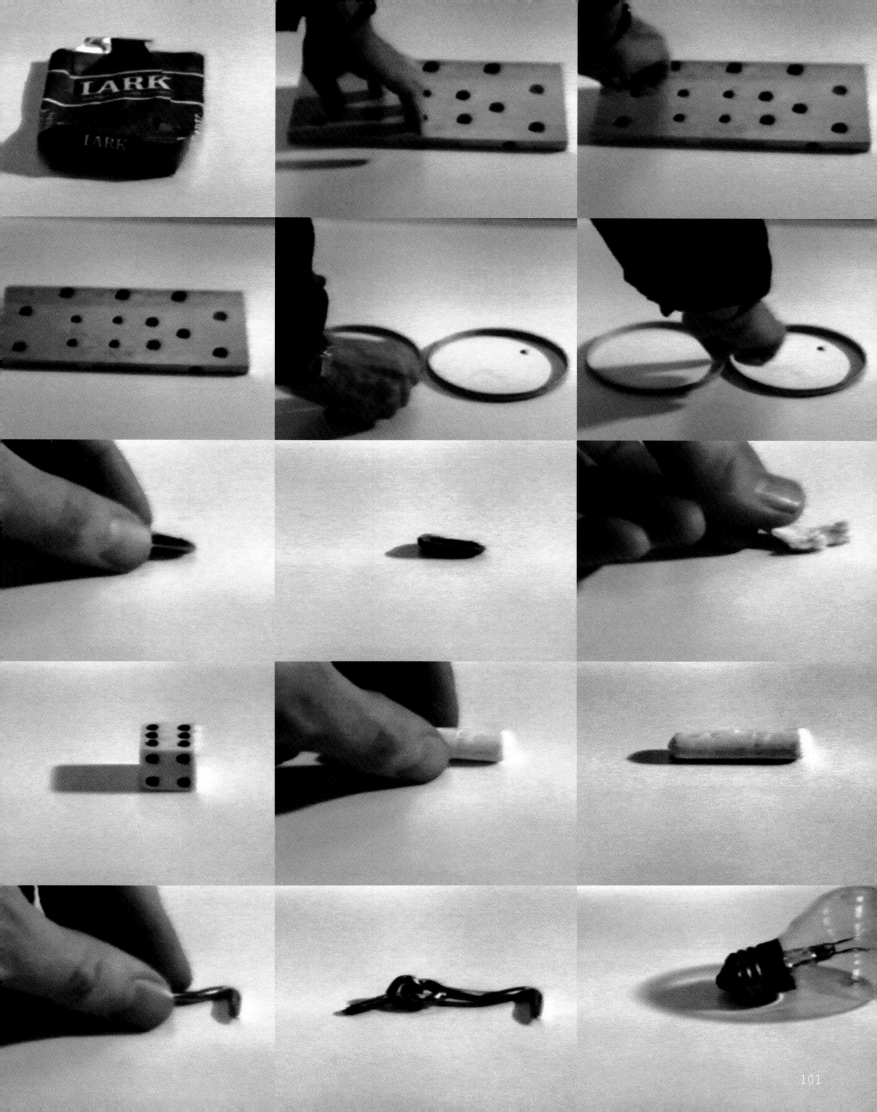

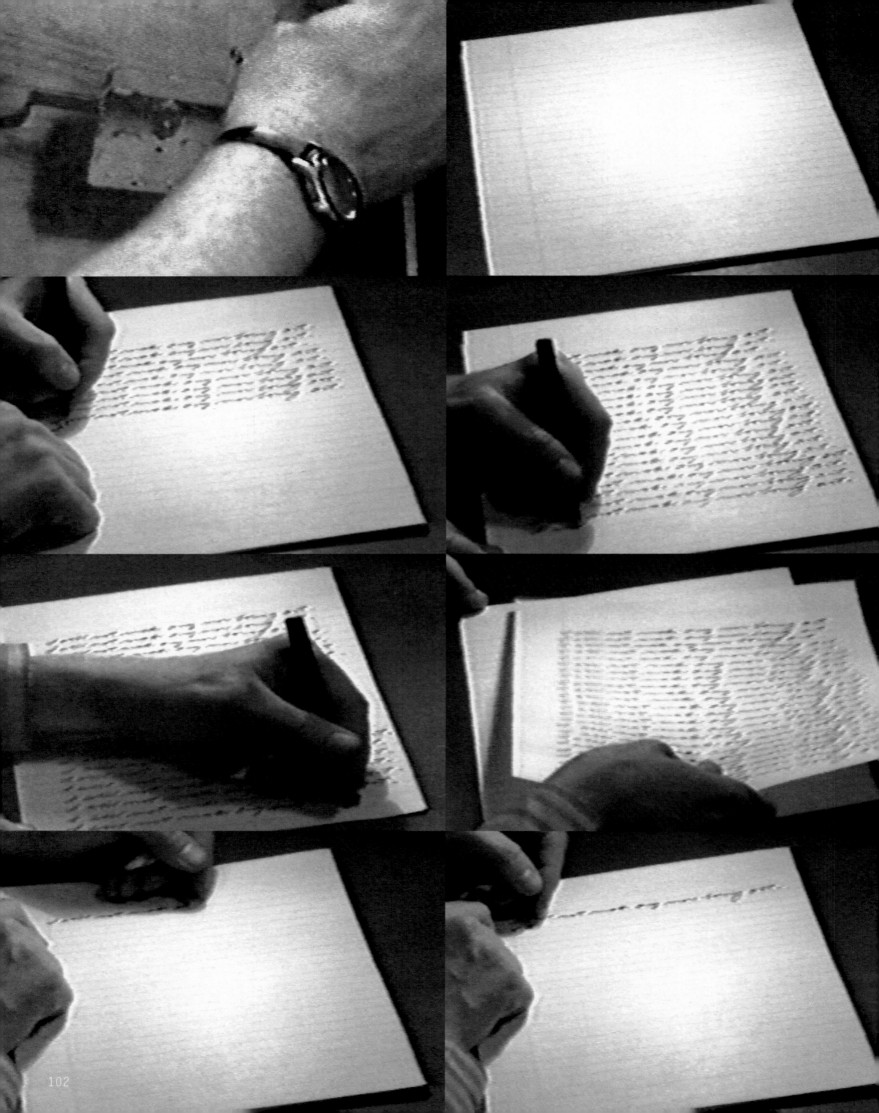

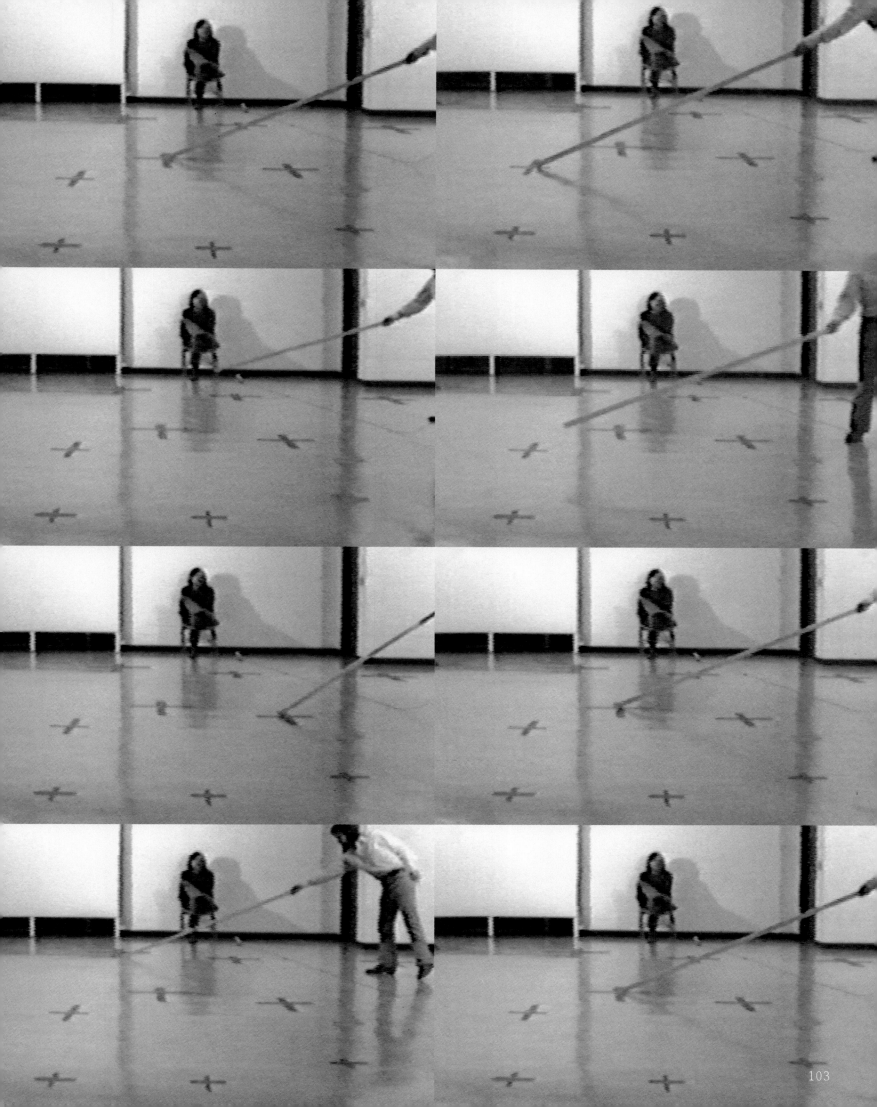

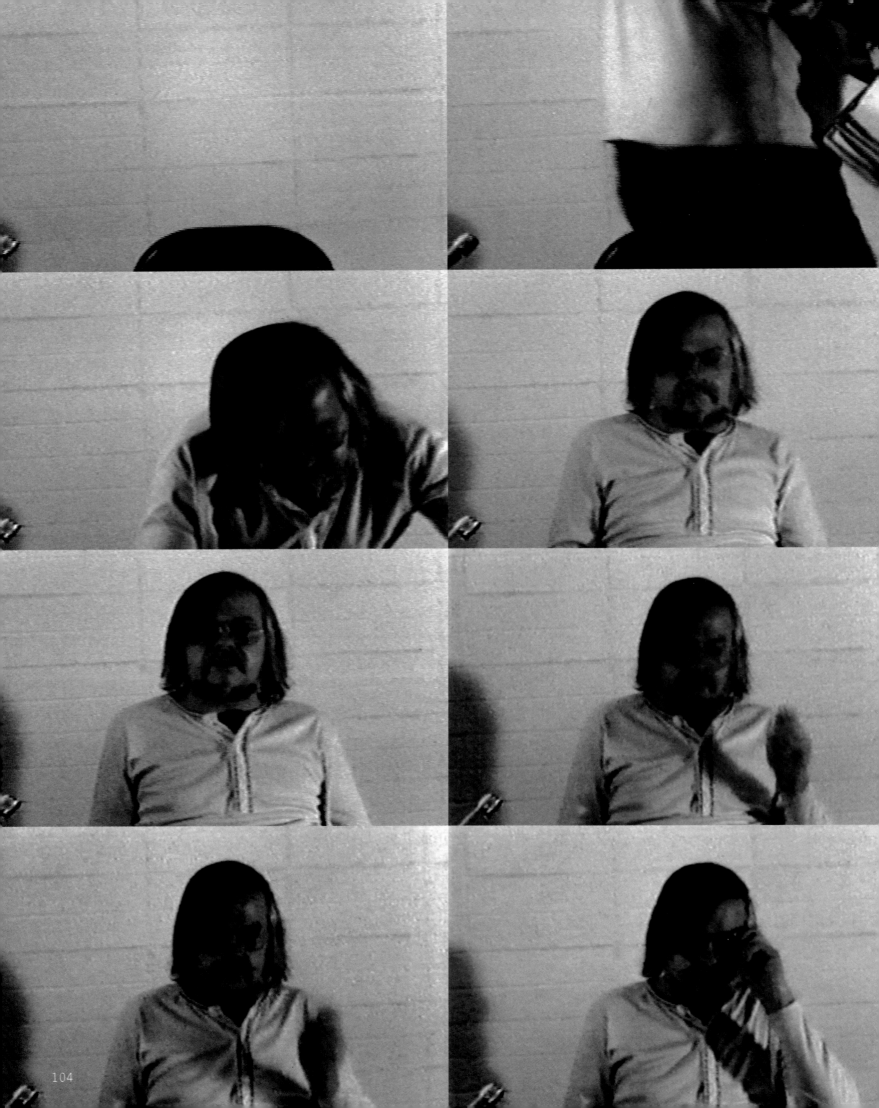

104

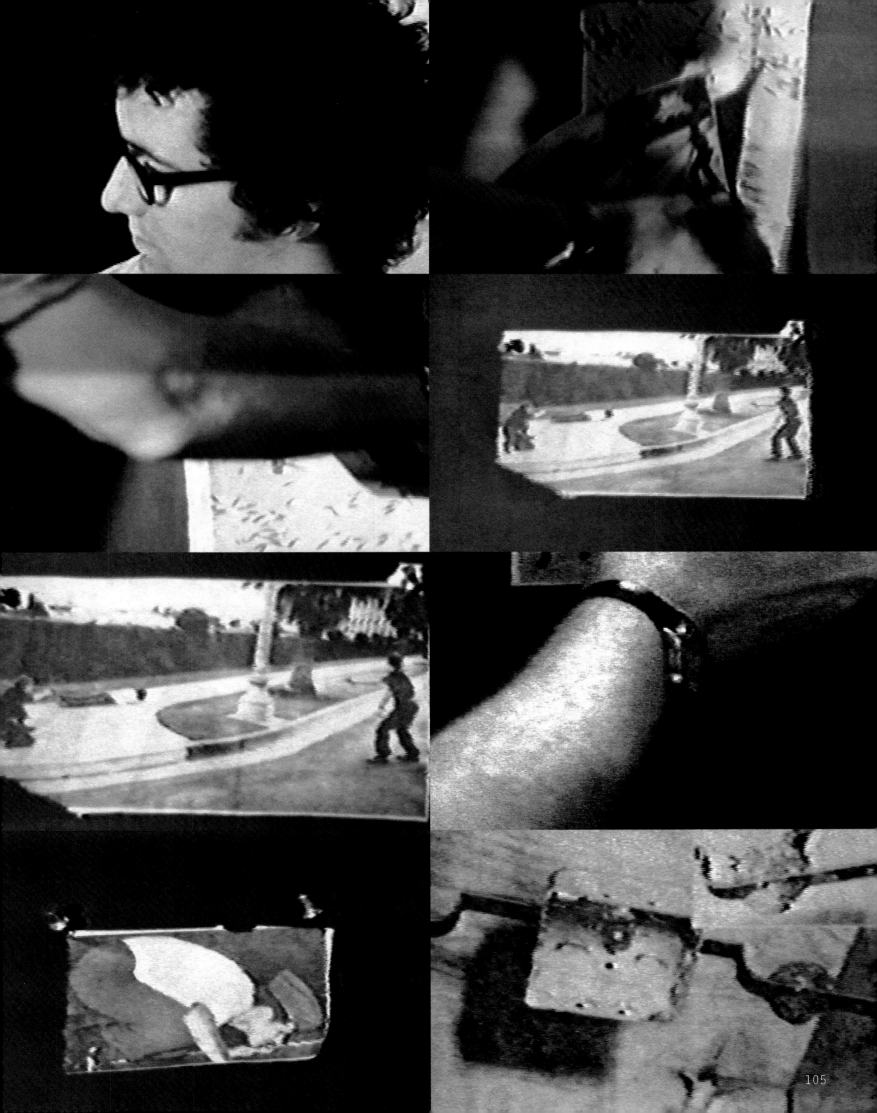

John Baldessari (b. 1931)
Selected Single Channel Film and Video Works

Isocephaly, 1968
What To Leave Out, 1968
Cremation, 1970
Black Painting, 1970
Black Curtain, 1970
Life Drawing, 1970
Folding Hat: Version 1, 1970
Folding Hat, 1970-71
New York City Art History, 1971
New York City Postcard Painting, 1971
Waterline, 1971
Dance, 1971
Minimalism, 1971
Tabula Rasa, 1971
Black-Out, 1971
Art Disaster, 1971
I Am Making Art, 1971
I Will Not Make Any More Boring Art, 1971
Police Drawing, 1971
Some Words I Mispronounce, 1971
Walking Forward-Running Past, 1971
Baldessari Sings Lewitt, 1972
Inventory, 1972
Teaching a Plant the Alphabet, 1972
Xylophone, 1972
Easel Painting, 1972-73
Time-Temperature, 1972-73
Water to Wine to Water, 1972-73
The Hollywood Film, 1972-73
Title, 1973
Throwing Leaves Back at Tree, 1973
Ed Henderson Reconstructs Movie Scenarios, 1973
Haste Makes Waste, 1973
How We Do Art Now, 1973
Practice Makes Perfect, 1973
The Meaning of Various News Photos to Ed Henderson, 1973
The Way We Do Art Now and Other Sacred Tales, 1973
Three Feathers and Other Fairy Tales, 1973
The Sound Made by Kicking a Bottle, 1973
Ice Cubes Sliding, 1974
Taking a Slate: Ilene and David (#1), 1974
Taking a Slate: Ilene and David (#2), 1974
Taking a Slate: David, 1974
Ted's Christmas Card, 1974
Ed Henderson Suggests Sound Tracks for Photographs, 1974
The Italian Tape, 1974
Four Minutes of Trying to Tune Two Glasses (For the Phil Glass Sextet), 1976
Script, 1973-77
Six Colorful Inside Jobs, 1977
Six Colorful Tales: From the Emotional Spectrum (Women), 1977
Two Colorful Melodies, 1977

All images courtesy of Electronic Arts Intermix (EAI), New York, except when noted.

(100-101) *Inventory*, 1972, 23:50 min, b&w, sound
(102) *I Will Not Make Any More Boring Art*, 1971, 13:06 min, b&w sound
(103) *The Way We Do Art Now and Other Sacred Tales*, 1973, 28:28 min, b&w, sound
(104) *Baldessari Sings Lewitt*, 1972, 15:00 min, b&w, sound, Courtesy of Video Data Bank
(105) *The Meaning of Various News Photos to Ed Henderson*, 1973, 15:00 min, b&w, sound, Courtesy of Video Data Bank
(106) Top to bottom: *Inventory*, 1972; *Four Minutes of Trying to Tune Two Glasses (For the Phil Glass Sextet)*, 1976; *Ed Henderson Reconstructs Movie Scenarios*, 1973; *The Way We Do Art Now and Other Sacred Tales*, 1973
(107) Top row: *How We Do Art Now*, 1973; *Folding Hat*, 1970-71
Second row: *Baldessari Sings Lewitt*, 1972; *The Meaning of Various News Photos to Ed Henderson*, 1973
Third row: *Six Colorful Tales: From the Emotional Spectrum (Women)*, 1977; *Teaching a Plant the Alphabet*, 1972
Bottom row: *Some Words I Mispronounce*, 1971; *Walking Forward-Running Past*, 1971

Dara Birnbaum

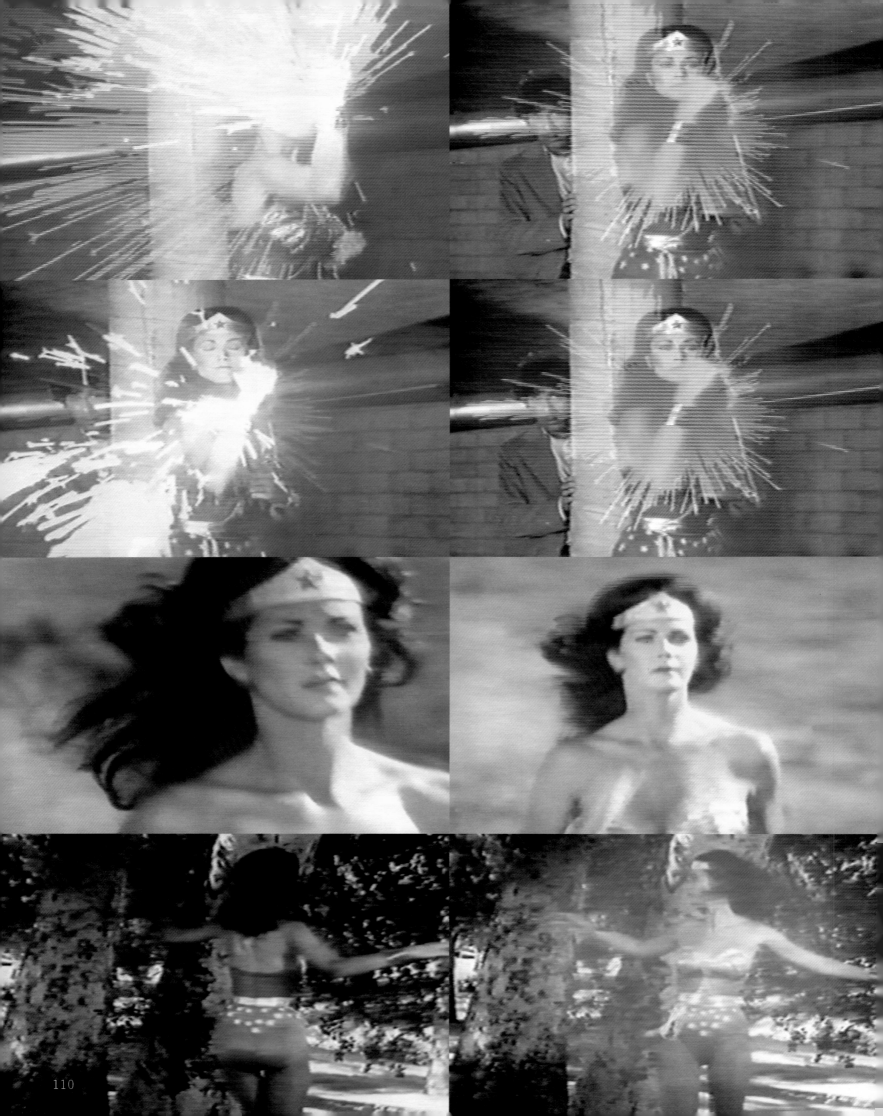

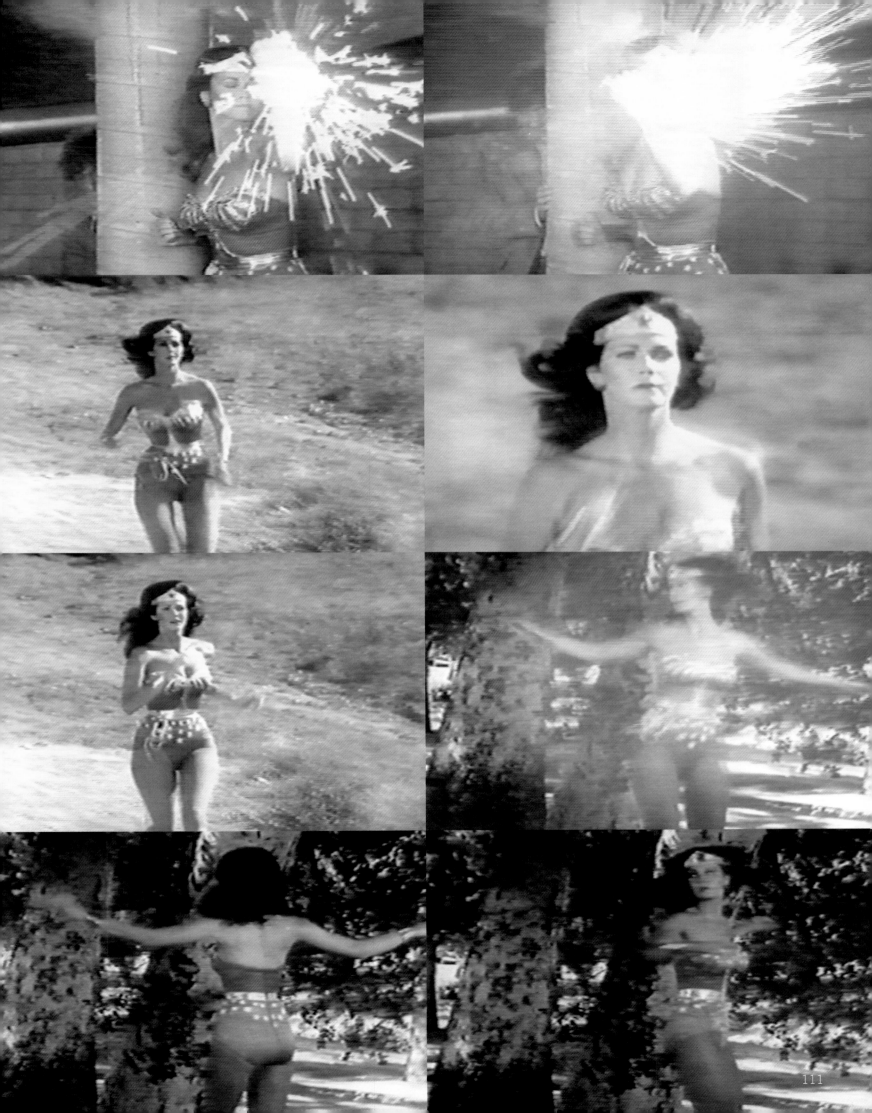

Dara Birnbaum (b. 1946)
Selected Single Channel Film and Video Works

Attack Piece, 1976
(A) Drift of Politics (Laverne & Shirley), 1978
Technology/Transformation: Wonder Woman, 1978-79
Kiss The Girls: Make Them Cry, 1979
Local TV News Analysis For Cable Television (with Dan Graham),
1980
Pop-Pop Video, 1980
General Hospital/Olympic Women Speed Skating, 1980
Kojak/Wang, 1980
Remy/Grand Central: Trains and Boats and Planes, 1980
New Music Shorts, 1981
Fire! Hendrix, 1982
PM Magazine/Acid Rock, 1982
Damnation of Faust: Evocation, 1983
Damnation of Faust: Will-o'-the-Wisp (A Deceitful Goal), 1985
Artbreak, MTV Networks, Inc., 1987
Damnation of Faust: Charming Landscape, 1987
*Canon: Taking to the Streets, Part One: Princeton University -
Take Back the Night*, 1990
Transgressions, 1992

All images courtesy of Electronic Arts Intermix (EAI), New York,
except when noted.

(110-111) *Technology/Transformation: Wonderwoman*, 1978-79, 5:50
min, color, sound
(112-113) *Attack Piece*, 1976, 7:40 min, b&w, silent. Courtesy of
Marian Goodman Gallery, New York
(114) Top to bottom: *Technology/Transformation: Wonder Woman*,
1978-79; *PM Magazine/Acid Rock*, 1982; *Damnation of Faust: Will-
o'-the-Wisp (A Deceitful Goal)*, 1985
(115) Top row: *Damnation of Faust: Charming Landscape*, 1987;
Fire! Hendrix, 1982
Middle row: *Damnation of Faust: Evocation*, 1983; *Kiss The Girls:
Make Them Cry*, 1979
Bottom row: *General Hospital/Olympic Women Speed Skating*, 1980

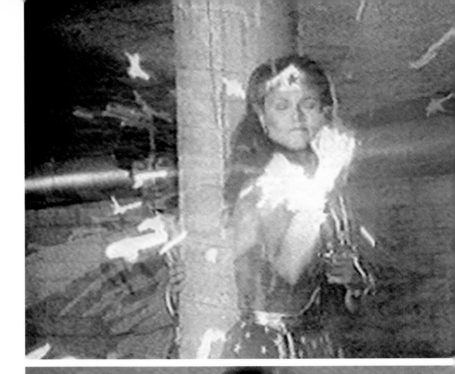

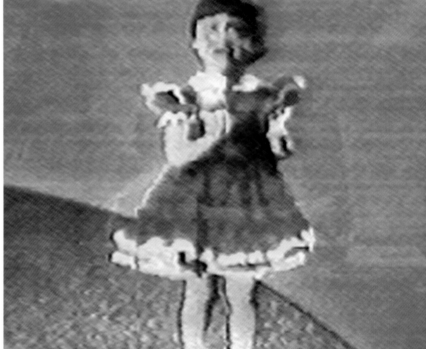

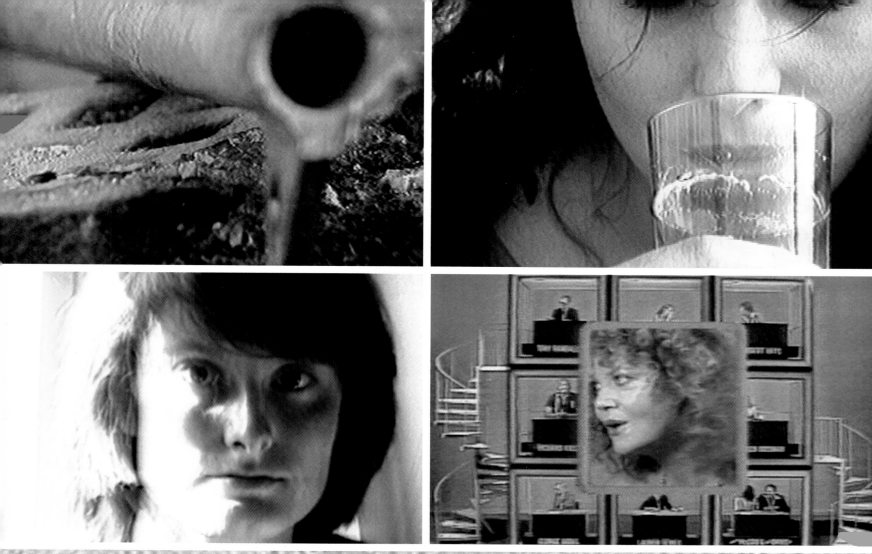

Peter Campus

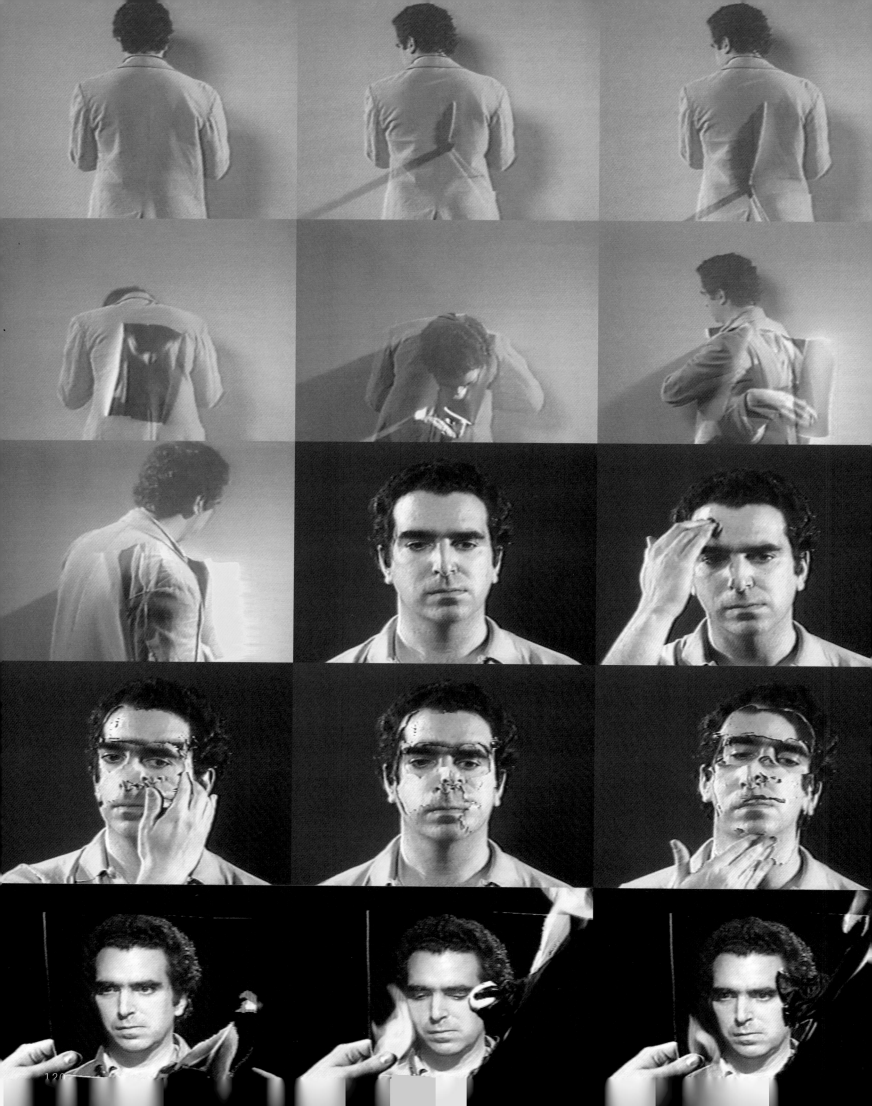

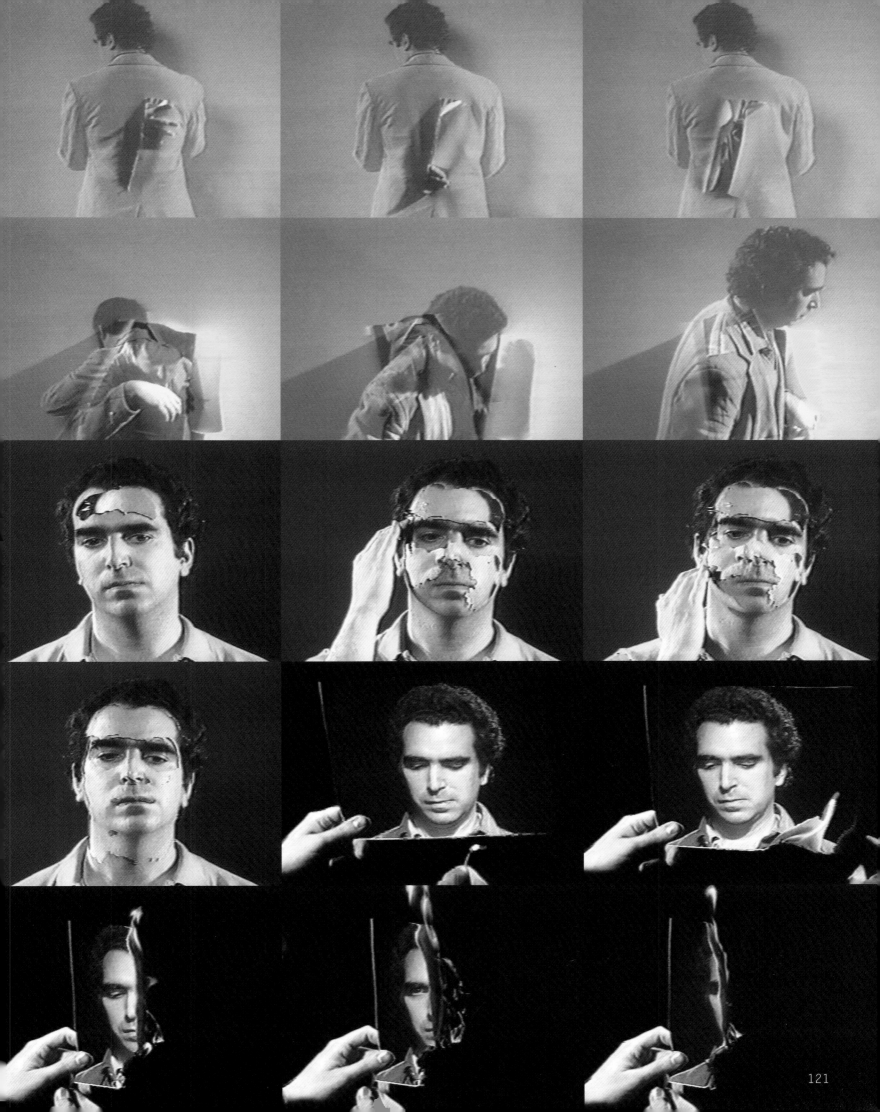

Peter Campus (b. 1937)
Selected Single Channel Video Works

Double Vision, 1971
Dynamic Field Series, 1971
Three Transitions, 1973
R-G-B, 1974
Set of Co-incidence, 1974
East Ended Tape, 1976
Four Sided Tape, 1976
Six Fragments, 1976
Third Tape, 1976
Winter Journal, 1997
Passing Storm, 1999
Breezes, 1999
Turning Toward, 1999
Heart Stream, 1999
Karneval und Jude, 1999
Death Threat, 2000 *(Receiving Radiation, 2000; Disappearance,*
2000; Death Threat, 2000)
The Material of Shadow, 2002

All images courtesy of Electronic Arts Intermix (EAI), New York,
except when noted.

(118) *Double Vision*, 1971, 14:45 min, b&w, silent
(119) *Dynamic Field Series*, 1971, 23:42 min, b&w, sound
(120-121) *Three Transitions*, 1973, 4:53 min, color, sound
(122) Top to bottom: *Three Transitions*, 1973; *R-G-B*, 1974; *Winter
Journal 1997*, 1997
(123) Top row: *Set of Co-incidence*, 1974; *Four Sided Tape*, 1976
Second row: *East Ended Tape*, 1976; *Dynamic Field Series*, 1971
Third row: *Double Vision*, 1971; *Six Fragments*, 1976
Bottom row: *Death Threat*, 2000; *Passing Storm*, 1999, Courtesy of
the artist and Leslie Tonkonow Gallery, New York

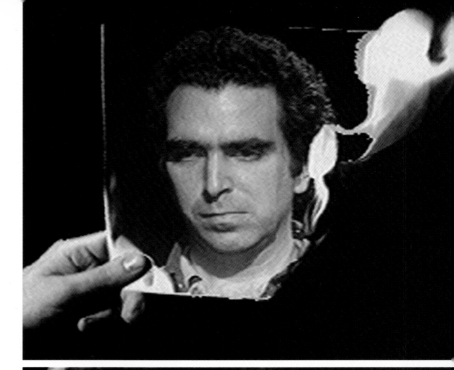

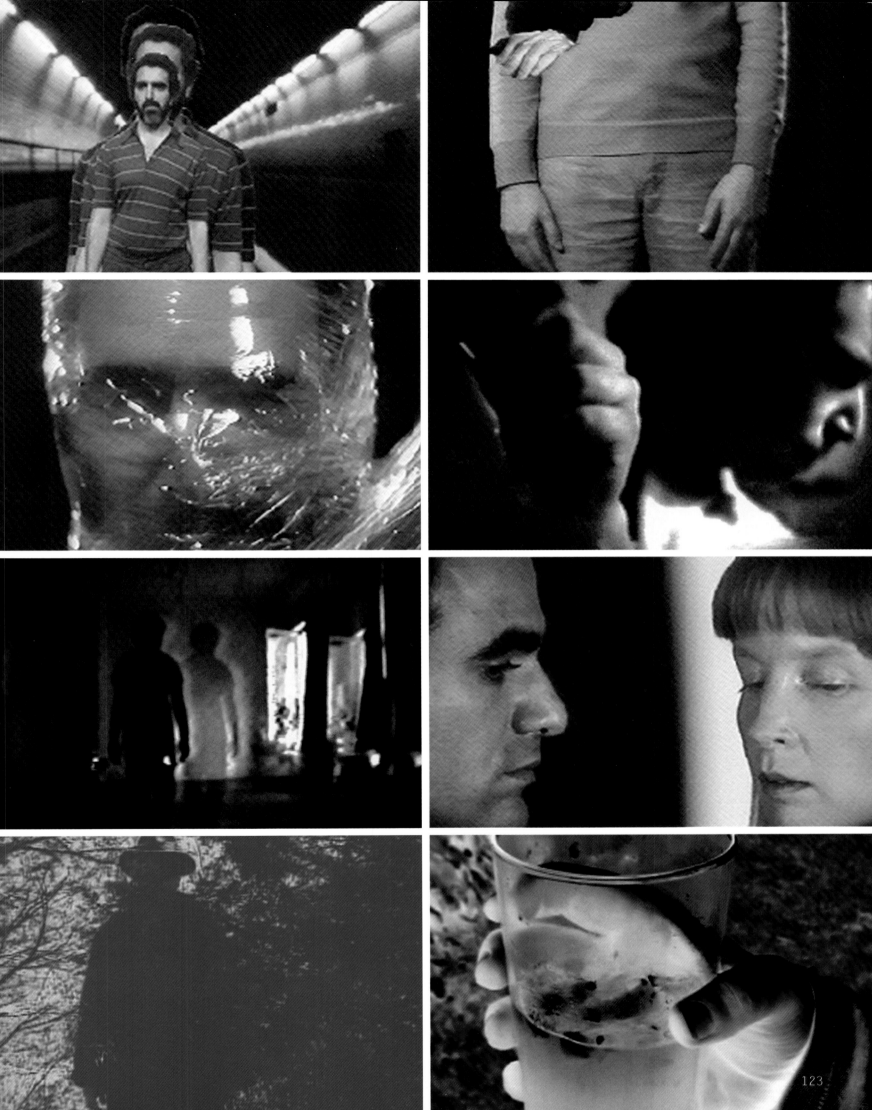

Valie Export

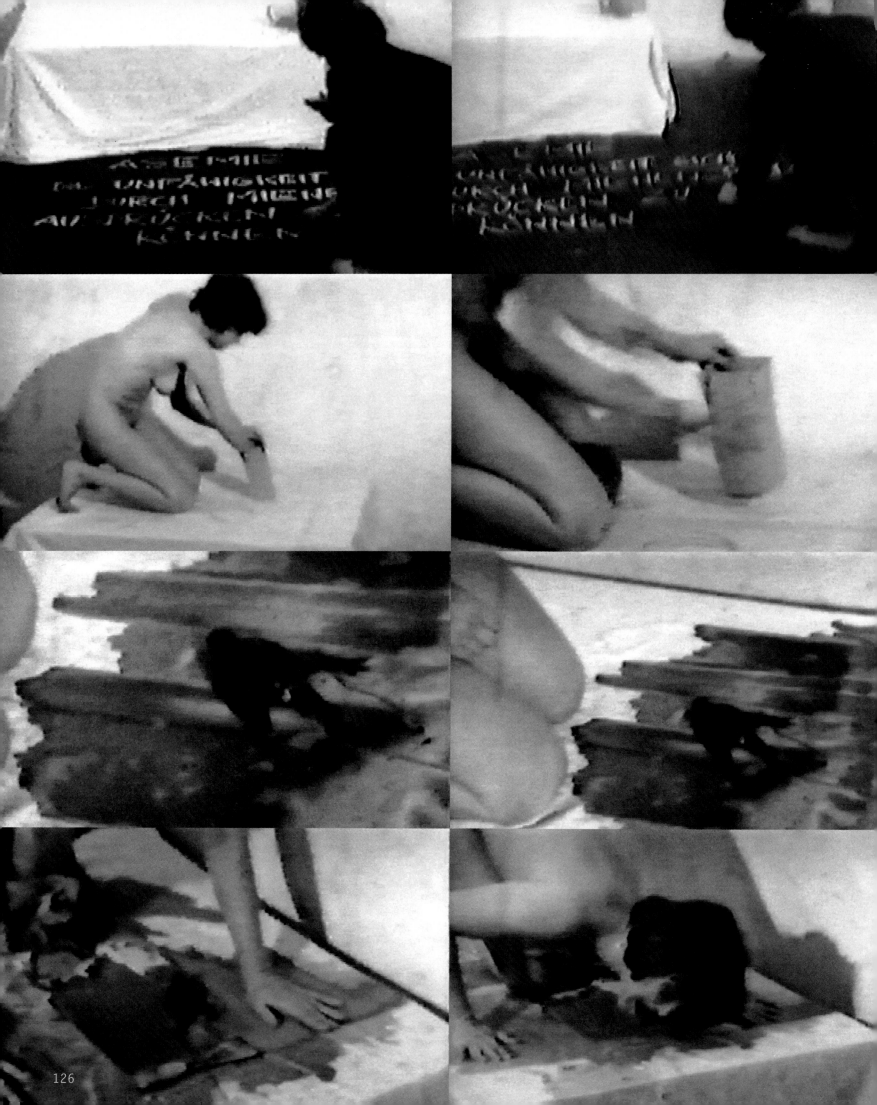

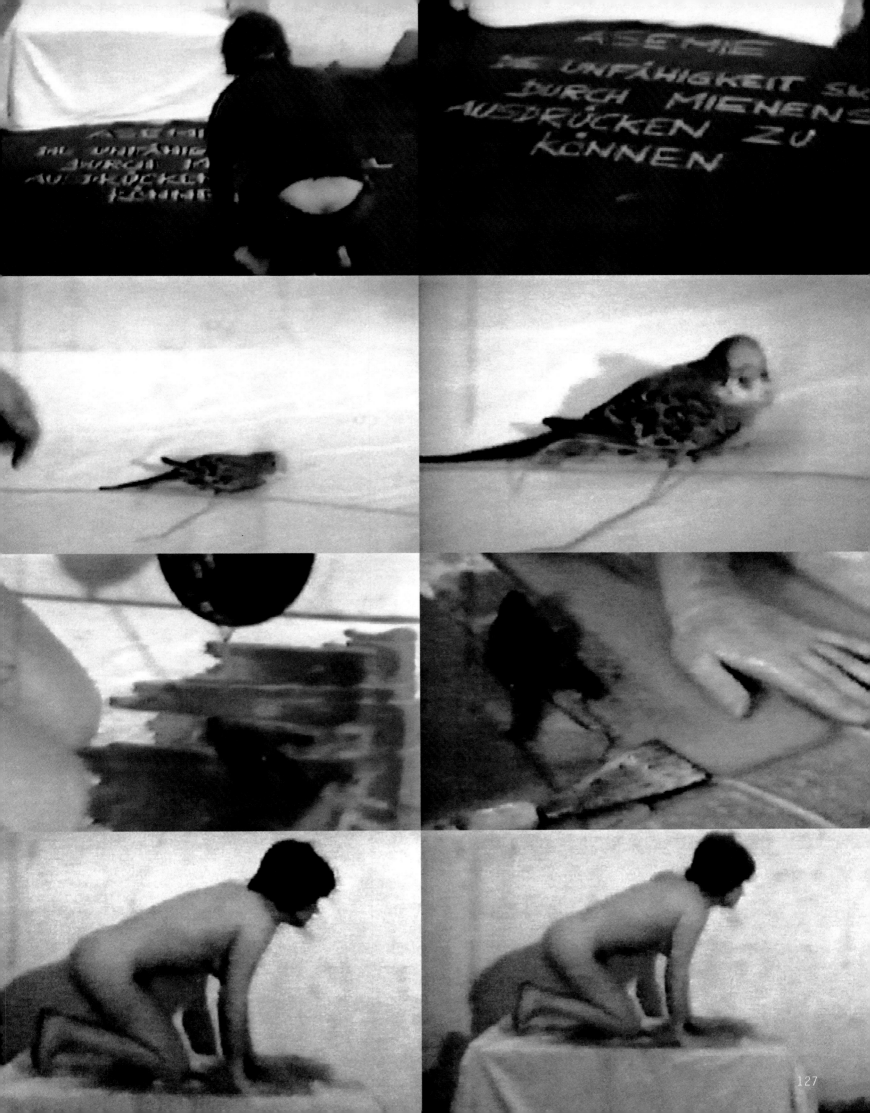

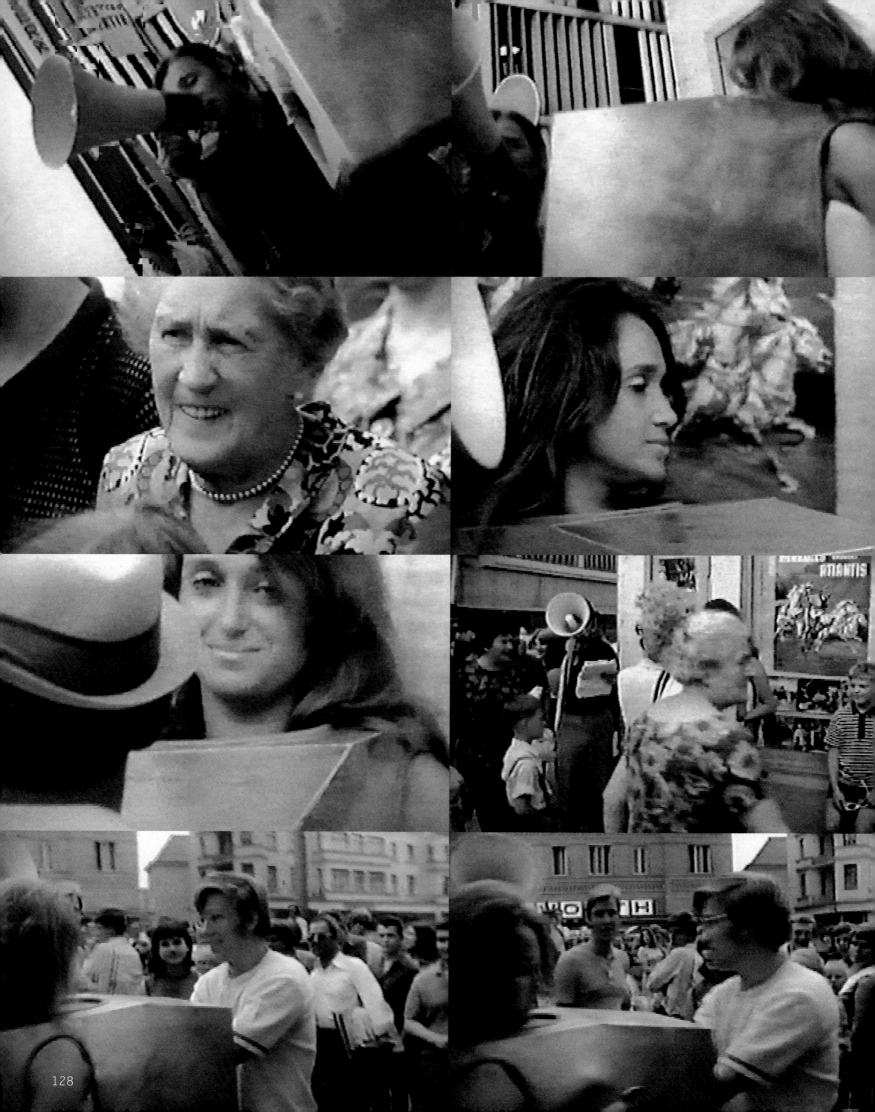

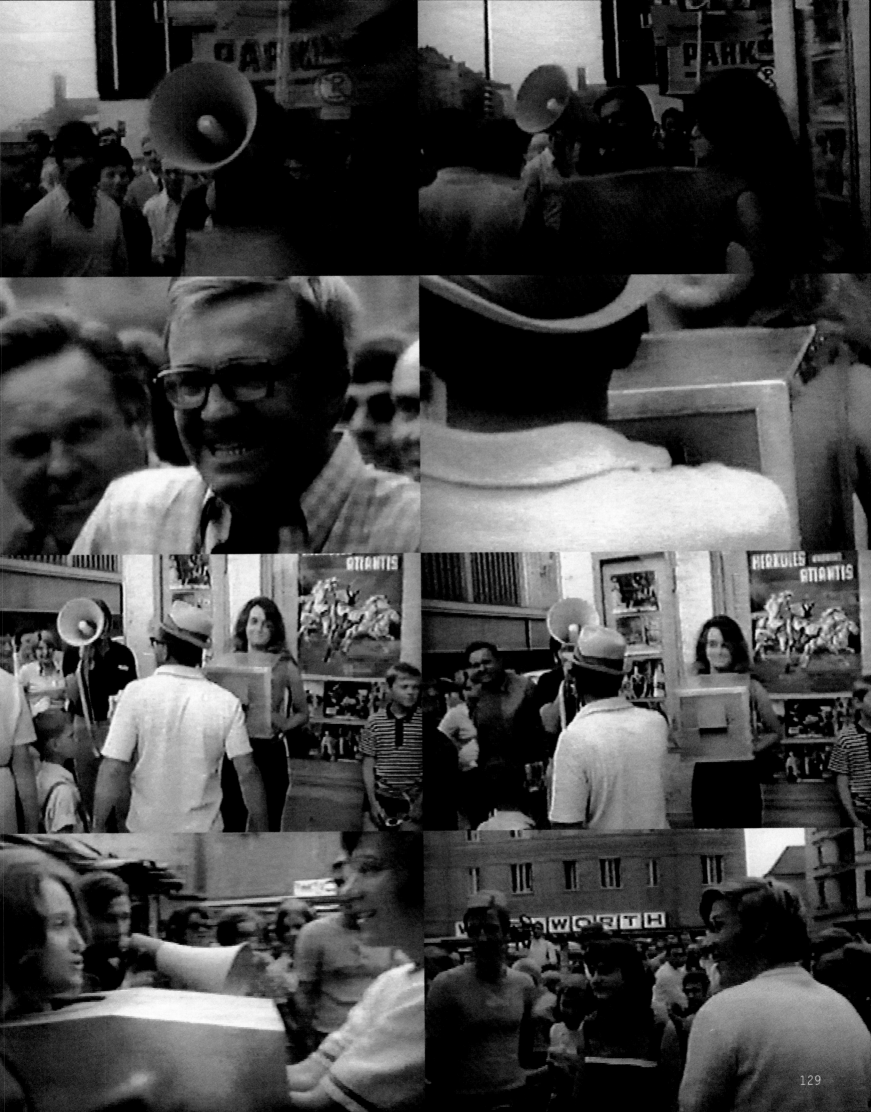

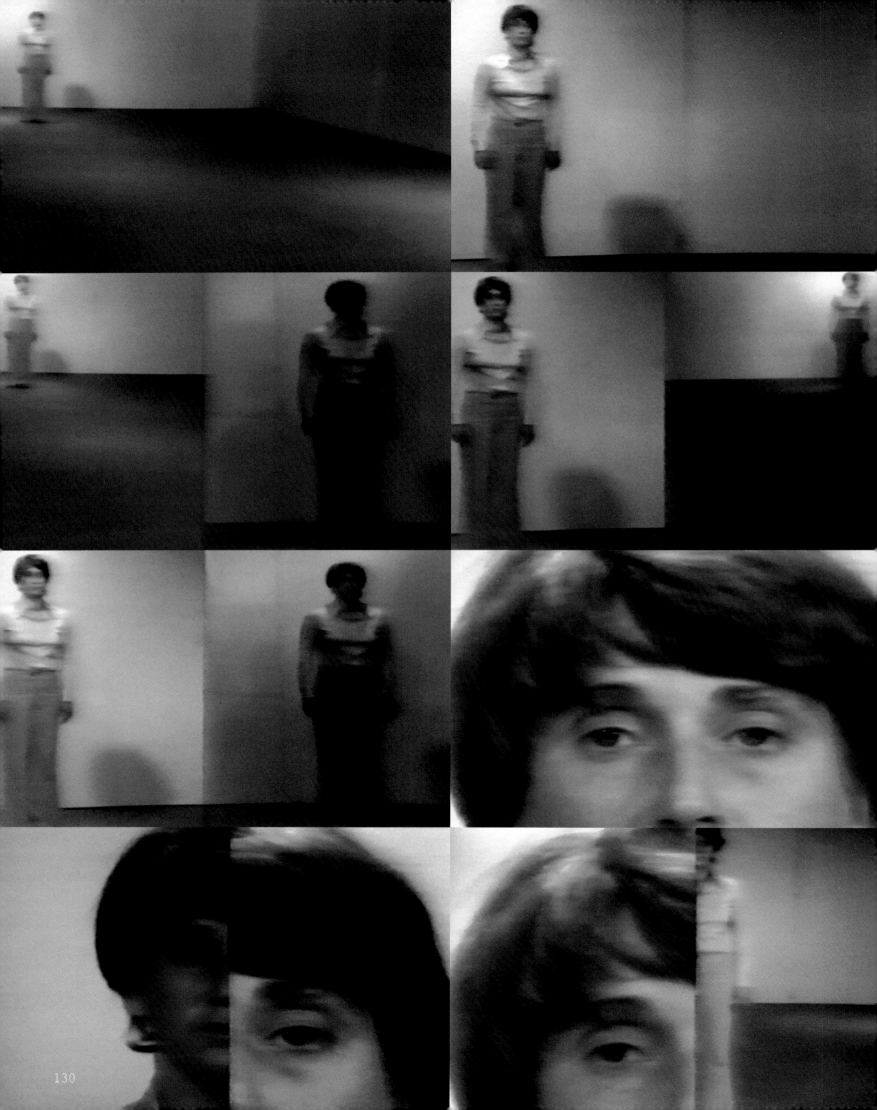

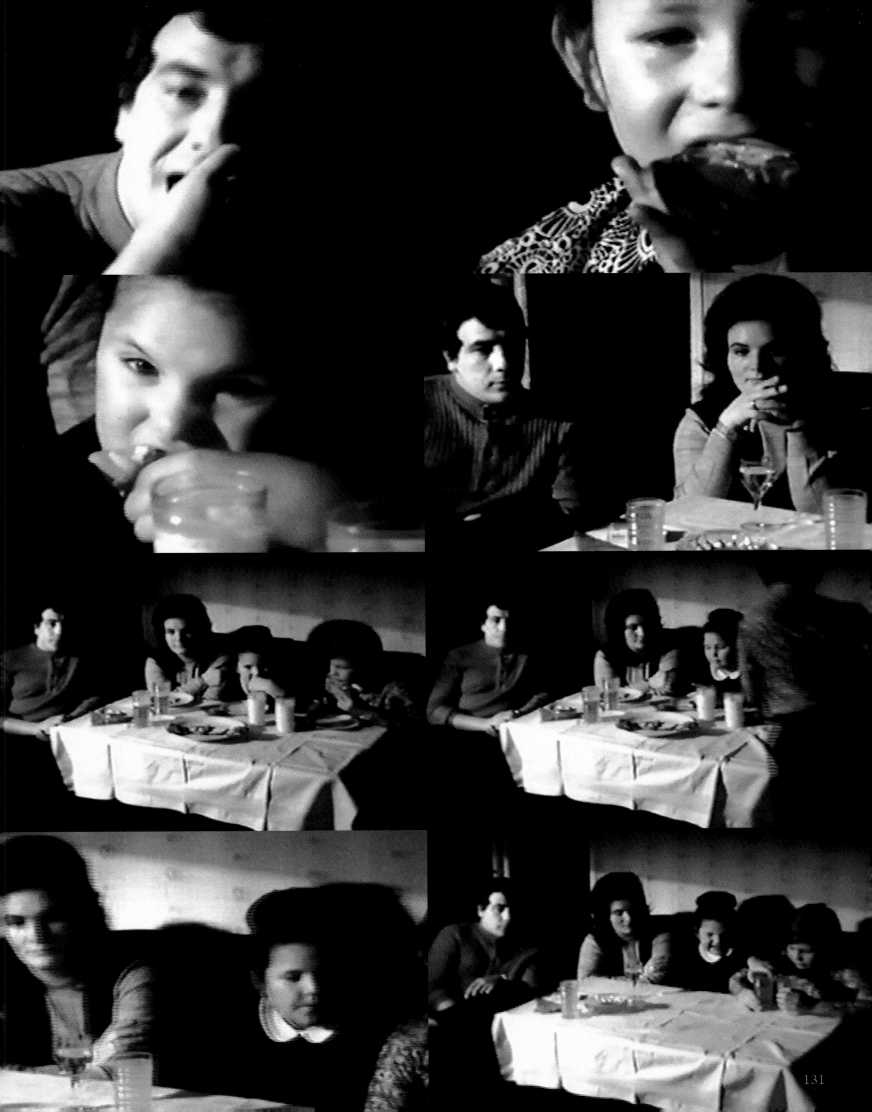

Valie Export (b. 1940)
Selected Single Channel Video Works

Cutting, 1967-68
Touch Cinema, 1968
Visual Text: Finger Poem, 1968-73
Body Tape, 1970
Breath Text: Love Poem, 1970-73
Facing a Family, 1971
Cuts: Elements of Observation, 1971-74
Asemie or the Inability of Expressing Oneself Through Facial Expressions, 1973
Hyperbulie, 1973
Space Seeing - Space Hearing, 1973-74
Adjunct Dislocations II, 1973-78
Delta. A Piece, 1976-77
The Duality of Nature, 1986

All images courtesy of Electronic Arts Intermix (EAI), New York

(126-127) *Asemie or the Inability of Expressing Oneself Through Facial Expressions*, 1973, 7:10 min, b&w, sound
(128-129) *Touch Cinema*, 1968, 1:08 min, b&w, sound
(130) *Space Seeing - Space Hearing*, 1973-1974, 6:19 min, b&w, sound
(131) *Facing a Family*, 1971, 4:44 min, b&w, sound
(132) Top to bottom: *Space Seeing - Space Hearing*, 1973-74; *Body Tape*, 1970; *Cutting*, 1967-68
(133) Top: *Adjunct Dislocations II*, 1973-78
Bottom: *Bilder der Berührungen*, 1998

Gilbert and George

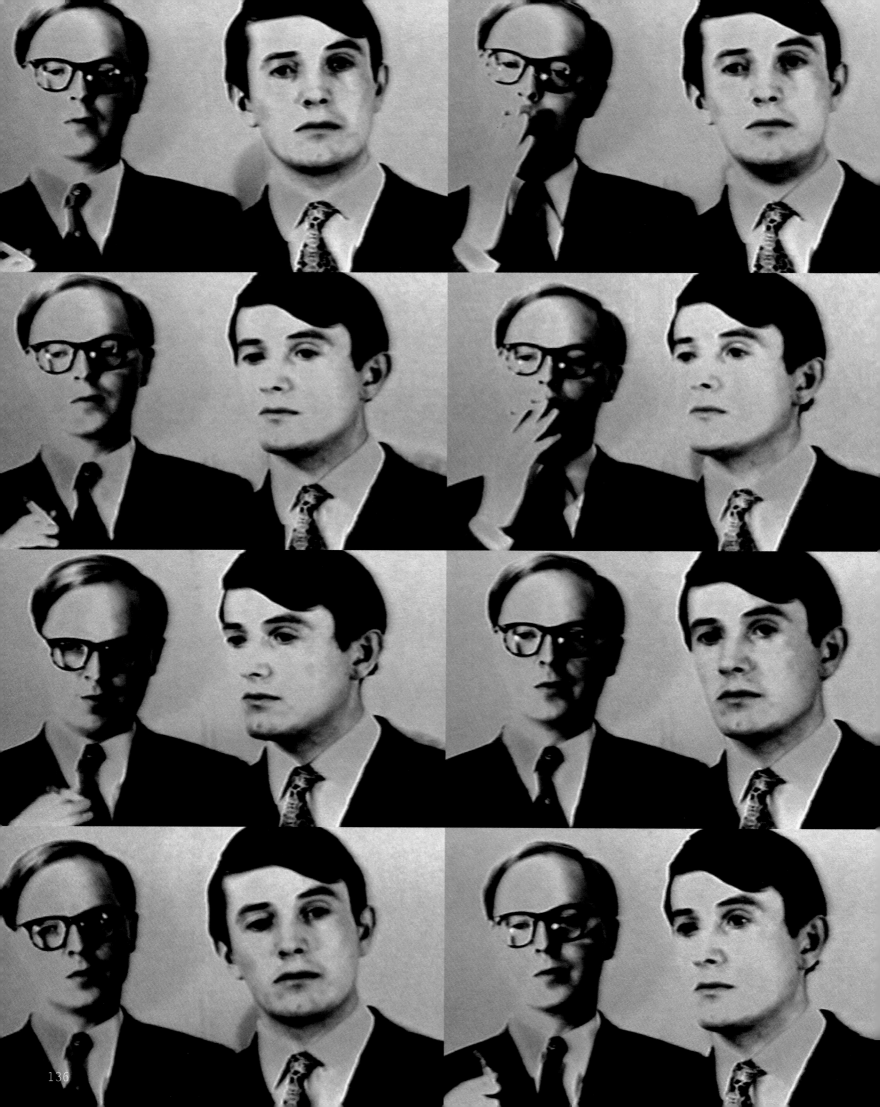

Gilbert (b. 1943) and George (b. 1942)
Selected Single Channel Film and Video Works

The Nature of Our Looking, 1970
Gordon's Makes Us Drunk, 1972
In the Bush, 1972
The Portrait of the Artists as Young Men, 1972
The World of Gilbert & George (dir. Philip Haas), 1981
Gilbert & George, 1984
Rencontre à Londres, 1986
The Singing Sculpture, 1992
Gilbert & George, 1998

All images courtesy of the Collection of Pamela and Richard
Kramlich

(136) *The Portrait of the Artists as Young Men*, 1972, 8 min, b&w,
sound
(137) *In the Bush*, 1972, 16 min, b&w, sound
(138-139) *Gordon's Makes Us Drunk*, 1972, 9 min, b&w, sound
(140) Top to bottom: *Gordon's Makes Us Drunk*, 1972
(141) Top: *In the Bush*, 1972
Bottom: *The Portrait of the Artists as Young Men*, 1972

Dan Graham

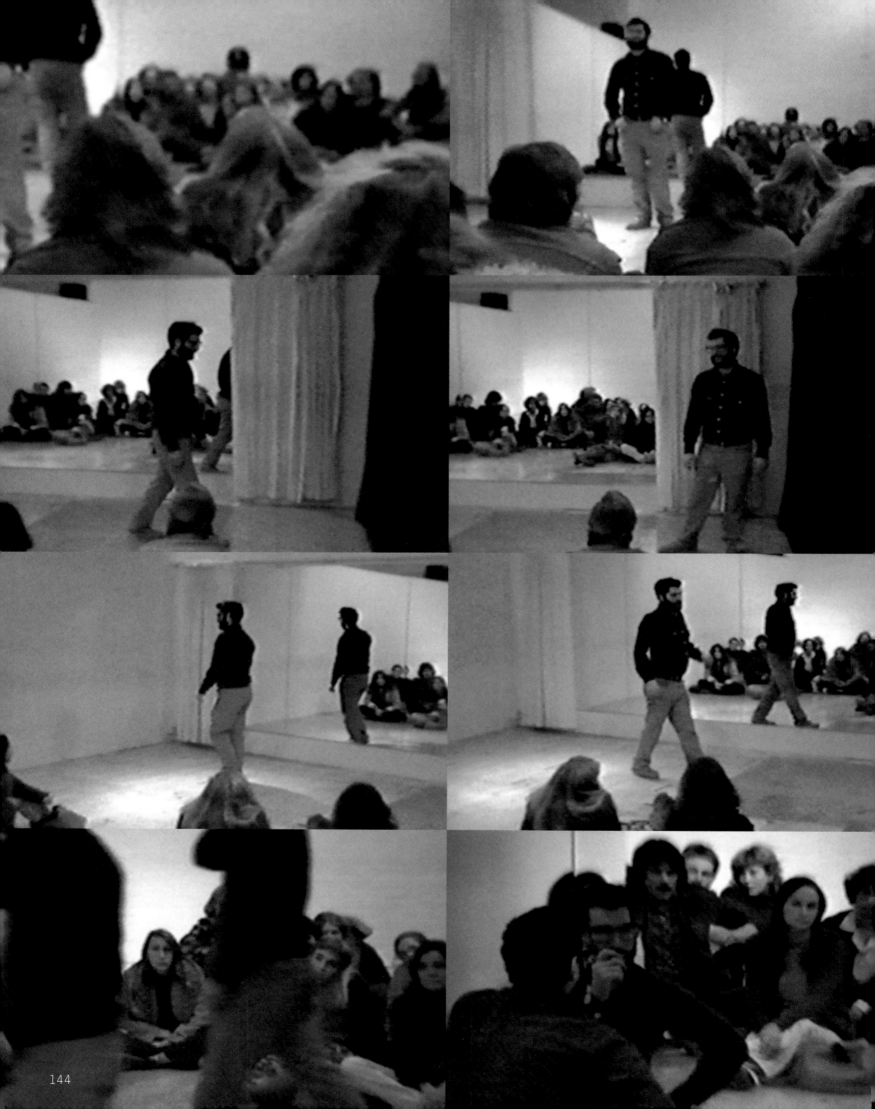

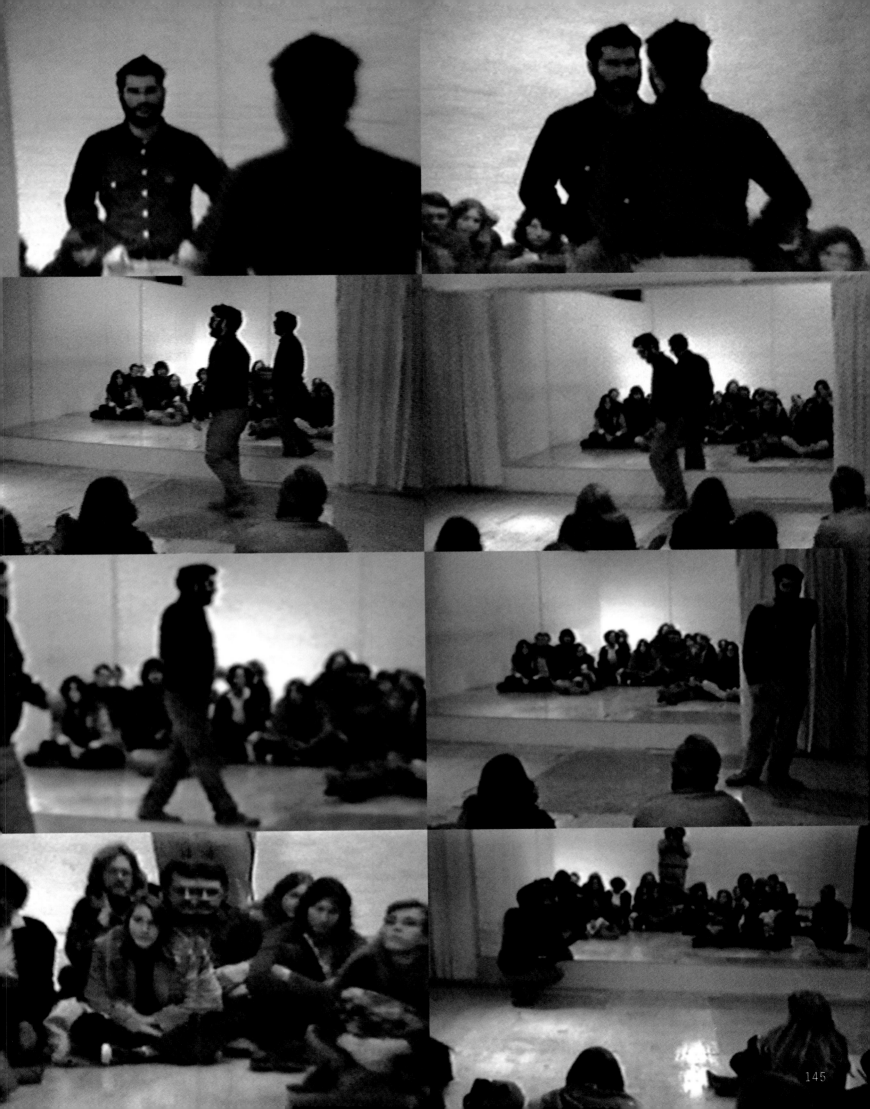

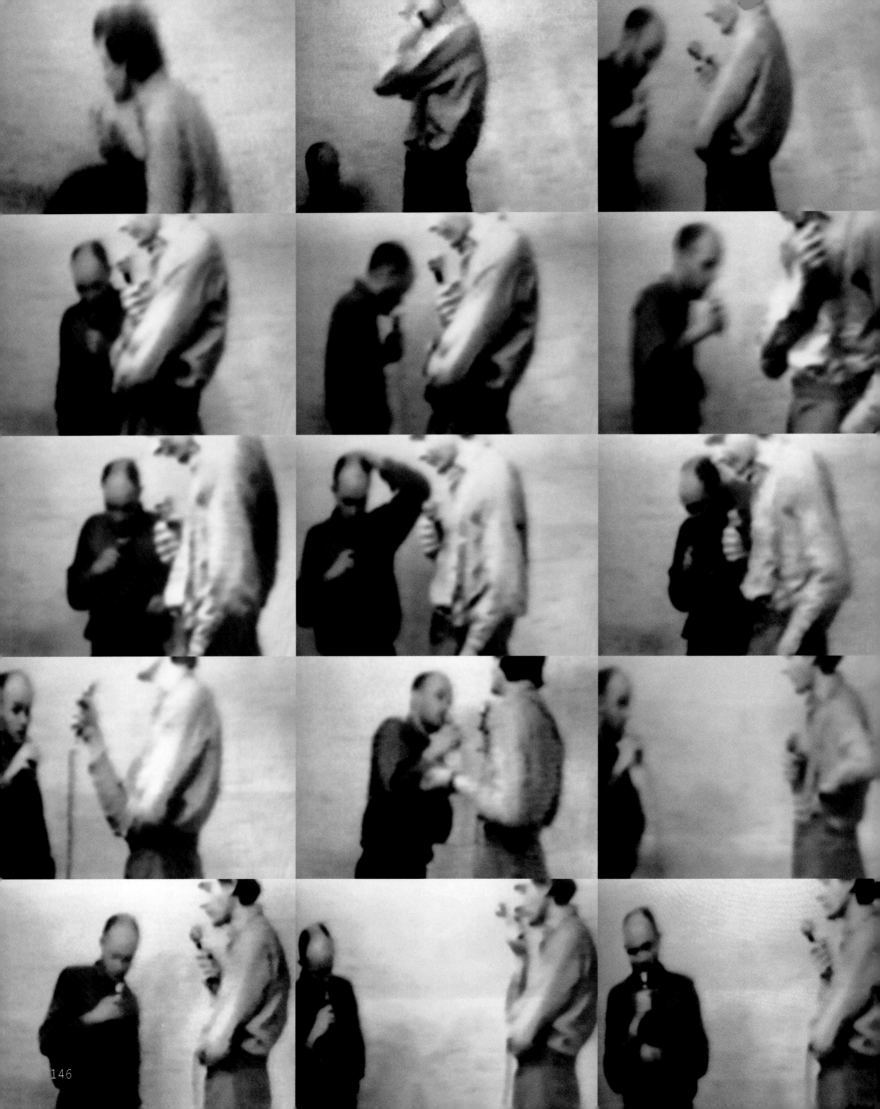

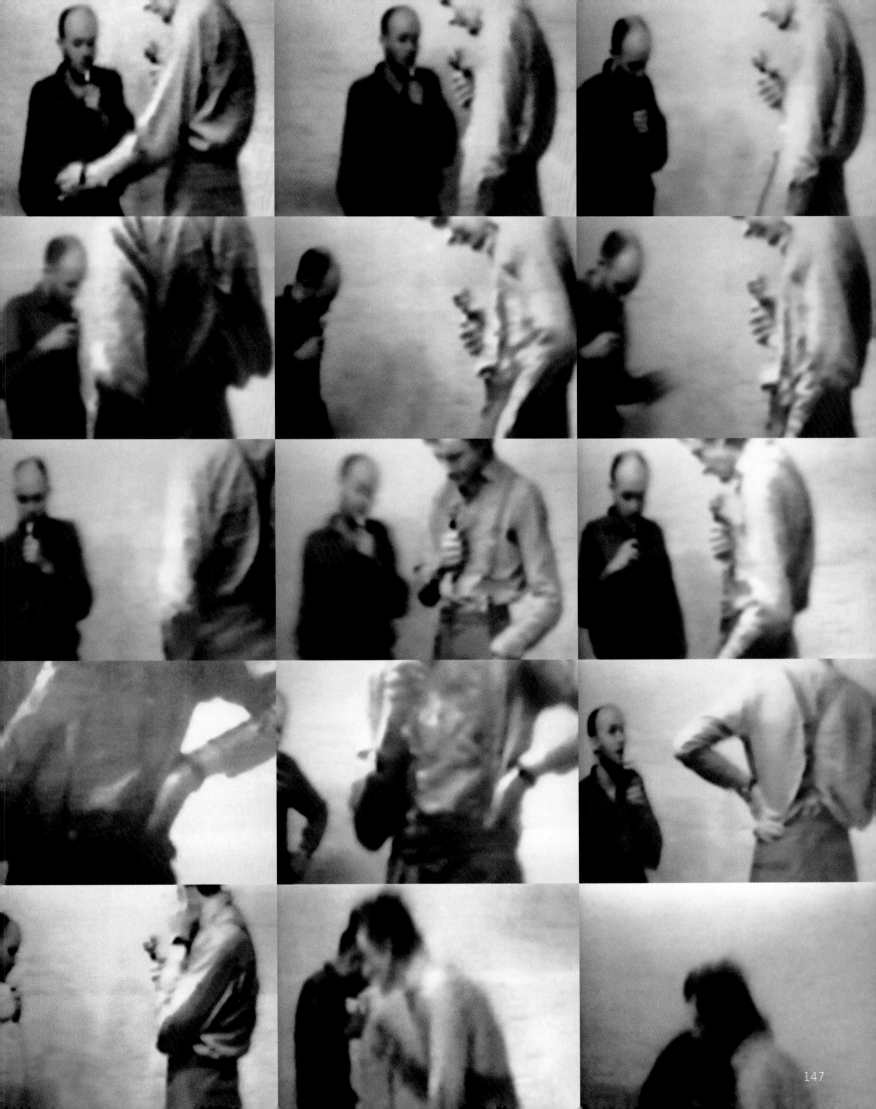

Dan Graham (b. 1942)
Selected Single Channel Film and Video Works

Sunset to Sunrise, 1969
Past Future Split Attention, 1972
Helix/ Spiral, 1973
Performer/Audience/Mirror, 1975
Westkunst (Modern Period): Dan Graham Segment, 1980
Local TV News Analysis For Cable Television (with Dara Birnbaum), 1980
Rock My Religion, 1982-84
Minor Threat, 1983
Performance and Stage-Set Utilizing Two-Way Mirror and Video Time Delay (with Glenn Branca), 1983
TWO-WAY MIRROR CYLINDER INSIDE CUBE and a video salon, 1992
Dan Graham: Video/Architecture/Performance, 1995
Pavilions, 1999

All images courtesy of Electronic Arts Intermix (EAI), New York

(144-145) *Performance/Audience/Mirror*, 1975, 22:52 min, b&w, sound
(146-147) *Past Future Split Attention*, 1972, 17:03 min, b&w, sound
(148) Top to bottom: *TWO-WAY MIRROR CYLINDER INSIDE CUBE and a video salon*, 1992; *Rock My Religion*, 1982-84; *Performer/Audience/Mirror*, 1975
(149) Top: *Video/Architecture/Performance (in collaboration with Michael Shamberg)*, 1995
Bottom: *Minor Threat*, 1983

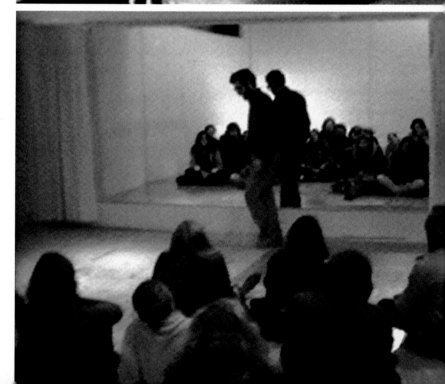

David Hammons

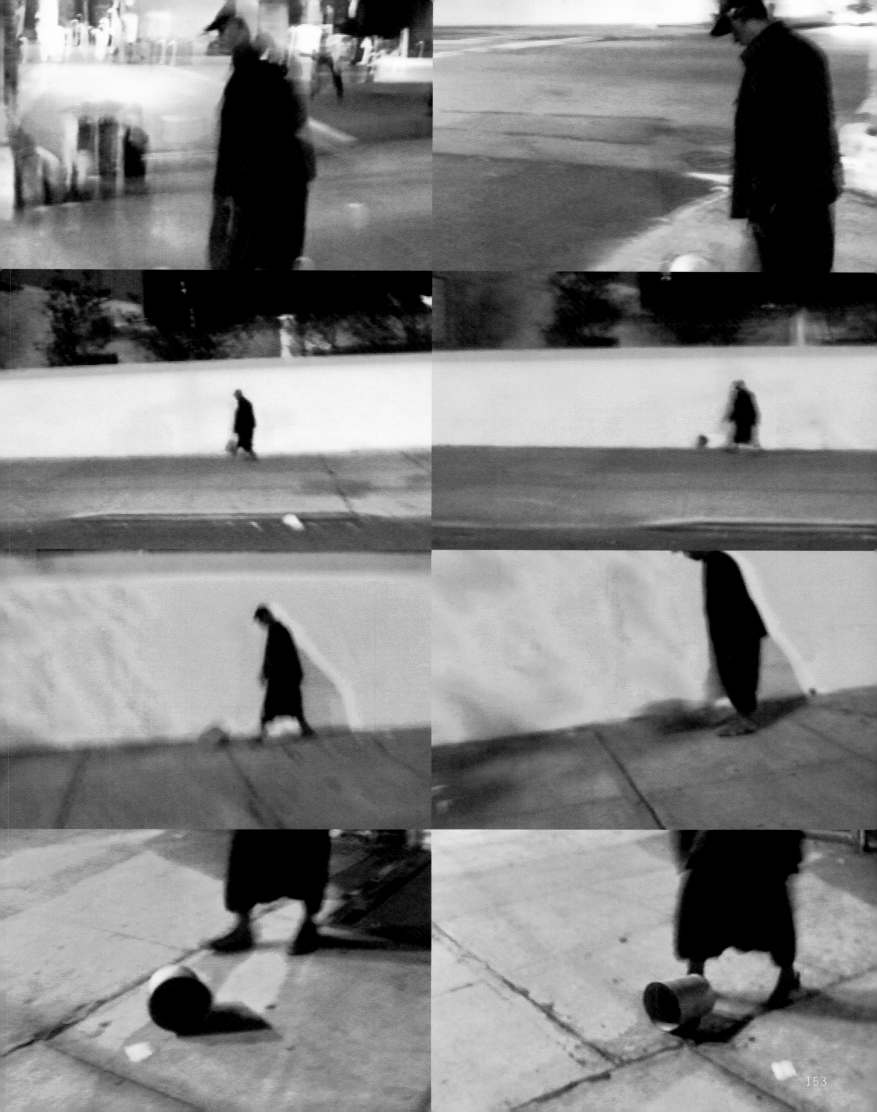

David Hammons (b. 1943)

(152-155) *Phat Free*, 1998, 5:04 min, color, sound
Courtesy of the Collection of Pamela and Richard Kramlich

Gary Hill

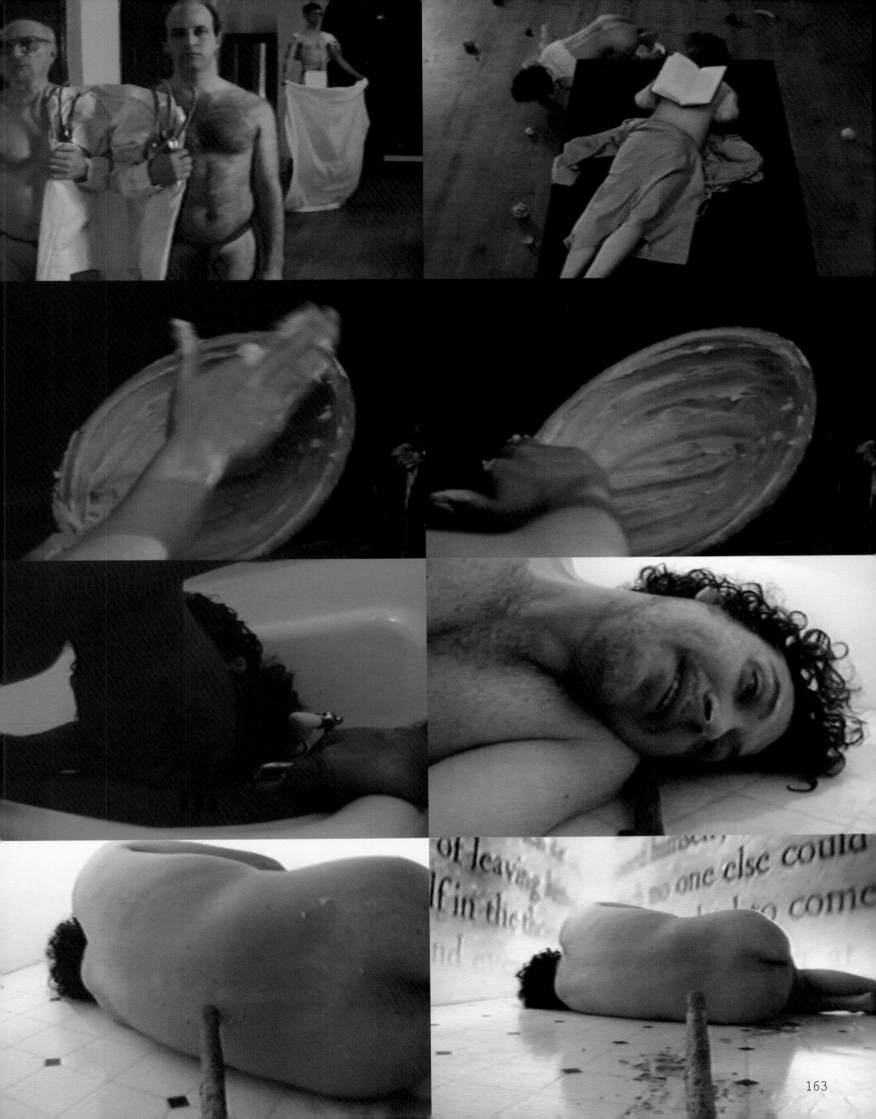

171

Gary Hill (b. 1951)
Selected Single Channel Video Works

The Fall, 1973
Air Raid, 1974
Rock City Road, 1974-75
Earth Pulse, 1975
Improvisations with Bluestone, 1976
Mirror Road, 1976
Bits, 1977
Bathing, 1977
Windows, 1978
Electronic Linguistics, 1978
Sums & Differences, 1978
Mouth Piece, 1978
Full Circle, 1978
Primary, 1978
Elements, 1978
Objects with Destinations, 1979
Equal Time, 1979
Picture Story, 1979
Soundings, 1979
Processual Video, 1980
Black/White/Text, 1980
Commentary, 1980
Around & About, 1980
Videograms, 1980-81
Primarily Speaking, 1981-83
Happenstance (part 1 of many parts), 1982-83
Why Do Things Get in a Muddle? (Come on Petunia), 1984
Tale Enclosure, 1985
URA ARU (the backside exists), 1985-86
Mediations (towards a remake of Soundings), 1979-86
Incidence of Catastrophe, 1987-88
Site/Recite (a prologue), 1989
Solstice d'Hiver, 1993

All images courtesy of Electronic Arts Intermix (EAI), New York

(158-163) *Incidence of Catastrophe*, 1987-88, 43:51 min, color, sound
(164-165) *Why Do Things Get In a Muddle? (Come on Petunia)*, 1984, 33:09 min, color, sound
(166-167) *Soundings*, 1979, 18:03 min, color, sound
(168) *Site/Recite (a prologue)*, 1989, 4:05 min, color, sound
(169) *Processual Video*, 1980, 11:13 min, b&w, sound
(170) *Mediations (towards a remake of Soundings)*, 1979-86, 4:17 min, color, sound
(171) *Tale Enclosure*, 1985, 5:30 min, color, sound
(172) Top to bottom: *Primarily Speaking*, 1981-83; *URA ARU (the backside exists)*, 1985-86; *Mediations (towards a remake of Soundings)*, 1979-86; *Sites Recited*, 1994 (by Carol Ann Klonarides with Joe Leonardi. In collaboration with Gary Hill)
(173) Top row: *Mediations (towards a remake of Soundings)*, 1979-86; *Black/White/Text*, 1980; *Mouthpiece*, 1978
Second row: *Happenstance (part one of many parts)*, 1982-83; *Commentary*, 1980; *Why Do Things Get In a Muddle? (Come on Petunia)*, 1984
Third row: *Incidence of Catastrophe*, 1987-88; *Processual Video*, 1980; *Videograms*, 1980-81
Fourth row: *Windows*, 1978
Bottom row: *Solstice d'Hiver*, 1993; *Soundings*, 1979

ONE
MANS MIND
CLAPPING IN
THE SOUND OF
A CLOSED HAND

Joan Jonas

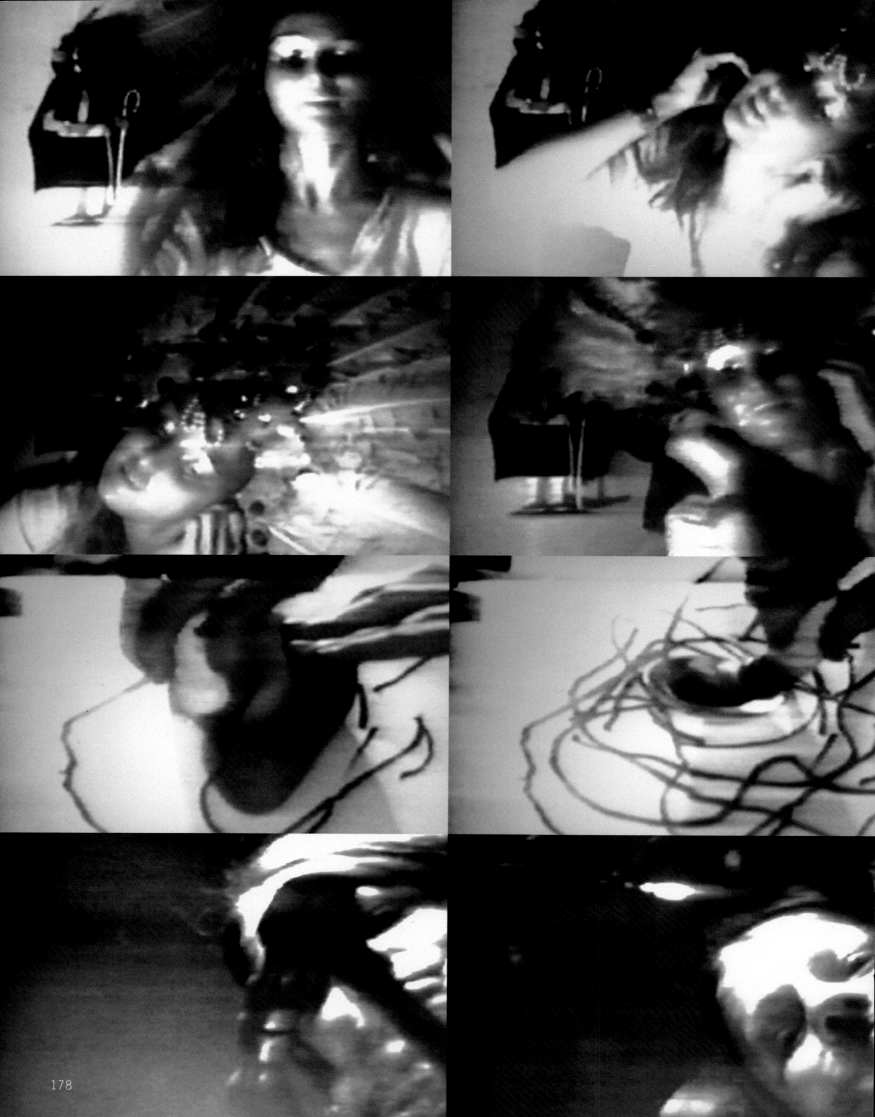

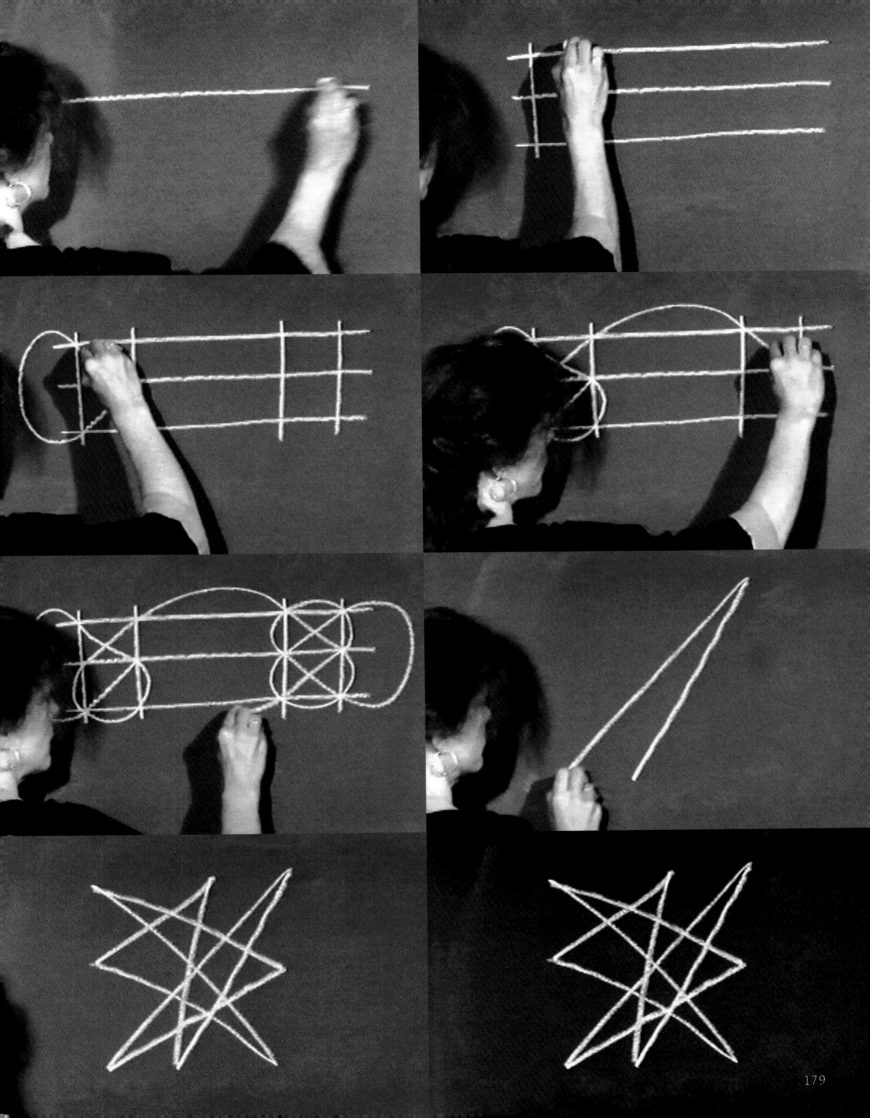

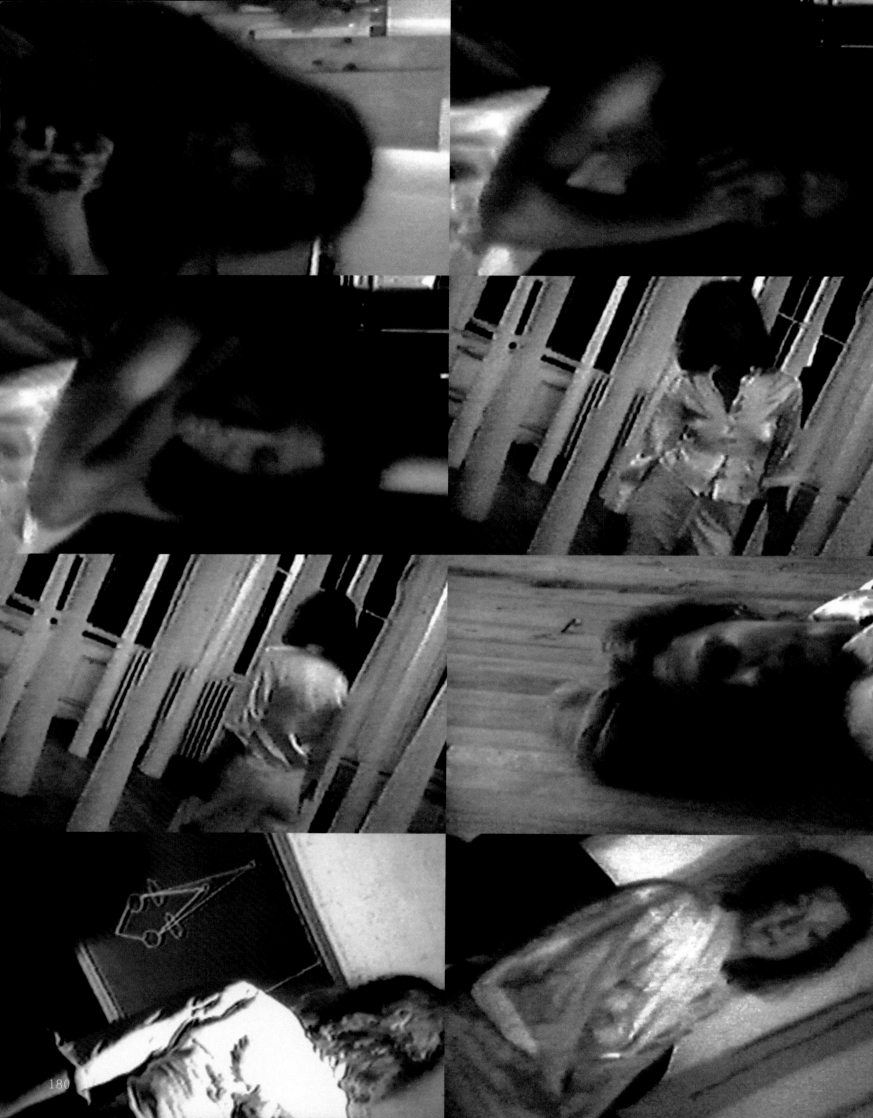

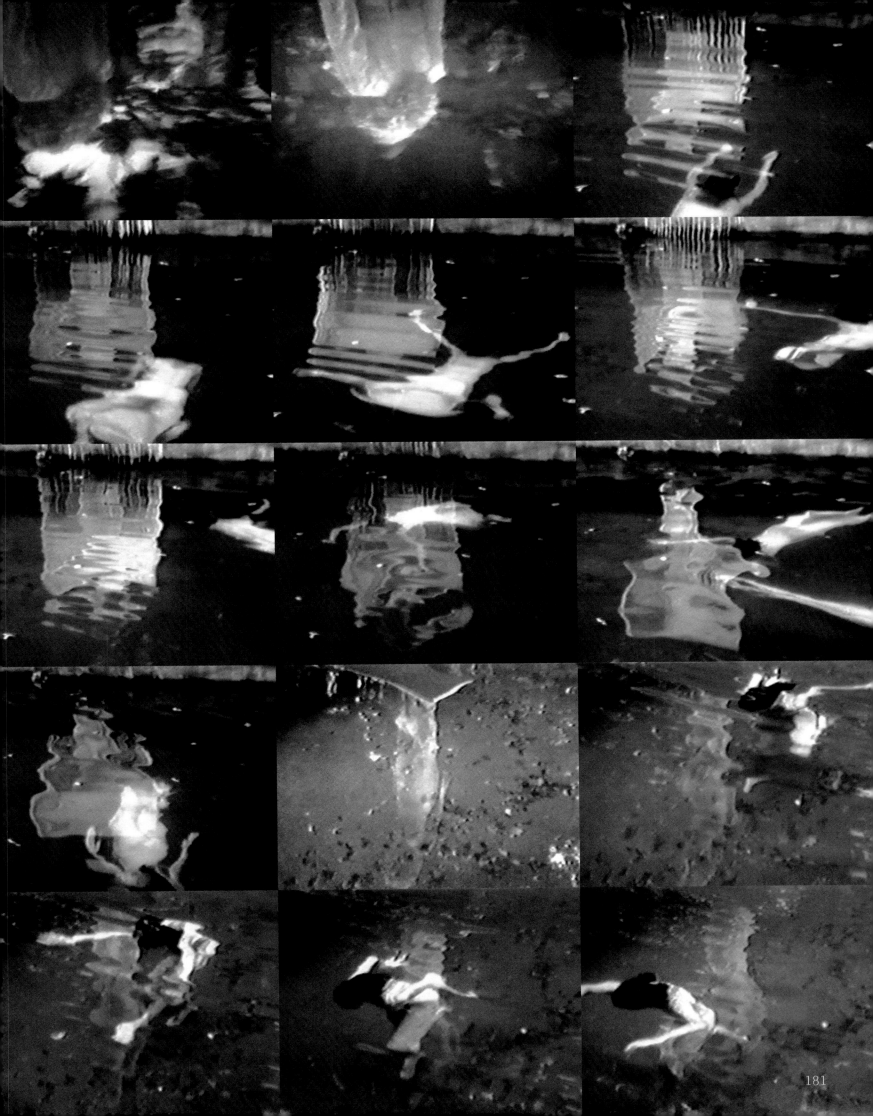

Joan Jonas (b. 1936)
Selected Single Channel Film and Video Works

Wind, 1968
Duet, 1972
Left Side Right Side, 1972
Organic Honey's Visual Telepathy, 1972
Vertical Roll, 1972
Glass Puzzle, 1973
Songdelay, 1973
Three Returns: Barking, 1973 / *Three Returns*, 1973 / *Barking*, 1973
Organic Honey's Vertical Roll, 1973-99
Disturbances, 1974
Good Night Good Morning, 1976
Mirage, 1976
I Want to Live in the Country (And Other Romances), 1979
Upsidedown and Backwards, 1980
He Saw Her Burning, 1983
Big Market, 1984
Double Lunar Dogs, 1984
Brooklyn Bridge, 1988
Volcano Saga, 1989
Mirage 2, 1976/2000

All images courtesy of Electronic Arts Intermix (EAI), New York

(176-177) *Vertical Roll*, 1972, 19:38 min, b&w, sound
(178) *Organic Honey's Visual Telepathy*, 1972, 17:24 min, b&w, sound
(179) *Mirage*, 1976, 31:00 min, b&w, silent, video from 16 mm film
(180) *Good Night Good Morning*, 1976, 11:38 min, b&w, sound
(181) *Disturbances*, 1974, 11:00 min, b&w, sound
(182) *Songdelay*, 1973, 18:35 min, b&w, sound, 16 mm film
(183) *Wind*, 1968, 5:37 min, b&w, silent, 16 mm film
(184-185) *Glass Puzzle*, 1973, 17:27 min, b&w, sound
(186) Top to bottom: *Duet*, 1972; *Upsidedown and Backwards*, 1980; *Songdelay*, 1973; *Organic Honey's Vertical Roll*, 1973-99
(187) Top row: *Barking*, 1973; *Double Lunar Dogs*, 1984
Second row: *Wind*, 1968; *Left Side Right Side*, 1972
Third row: *Glass Puzzle*, 1973; *Volcano Saga*, 1989
Bottom row: *Mirage*, 1976; *Vertical Roll*, 1972

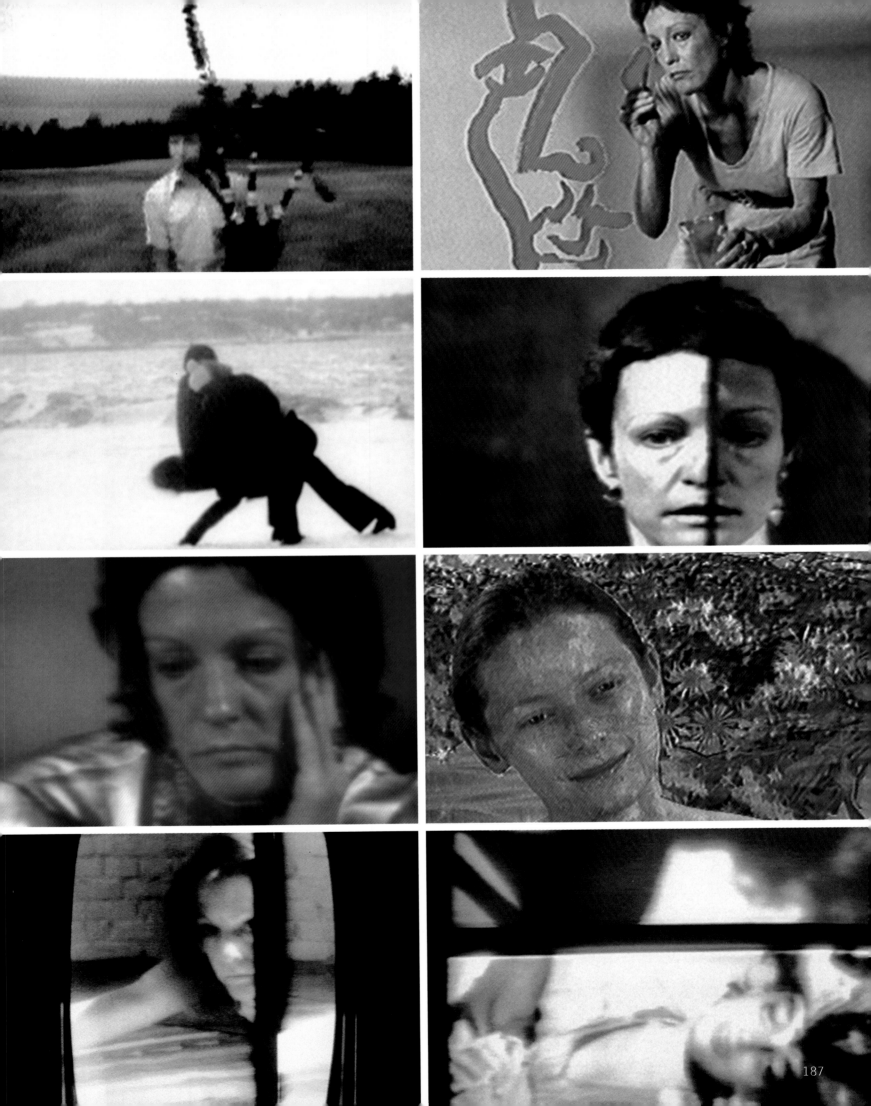

Mike Kelley / Jim Shaw
Mike Kelley / Paul McCarthy

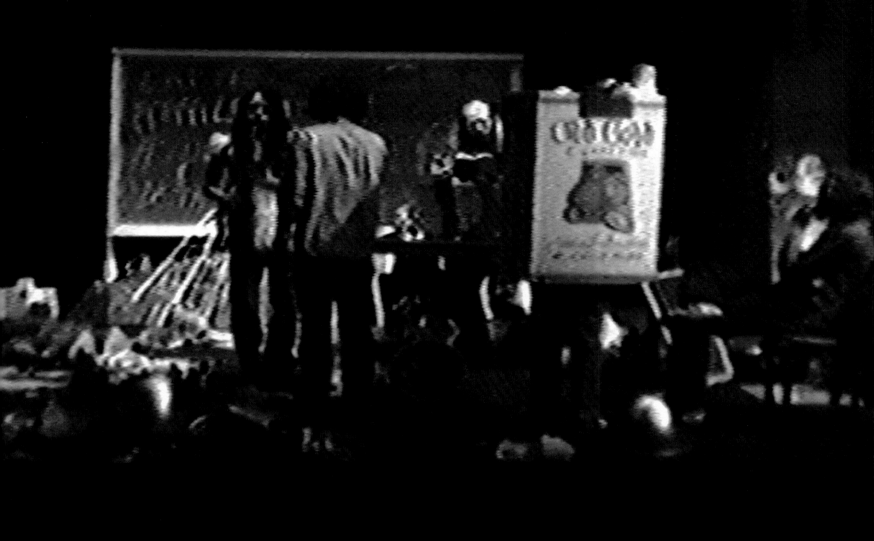

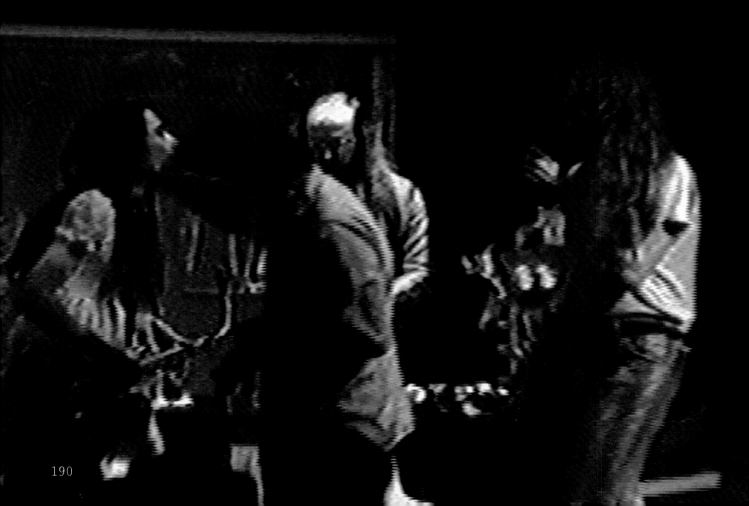

194

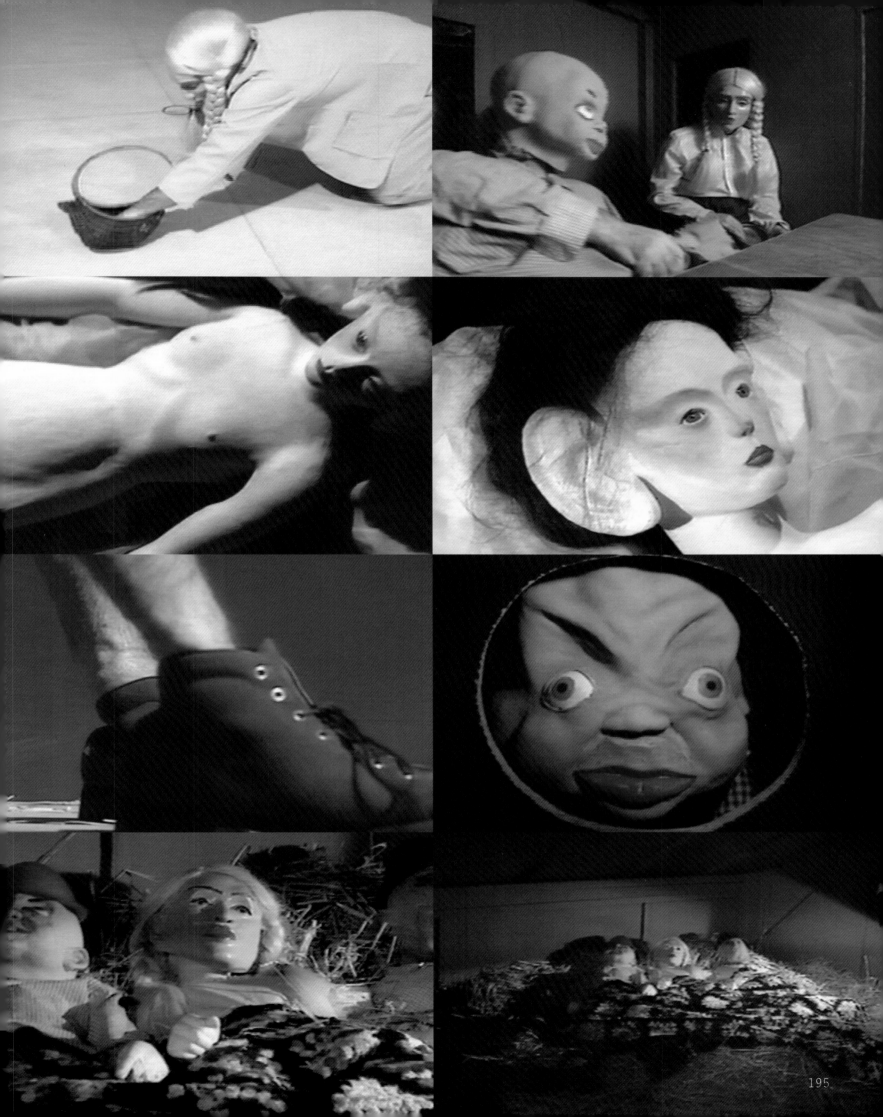

Mike Kelley (b. 1954)
Selected Single Channel Video Works

The Futurist Ballet (with Jim Shaw and others), 1973
Beholden to Victory, 1980-83
The Banana Man, 1983
Kappa (with Bruce and Norman Yonemoto), 1986
Family Tyranny/Cultural Soup (with Paul McCarthy), 1987
Blind Country (with Ericka Beckman), 1989
Sir Drone, 1989
100 Reasons (with Bob Flanagan and Sheree Rose), 1991
Heidi (with Paul McCarthy), 1992
Fresh Acconci (with Paul McCarthy), 1995
Sad and Sadie Sack (with Paul McCarthy), 1996
Pole Dance (with Tony Oursler and Anita Pace), 1997
Out O' Actions (with Paul McCarthy), 1998
Sod and Sodie Sock Comp O.S.O. (with Paul McCarthy), 1998
Superman Recites Selections from 'The Bell Jar' and Other Works by Sylvia Plath, 1999
Test Room Containing Multiple Stimuli Known to Elicit Curiosity and Manipulatory Responses, 1999
A Dance Incorporating Movements Derived from Experiments by Harry F. Harlow and Choreographed in the Manner of Martha Graham, 1999
Extracurricular Activity Projective Reconstruction #1 (A Domestic Scene), 2000
Runway for Interactive DJ Event, 2000
Heidi's Four Basket Dances, 1992/2001

All images courtesy Electronic Arts Intermix (EAI), New York, except when noted.

(190-191) *Futurist Ballet (collaboration with Jim Shaw)*, 1973, 26:45 min, b&w, sound. Courtesy of the New Art Trust (NAT)
(192-195) *Heidi (in collaboration with Paul McCarthy)*, 1992, 62:40 min, color, sound
(196) Top to bottom: *Heidi (in collaboration with Paul McCarthy)*, 1992
(197) *Futurist Ballet (collaboration with Jim Shaw)*, 1973

Paul McCarthy

Paul McCarthy (b. 1945)
Selected Single Channel Film and Video Works

Girls, 1967
Boys, 1967
Spinning, 1970
Black and White Tapes, 1970-75
Fellowship Parkway, House, 1970-71
Outdoor Circle Run, 1971
Indoor Circle Run, 1971
Ma Bell, 1971
Broadway Building, 1971
Red Poster Video Tapes, 1972
Basement, 1973-1975
Stomach of the Squirrel, 1973
Dress, 1973
Couch, 1973
Gray Shirt, 1973
Penis Brush Painting, 1974
Heinz Ketchup Sauce, 1974
Hot Dog, 1974
Meat Cake, #1, #2, #3, 1974
Tubbing, 1975
Sailor's Meat, 1975
Experimental Dancer-Rumpus Room, 1975
Rocky, 1976
Class Fool, 1976
Grand Pop, #1 and #2, 1977
Contemporary Cure All, 1978
Deadening, 1979
Pig Man, 1980
Death Ship, 1981
King for a Day, 1983
Family Tyranny/Cultural Soup (with Mike Kelley), 1987
Fun with Money - In Mine, 1989
Jungle Doctor, 1991
A Hoot, 1991
Bossy Burger, 1991
Heidi, Midlife Crisis, Trauma Center and Negative Media-Engram Release Zone (with Mike Kelley), 1992
Pinocchio Pipenose Householddilemma, 1994
Fresh Acconci (with Mike Kelley), 1995
Painter, 1995
Saloon, 1996
Tokyo Santa, 1996
Sad and Sadie Sack (with Mike Kelley), 1996
Santa Chocolate Shop, 1997
Sod and Sodie Sock Comp O.S.O (with Mike Kelley), 1998
Out O' Actions (with Mike Kelley), 1998

All images courtesy Luhring Augustine Gallery, New York, except when noted.

(200-201) *Bossy Burger*, 1991, 59:00 min, color, sound. Courtesy of the New Art Trust (NAT)
(202-203) *Black & White Tapes*, 1970-1975, 32:50 min, b&w, sound. Courtesy of the New Art Trust (NAT)
(204) Top to bottom: *Black & White Tapes*, 1970-1975; *Family Tyranny/Cultural Soup (in collaboration with Mike Kelley)*, 1987. Courtesy of Electronic Arts Intermix (EAI), New York; *Heidi*, 1992
(205) Top row: *Face Painting*, 1972; *Painter*, 1995
Middle row: *Death Ship*, 1981; *Face Painting*, 1972
Bottom row: *Fresh Acconci (in collaboration with Mike Kelley)*, 1995; *Grandpop*, 1977

Steve McQueen

Steve McQueen (b. 1969)
Selected Single Channel Film and Video Works

Exodus, 1992/97
Bear, 1993
Five Easy Pieces, 1995
Just Above My Head, 1996
Something old, Something new, Something borrowed, Something blue,
1996/1998
Catch, 1997
Deadpan, 1997
Prey, 1999
Cold Breath, 2000
Western Deep, 2002
Carib's Leap, 2002

All images courtesy of Marian Goodman Gallery, except when noted.

(208-209) *Just Above My Head*, 1996, .9:35 min, b&w, silent, 16 mm
film. Collection of Pamela and Richard Kramlich
(210-211) *Bear*, 1993

Bruce Nauman

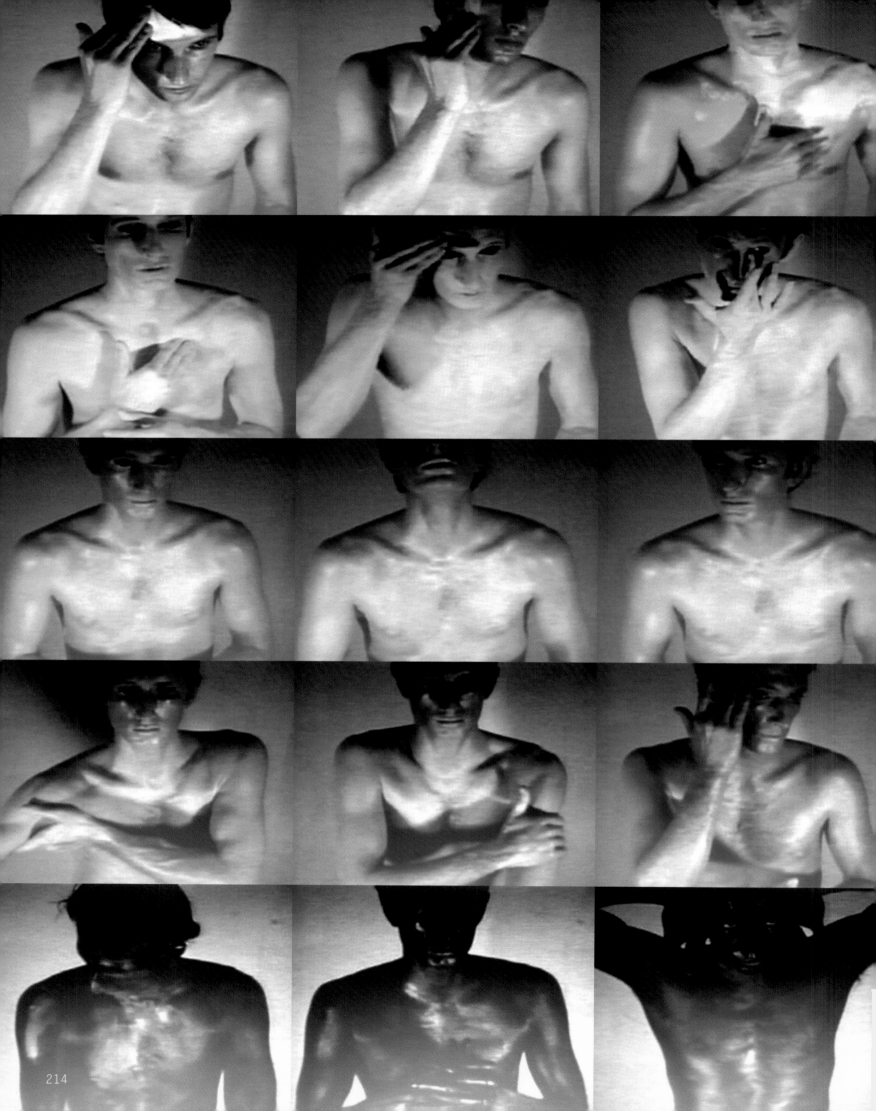

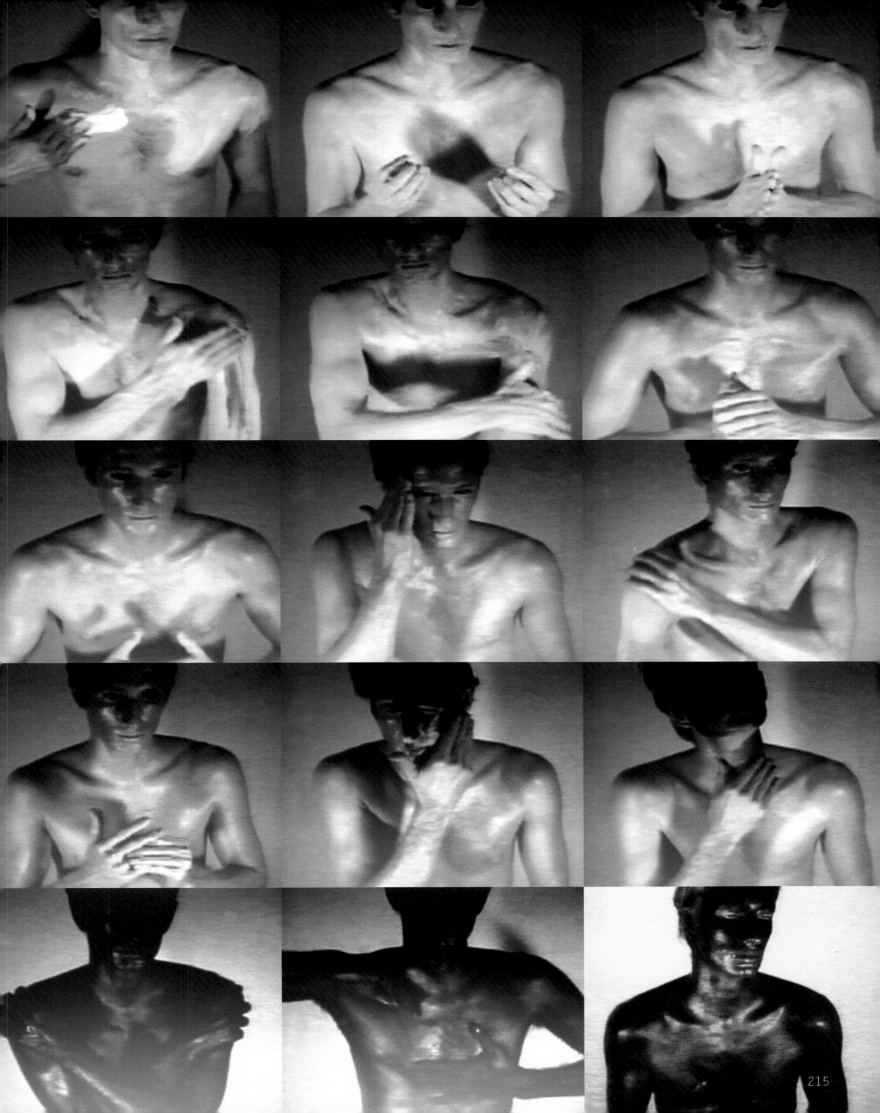

215

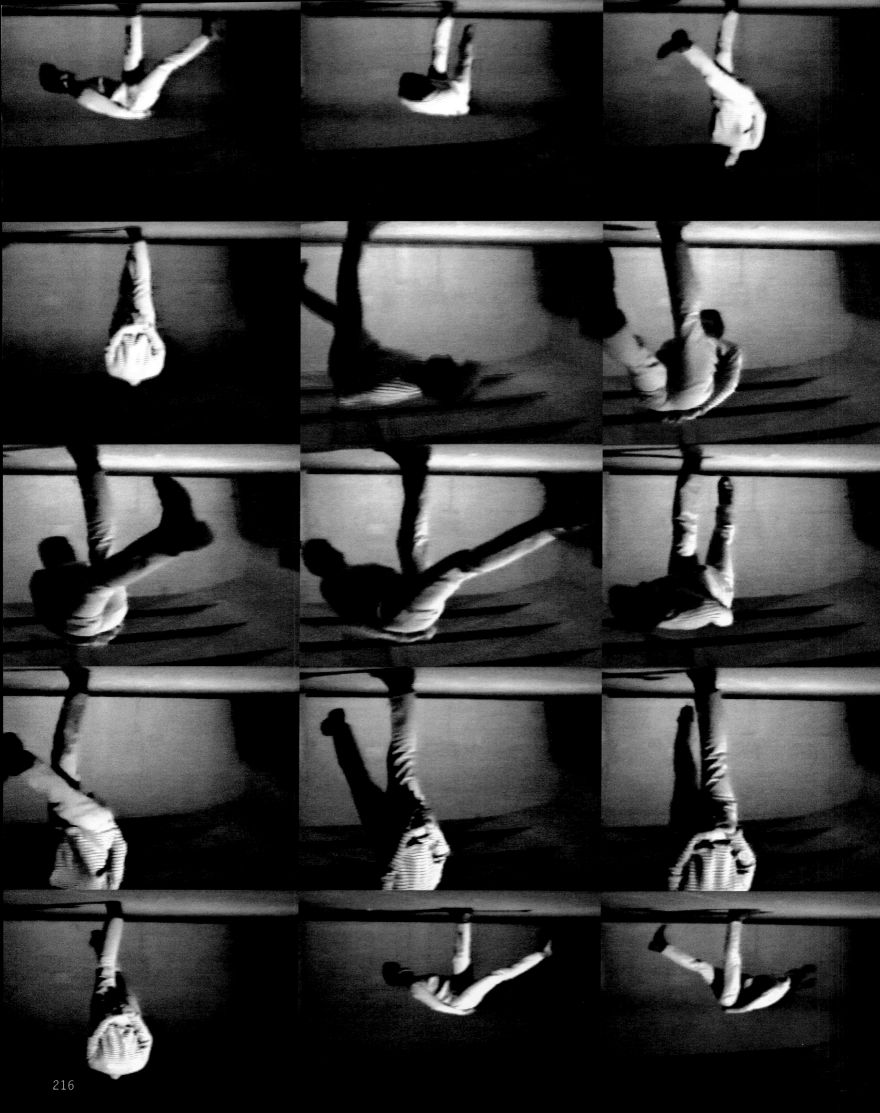

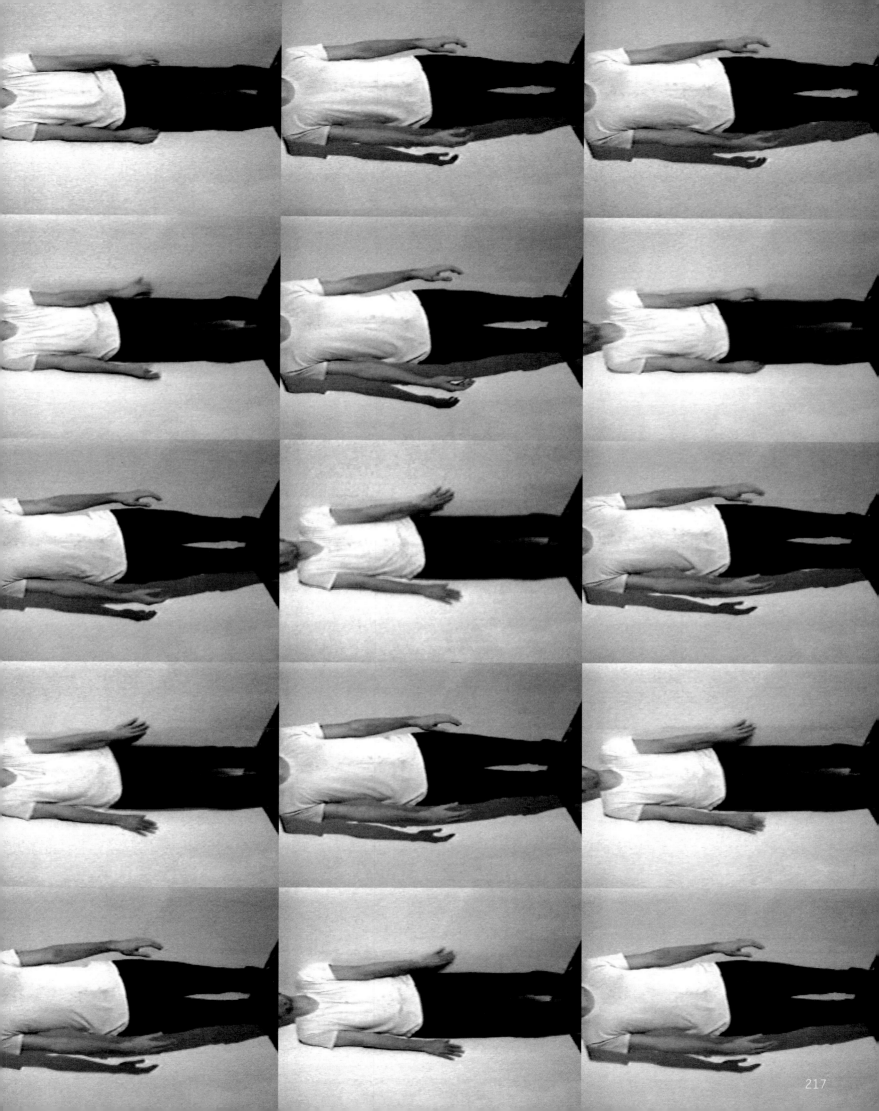

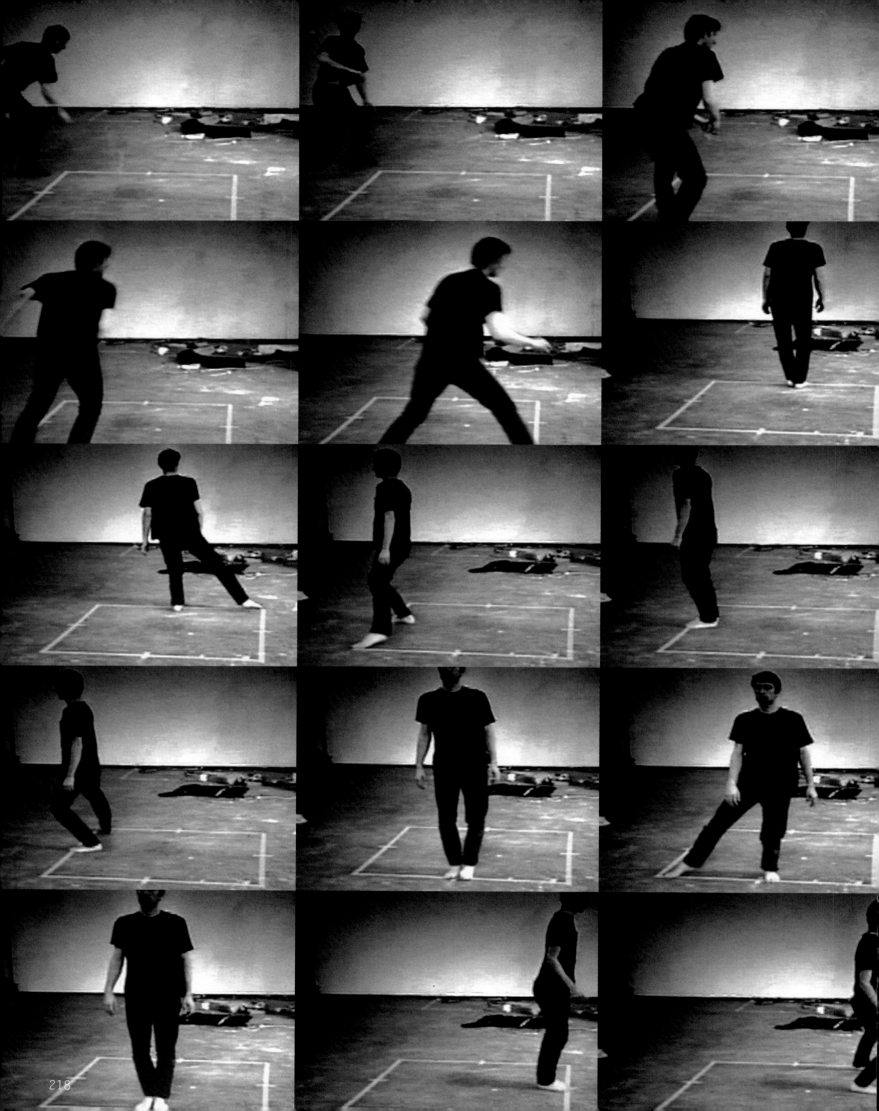

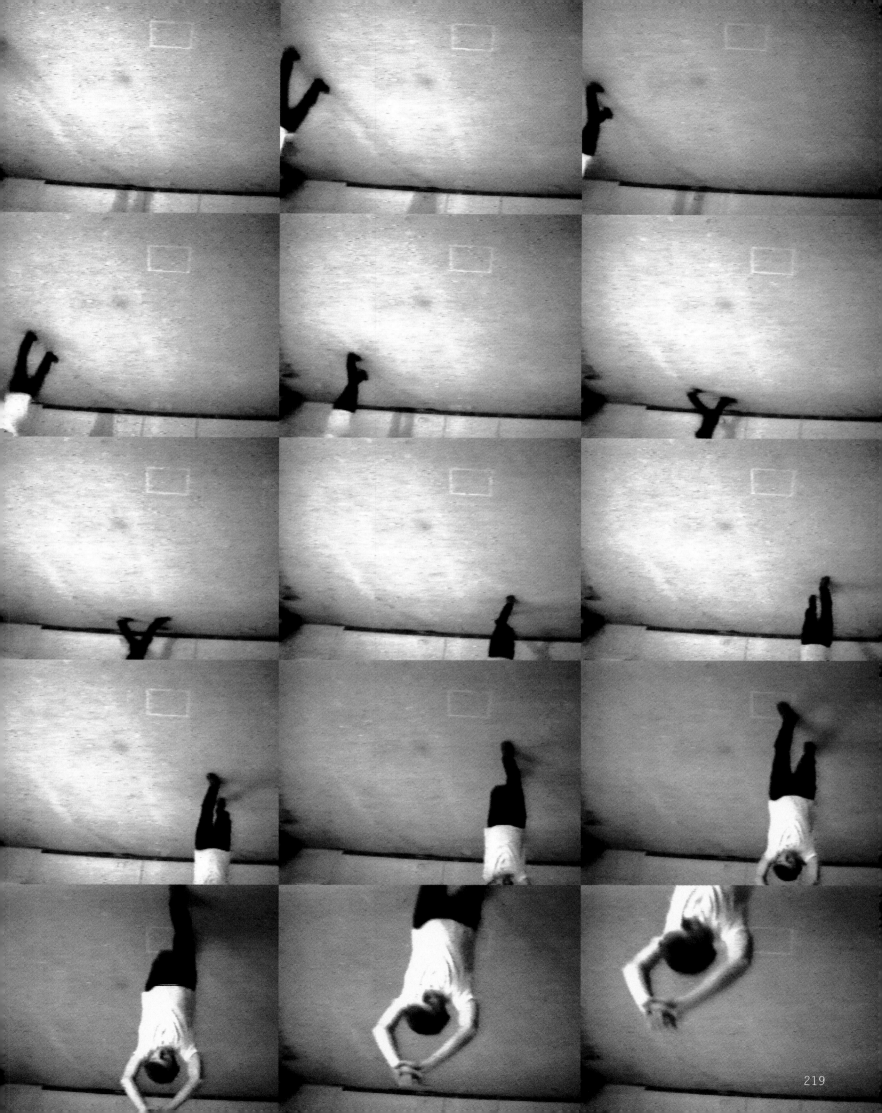

219

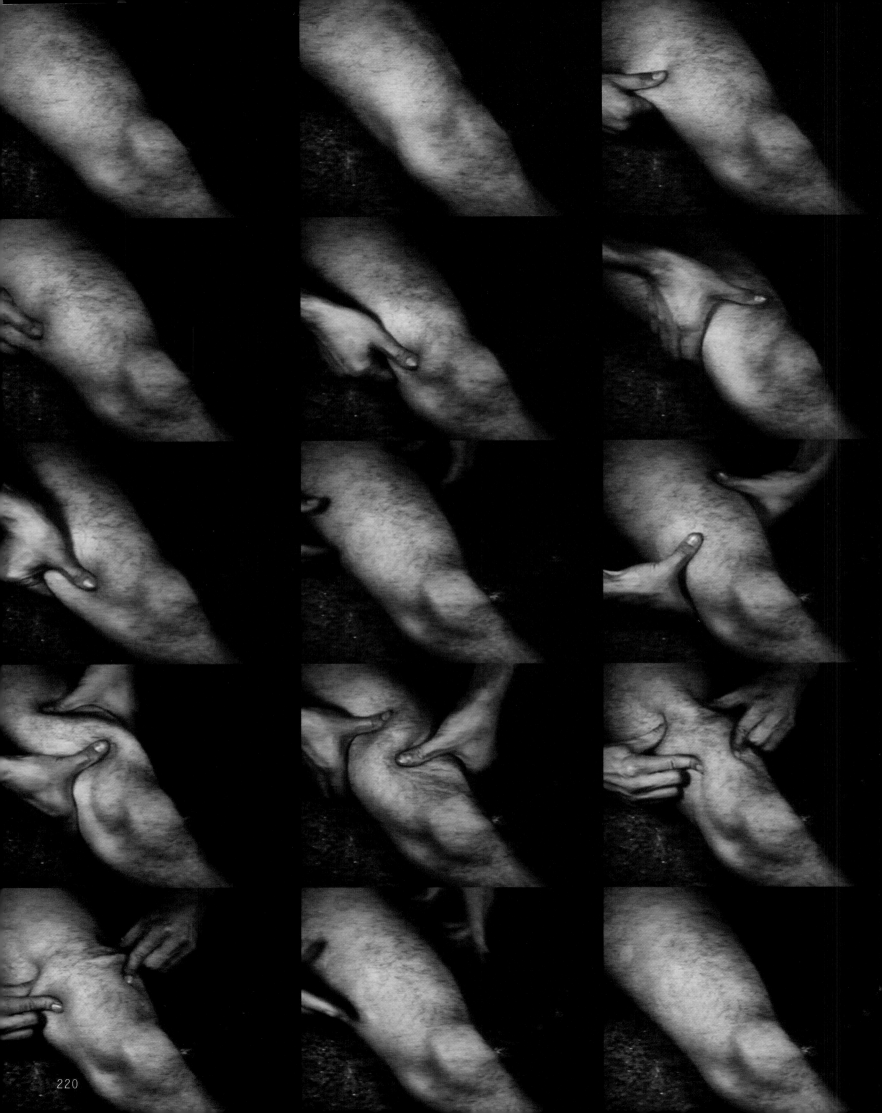

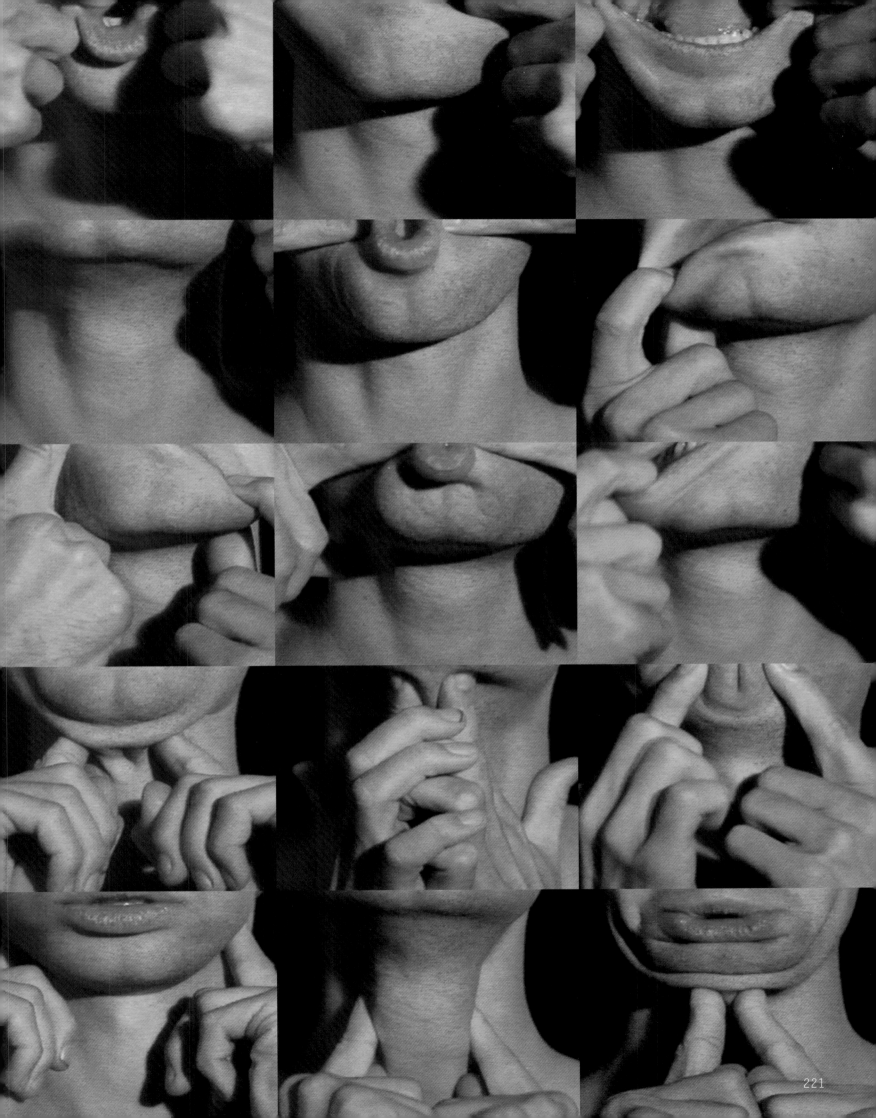

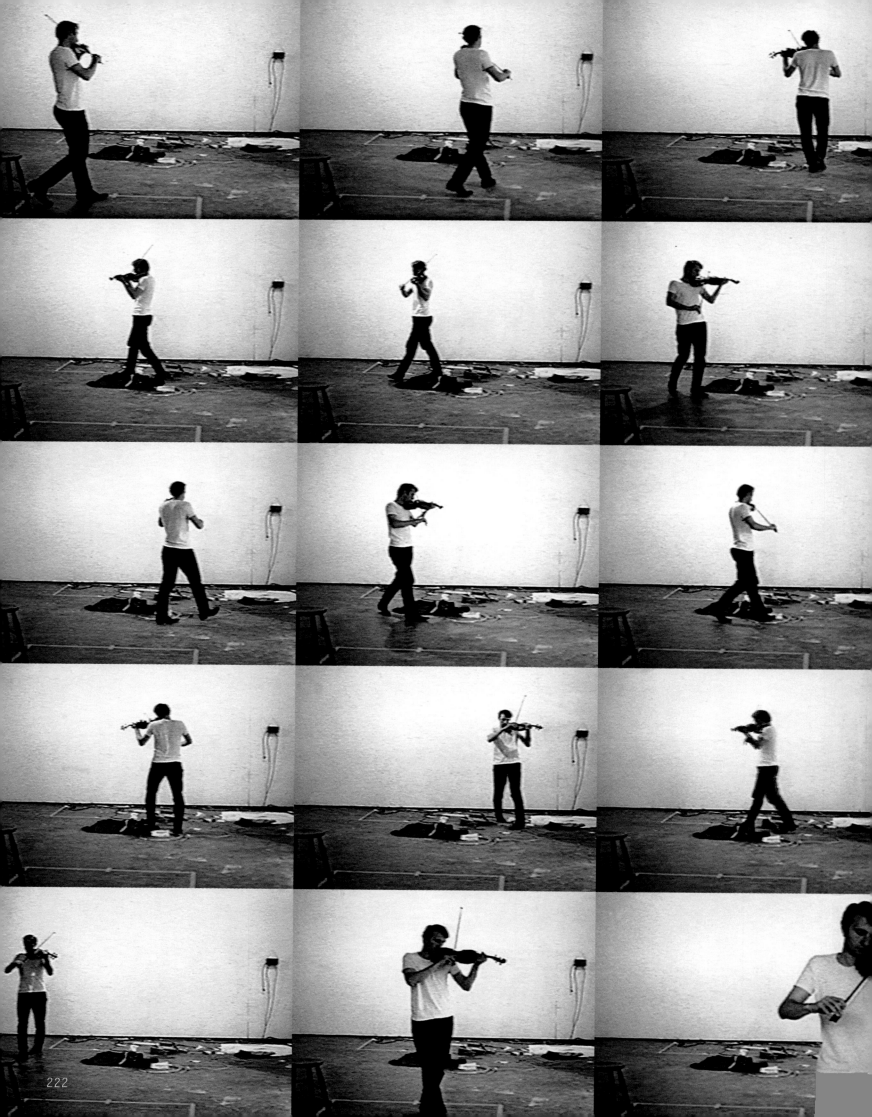

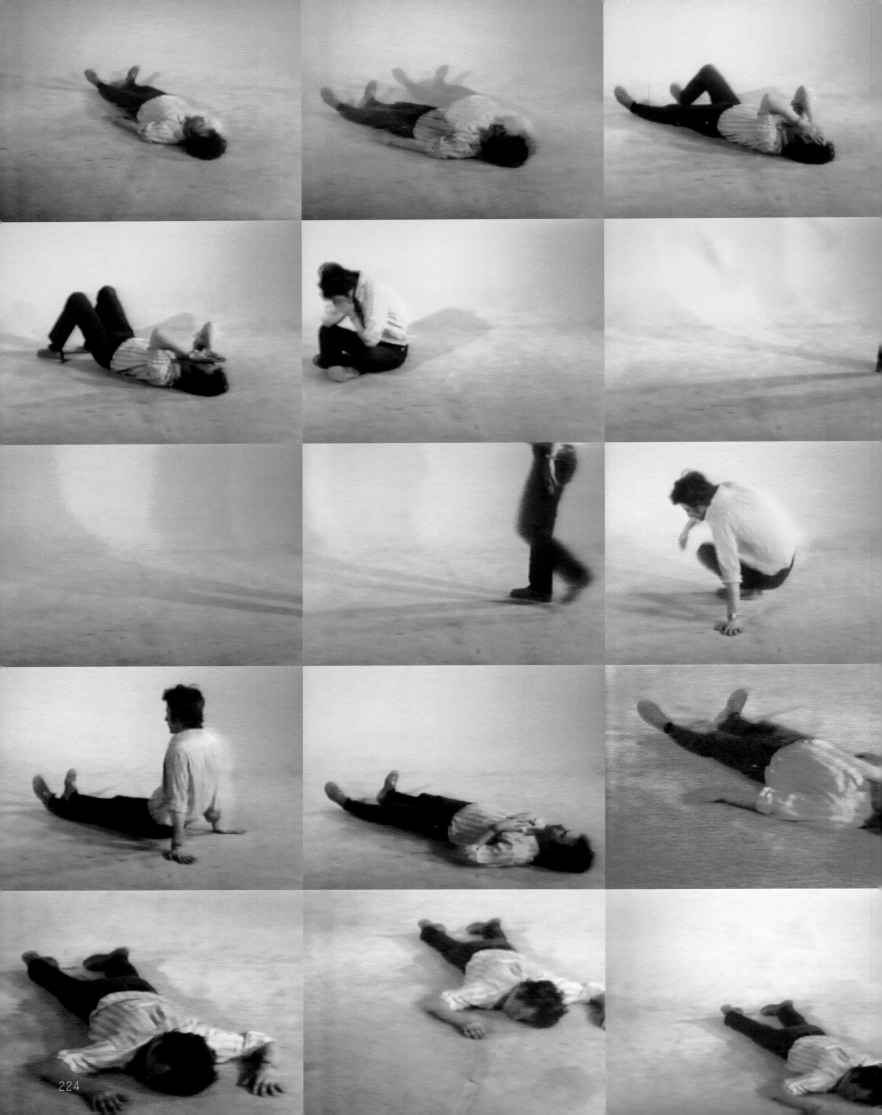

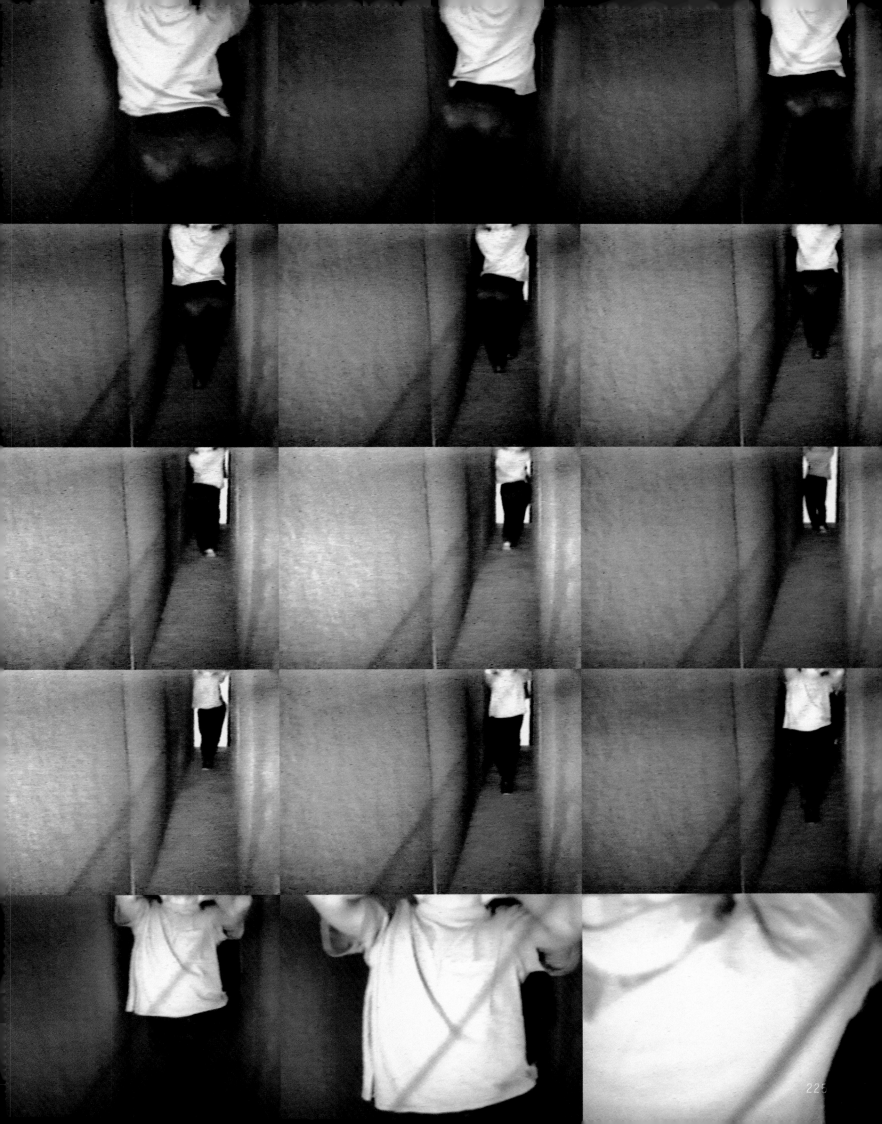

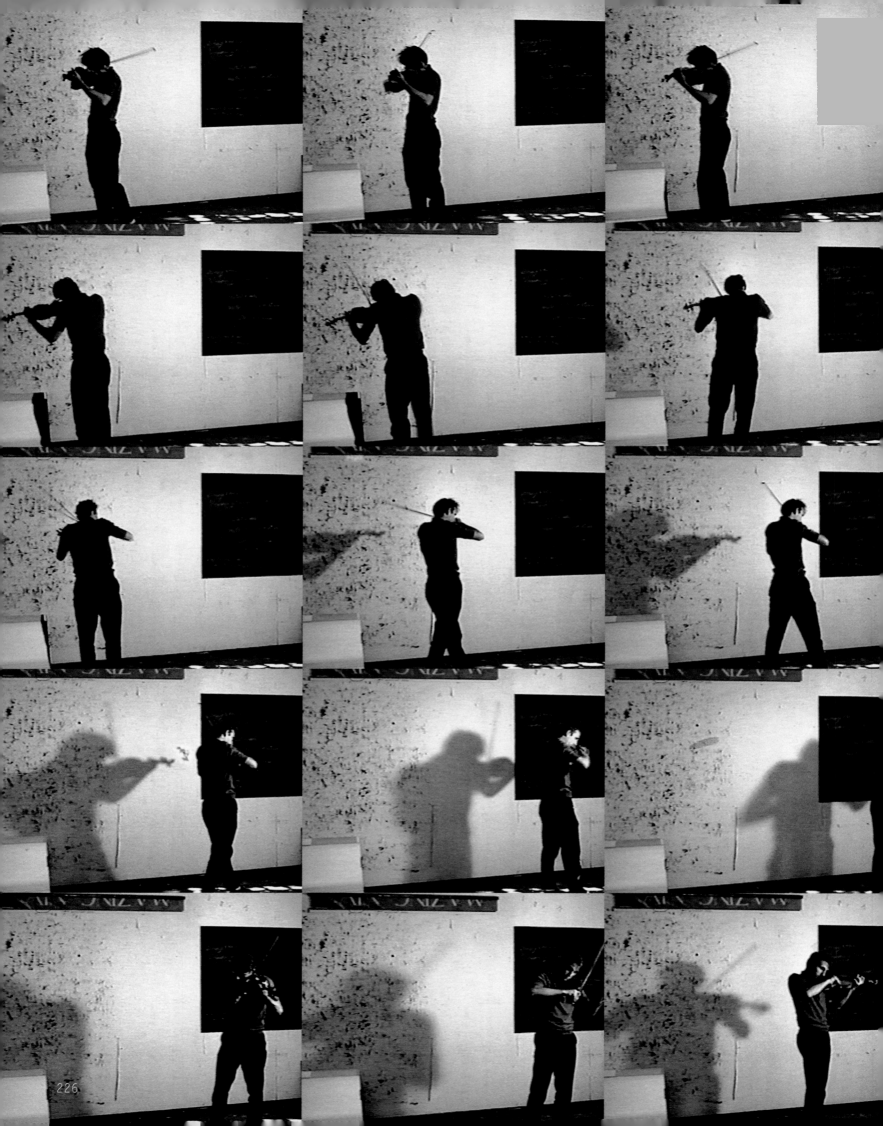

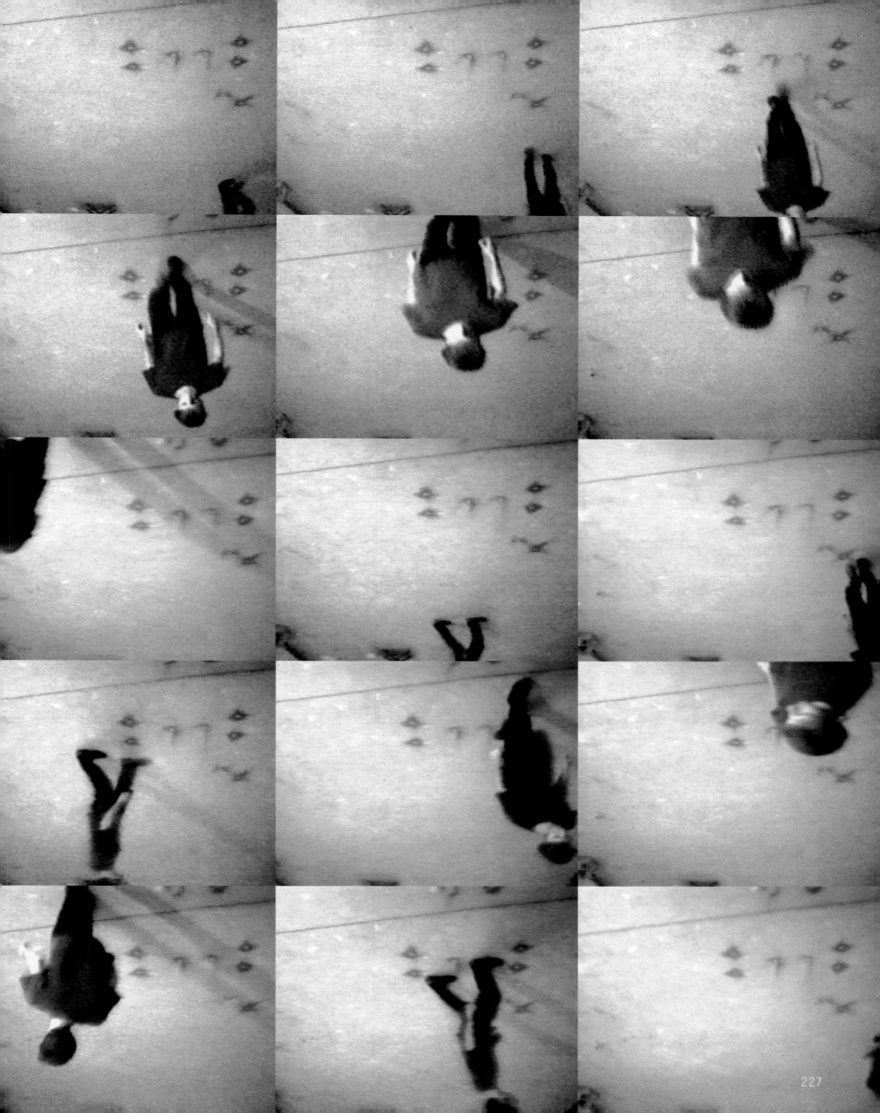

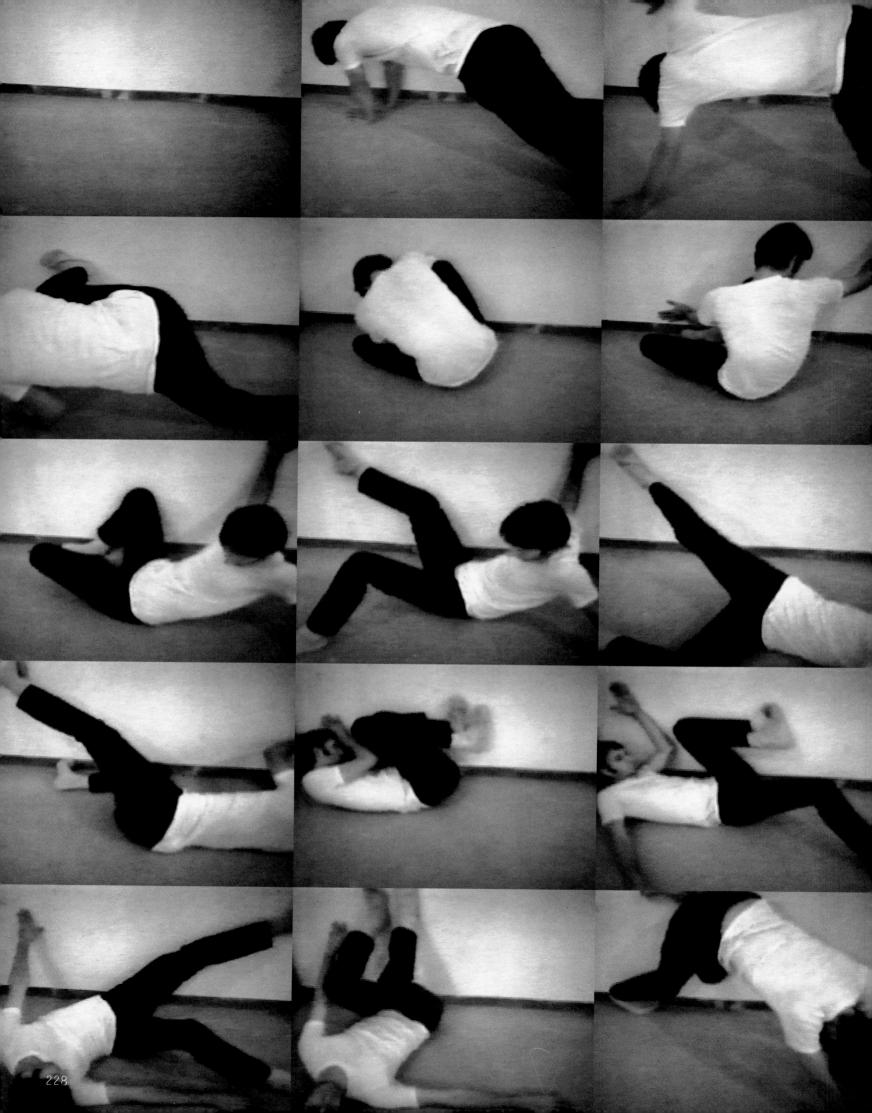

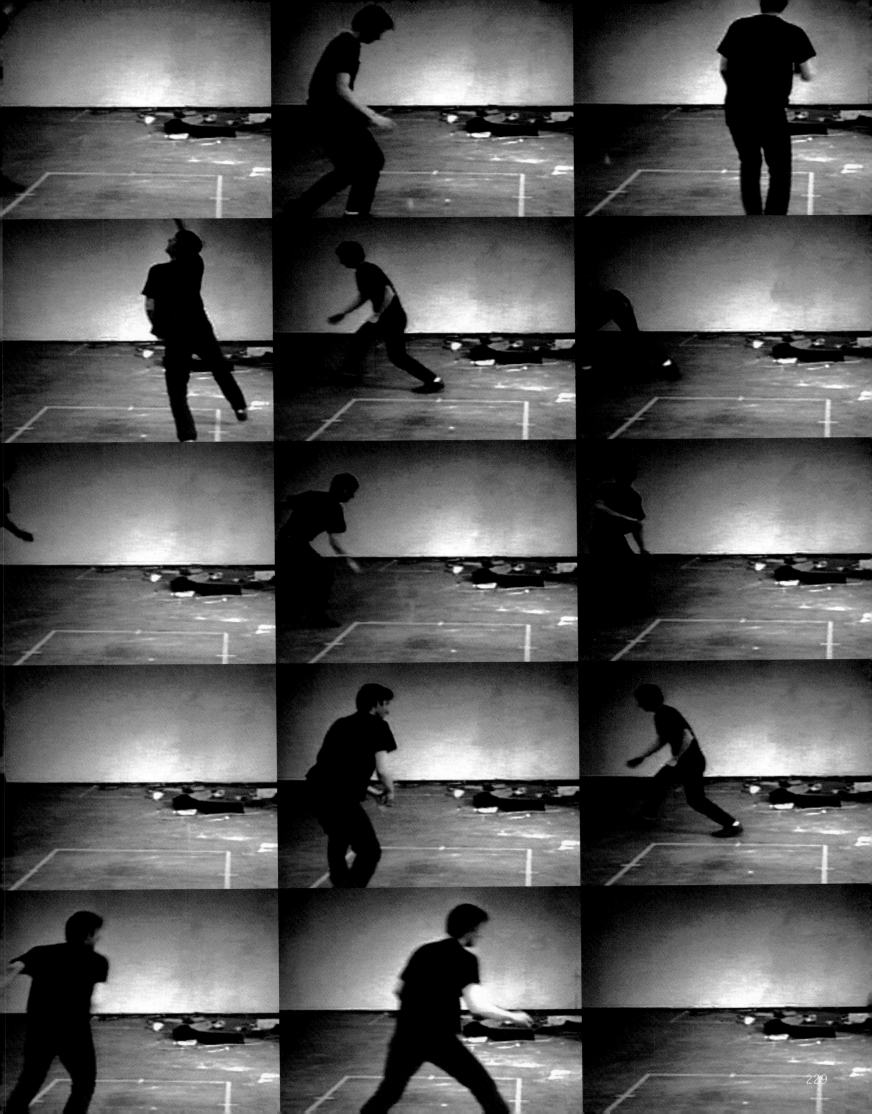

234

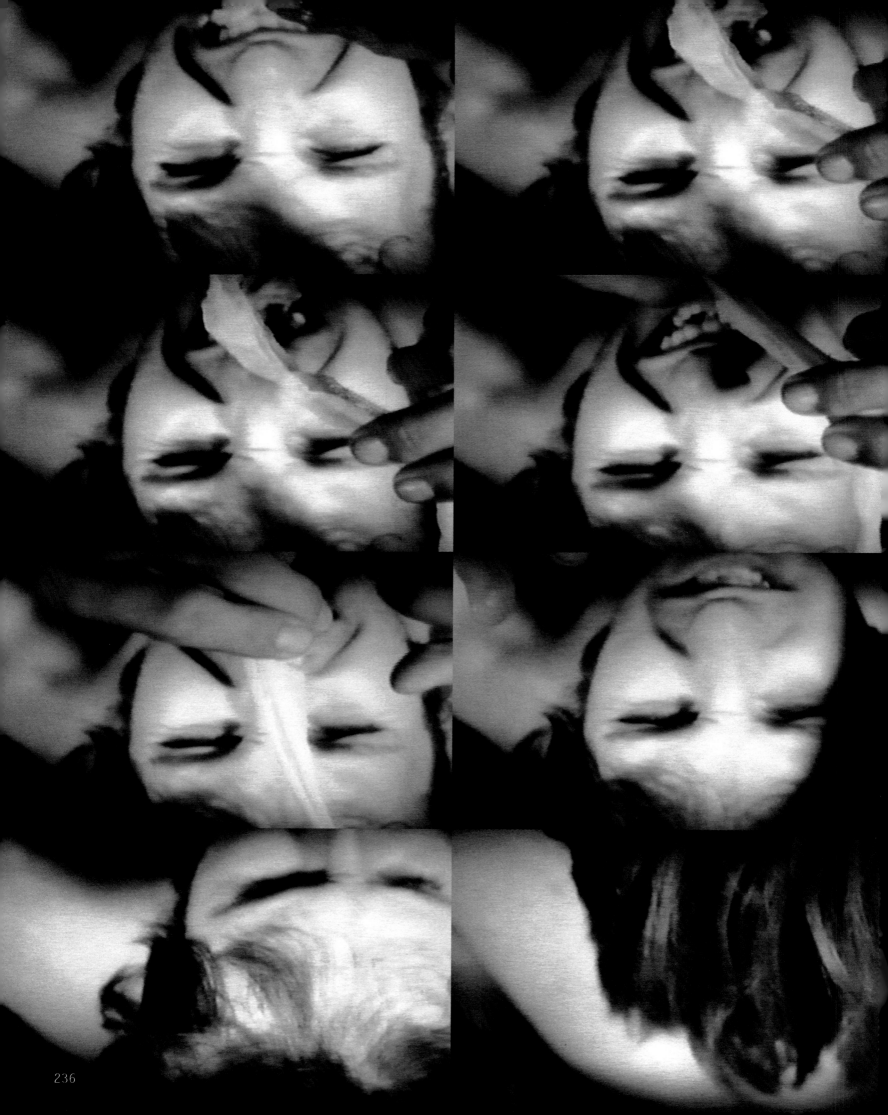

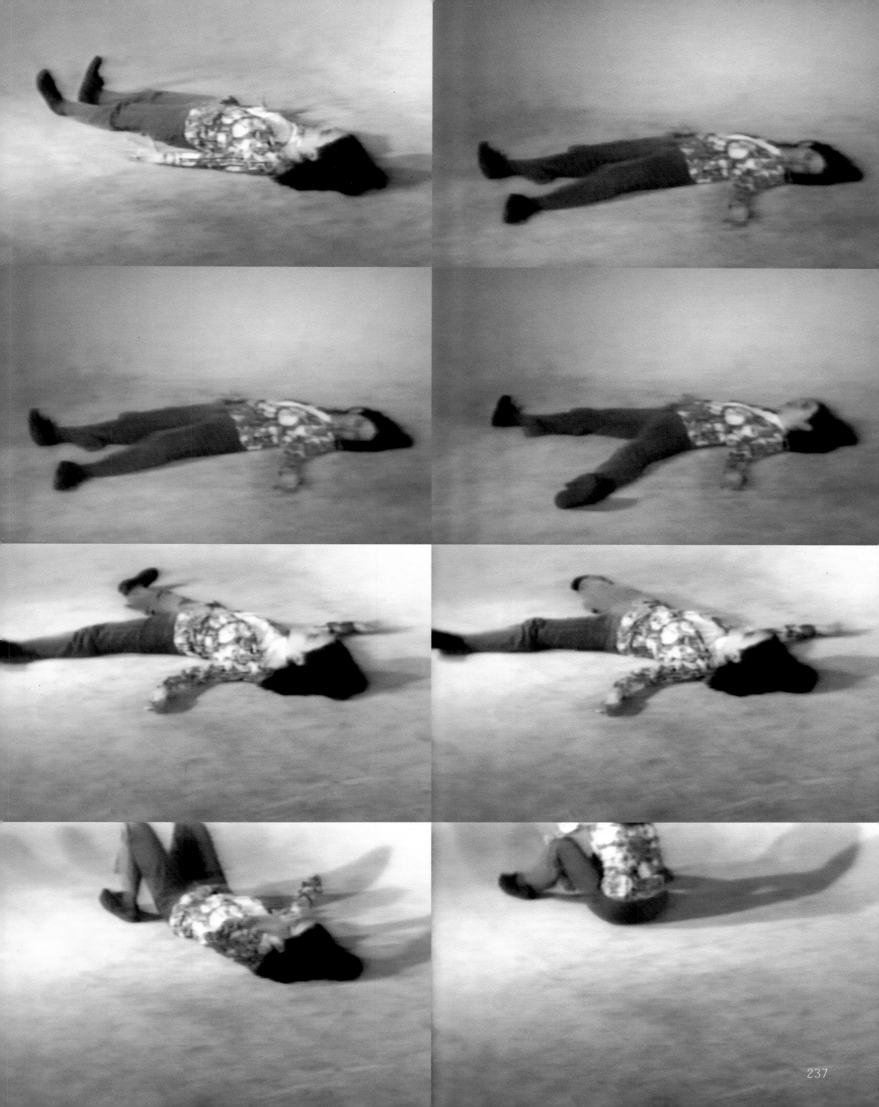

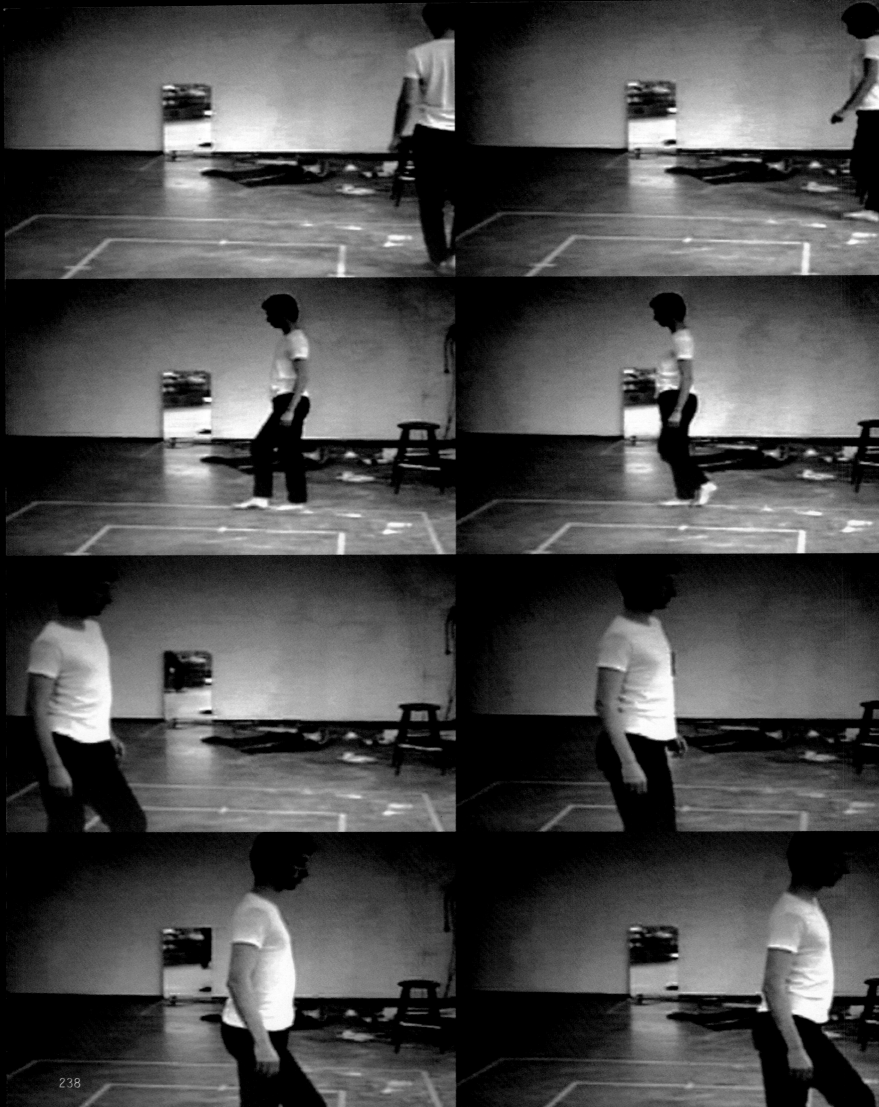

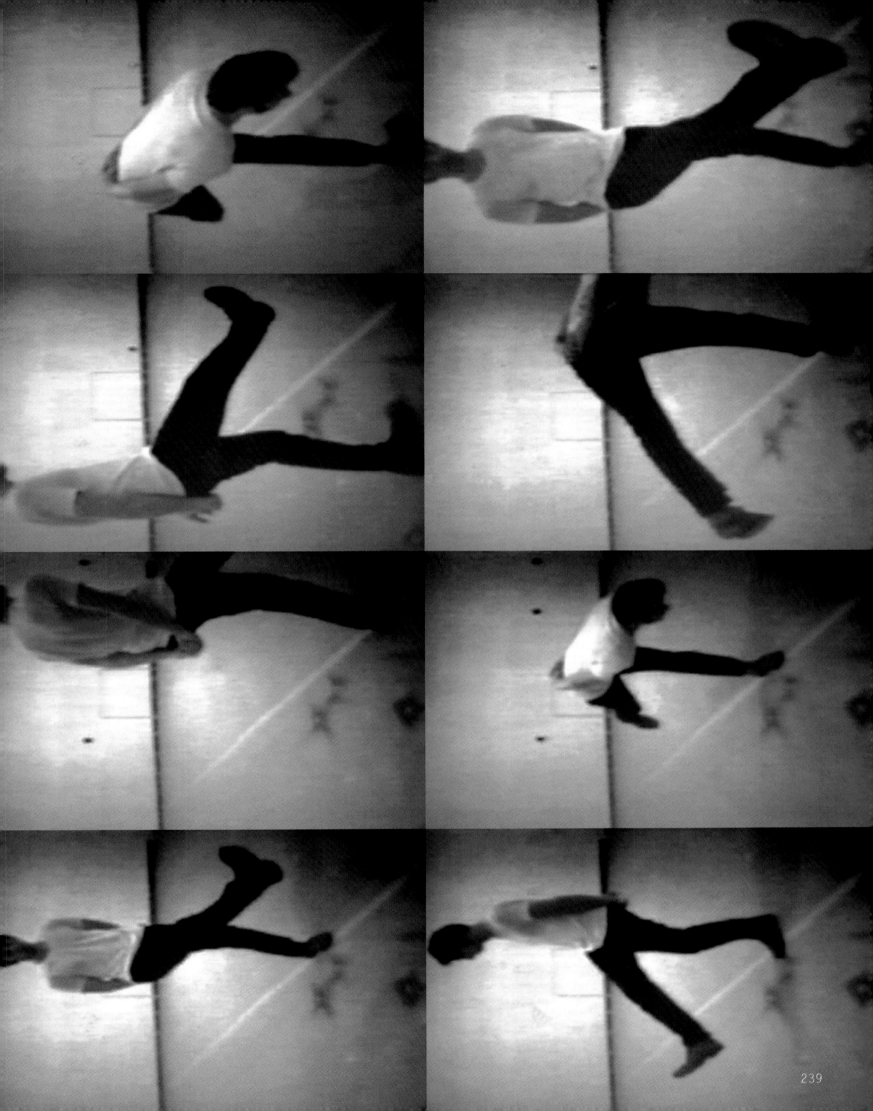

Bruce Nauman (b. 1941)
Selected Single Channel Film and Video Works

Thighing (Blue), 1967
Art Make-Up, 1967-68: *No. 1, White*, 1967 / *No. 2, Pink*, 1967-68
No. 3, Green, 1967-68 / *No. 4, Black*, 1967-68
*Bouncing Two Balls Between the Floor and Ceiling with Changing
Rhythms*, 1967-68
Dance or Exercise on the Perimeter of a Square (Square Dance),
1967-68
Playing A Note on the Violin While I Walk Around the Studio,
1967-68
Violin Film # 1 (Playing The Violin As Fast As I Can), 1967-68
*Walking in an Exaggerated Manner Around the Perimeter of a
Square*, 1967-68
Bouncing in the Corner No. 1, 1968
Flesh to White to Black to Flesh, 1968
Pinchneck, 1968
Slow Angle Walk (Beckett Walk), 1968
Stamping in the Studio, 1968
Walk with Contrapposto, 1968
Wall-Floor Positions, 1968
Black Balls, 1969
Bouncing Balls, 1969
Bouncing in the Corner, No. 2: Upside Down, 1969
Gauze, 1969
Lip Sync, 1969
Manipulating a Fluorescent Tube, 1969
Pacing Upside Down, 1969
Pulling Mouth, 1969
Revolving Upside Down, 1969
Violin Tuned D.E.A.D., 1969
Elke Allowing the Floor to Rise Up Over Her, Face Up, 1973
Tony Sinking into the Floor, Face Up, and Face Down, 1973

All images courtesy of Electronic Arts Intermix (EAI), New York.
© 2002 Bruce Nauman/Artists Rights Society (ARS), New York

(214-215) *Art Make-Up*, 1967-68, 40:00 min, color, silent, video
from 16 mm film
(216) *Revolving Upside Down*, 1969, 61:00 min, b&w, sound
(217) *Bouncing in the Corner No. 1*, 1968, 60:00 min, b&w, sound
(218) *Dance or Exercise on the Perimeter of a Square (Square
Dance)*, 1967-68, 10:00 min, b&w, sound, 16 mm film
(219) *Pacing Upside Down*, 1969, 56:00 min, b&w, sound
(220) *Thighing (Blue)*, 1967, 10:00 min, color, sound, 16 mm film
(221) *Pinchneck*, 1968, 2:00 min, color, silent, 16 mm film
(222) *Playing a Note on the Violin While I Walk Around the
Studio*, 1967-68, 10:00 min, b&w, sound, 16 mm film
(223) *Violin Tuned D.E.A.D.*, 1969, 60:00 min, b&w, sound
(224) *Tony Sinking into the Floor, Face Up, and Face Down*, 1973,
60:00 min, color, sound
(225) *Walk with Contrapposto*, 1968, 60:00 min, b&w, sound
(226) *Violin Film #1 (Playing the Violin As Fast As I Can)*,
1967-68, 10:54 min, b&w, sound
(227) *Stamping in the Studio*, 1969, 62:00 min, b&w, sound
(228) *Wall-Floor Positions*, 1968, 60:00 min, b&w, sound
(229) *Bouncing Two Balls Between the Floor and Ceiling with
Changing Rhythms*, 1967-68, 10:00 min, b&w, sound, 16 mm film
(230) *Flesh to White to Black to Flesh*, 1968, 51:00 min, b&w,
sound
(231) *Pulling Mouth*, 1969, 61:00 min, b&w, silent, 16 mm film
(232) *Bouncing Balls*, 1969, 9:00 min, b&w, silent, 16 mm film
(233) *Lip Sync*, 1969, 57:00 min, b&w, sound
(234) *Black Balls*, 1969, 8:00 min, b&w, silent, 16 mm film
(235) *Manipulating a Fluorescent Tube*, 1969, 62:00 min, b&w,
sound
(236) *Gauze*, 1969, 8:00 min, b&w, silent, 16 mm film
(237) *Elke Allowing the Floor to Rise Up Over Her, Face Up*, 1973,
39:00 min, color, sound
(238) *Walking in an Exaggerated Manner Around the Perimeter of a
Square*, 1967-68, 10:00 min, b&w, silent, 16 mm film
(239) *Slow Angle Walk (Beckett Walk)*, 1968, 60:00 min, b&w, sound
(240) Top to bottom: *Thighing (Blue)*, 1967; *Revolving Upside
Down*, 1969; *Violin Film #1 (Playing the Violin As Fast As I Can)*,
1967-68; *Wall-Floor Positions*, 1968
(241) Top row: *Pulling Mouth*, 1969; *Black Balls*, 1969; *Bouncing
in the Corner No.1*, 1968
Second row: *Bouncing Balls*, 1969; *Bouncing Two Balls Between the
Floor and Ceiling with Changing Rhythms*, 1967-68; *Walk with
Contrapposto*, 1968
Third row: *Dance or Exercise on the Perimeter of a Square (Square
Dance)*, 1967-68; *Gauze*, 1969; *Manipulating a Fluorescent Tube*,
1969
Fourth row: *Pacing Upside Down*, 1969; *Walking in an Exaggerated
Manner Around the Perimeter of a Square*, 1967-68; *Pinchneck*, 1968
Bottom row: *Art Make-Up*, 1967-68; *Slow Angle Walk (Beckett Walk)*,
1968; *Stamping in the Studio*, 1969

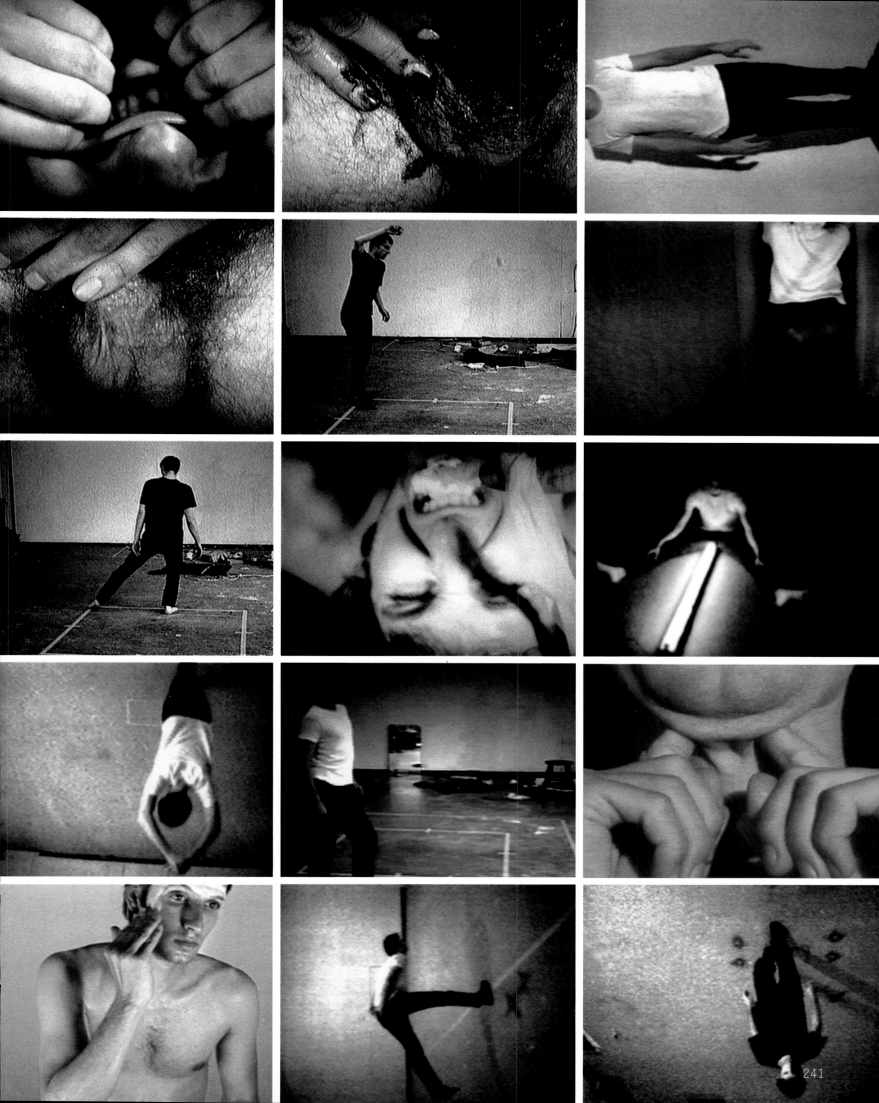

Tony Oursler

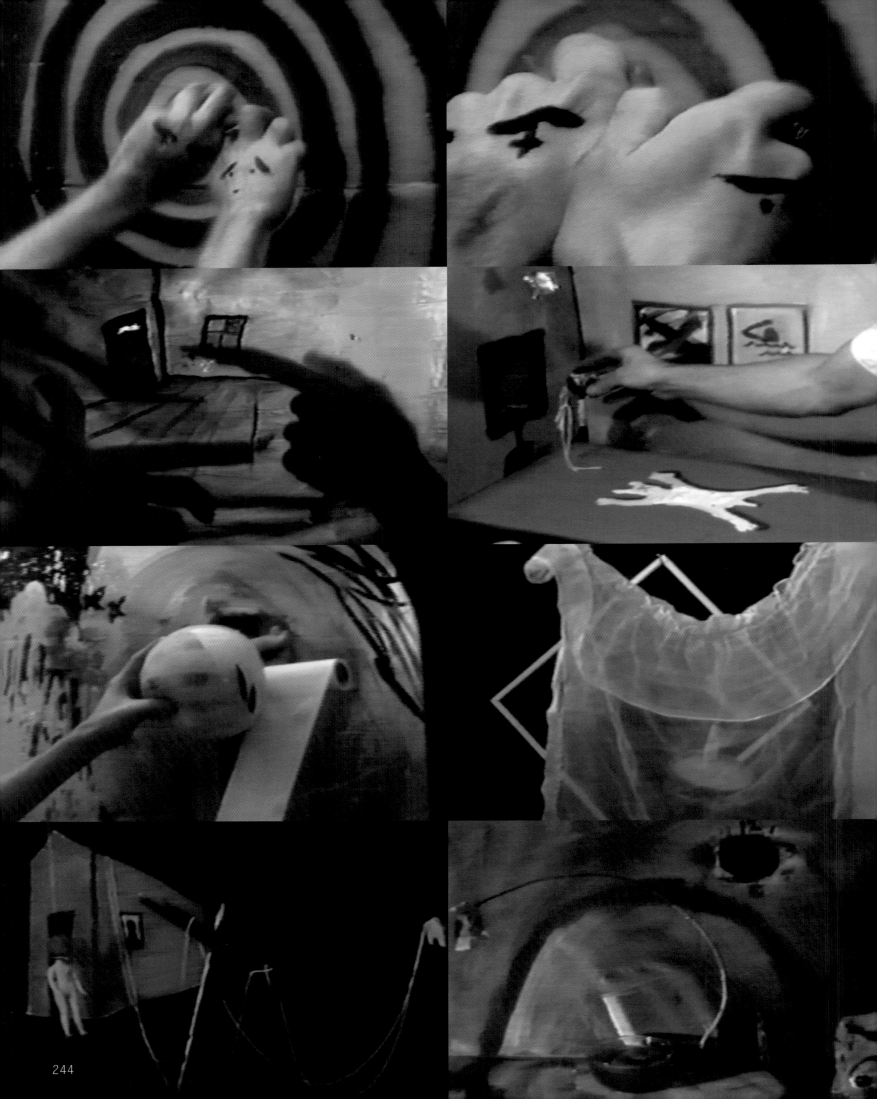

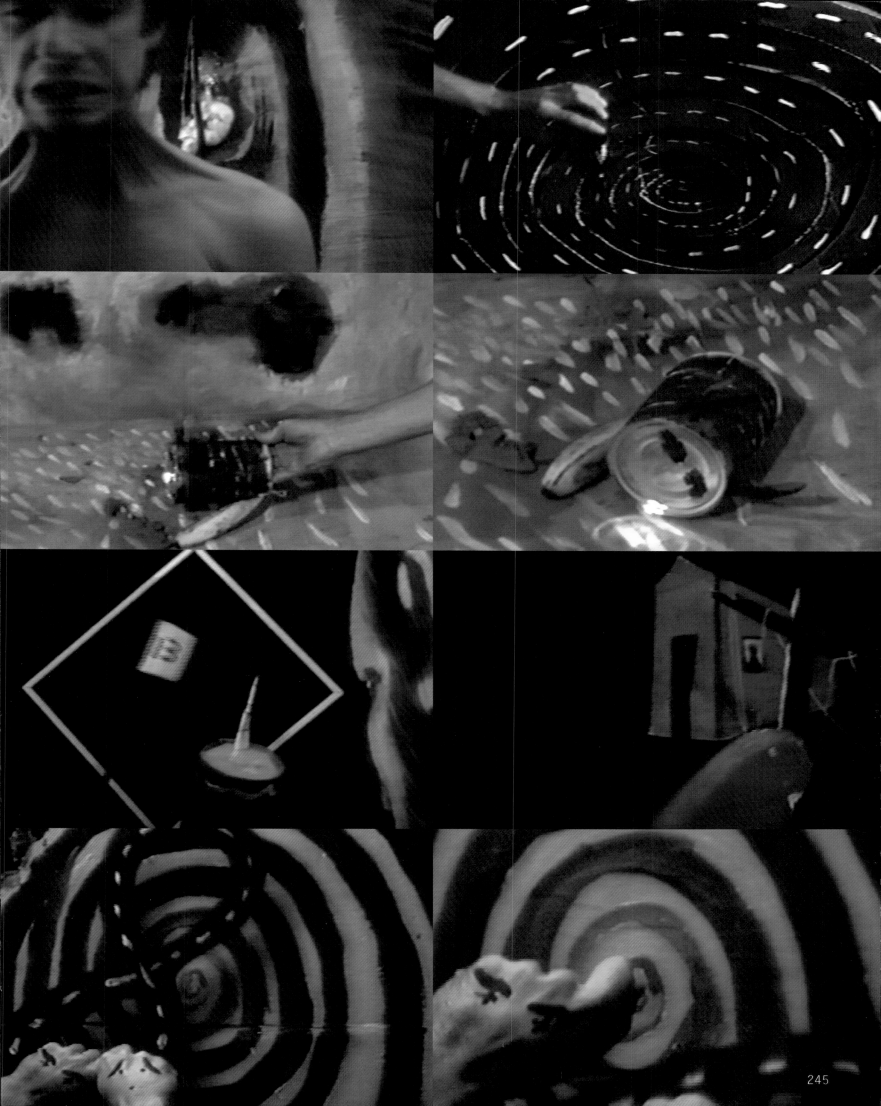

Tony Oursler (b. 1957)
Selected Single Channel Film and Video Works

Joe, Joe's Transsexual Brother and Joe's Woman, 1976
The Life of Phillis, 1977/78
Shorts, 1977-79
The Rosey Finger of Dawn, 1979
Tony Oursler: Selected Works, 1979 (*Diamond (Head)*, 1979; *Good Things and Bad Things*, 1979; *Life*, 1979)
The Loner, 1980
The Weak Bullet, 1980
Grand Mal, 1981
Son of Oil, 1982
Theme Song from Si Fi, 1983
Rome Hilton, 1983
My Class, 1983
Spinout, 1983
EVOL, 1984
Sphères d'influence, 1985
Diamond: The 8 Lights (Spheres of Influence), 1985
Sucker, 1987
Joyride (TM), 1988
ONOUROWN, 1990
Tunic (Song for Karen), 1990
Kepone, 1991
Model Release, 1992
Paranoid-Schizoid-Position, 1992
Test, 1992
Toxic Detox, 1992
Air, 1993-1997
Pole Dance, 1997
Off, 1999
9/11, 2001

All images courtesy of Electronic Arts Intermix (EAI), New York

(244-245) *The Weak Bullet*, 1980, 12:41 min, color, sound
(246-249) *The Loner*, 1980, 29:56 min, color, sound
(250) Top to bottom: *The Loner*, 1980; *Sucker*, 1987; *Tunic (Song for Karen) (in collaboration with Sonic Youth)*, 1990; *The Weak Bullet*, 1980
(251) Top row: *Son of Oil*, 1982; *9/11*, 2001
Middle row: *EVOL*, 1984; *Grand Mal*, 1981
Bottom row: *Joyride (TM) (in collaboration with Constance DeJong)*, 1988; *Off*, 1999

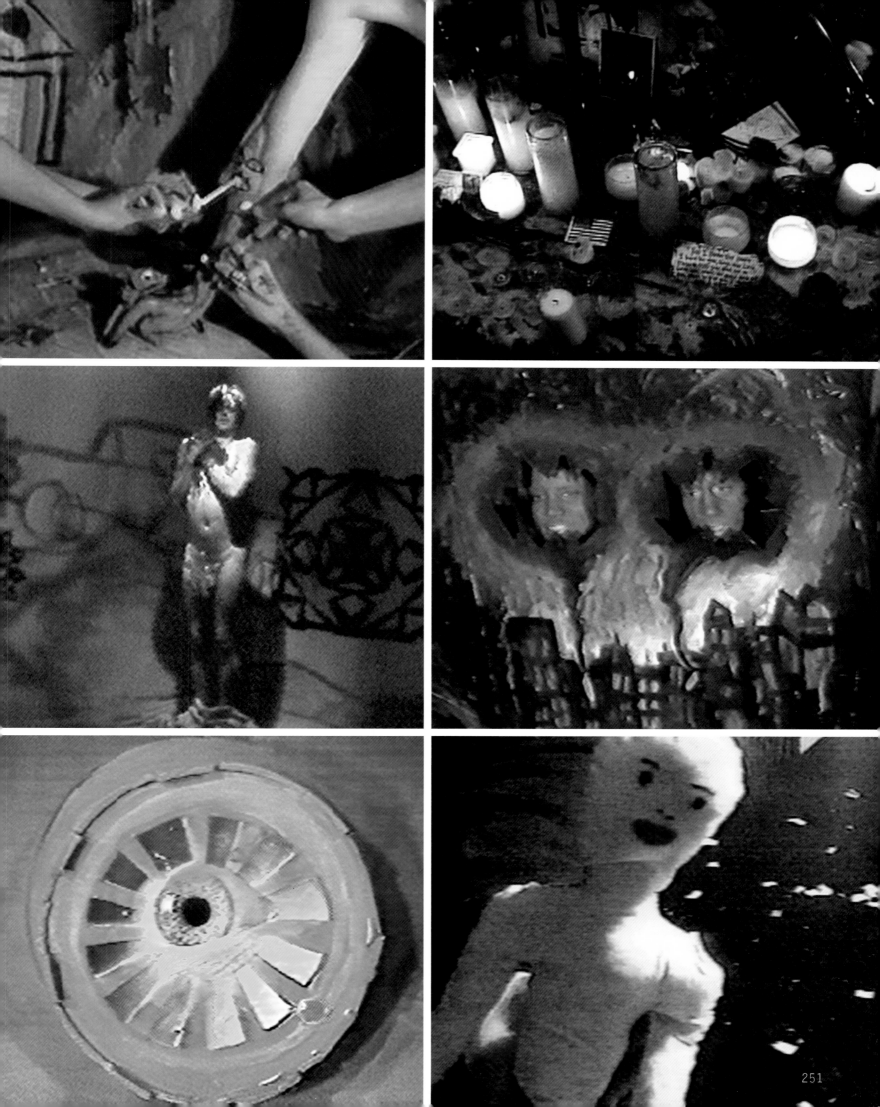

251

Nam June Paik

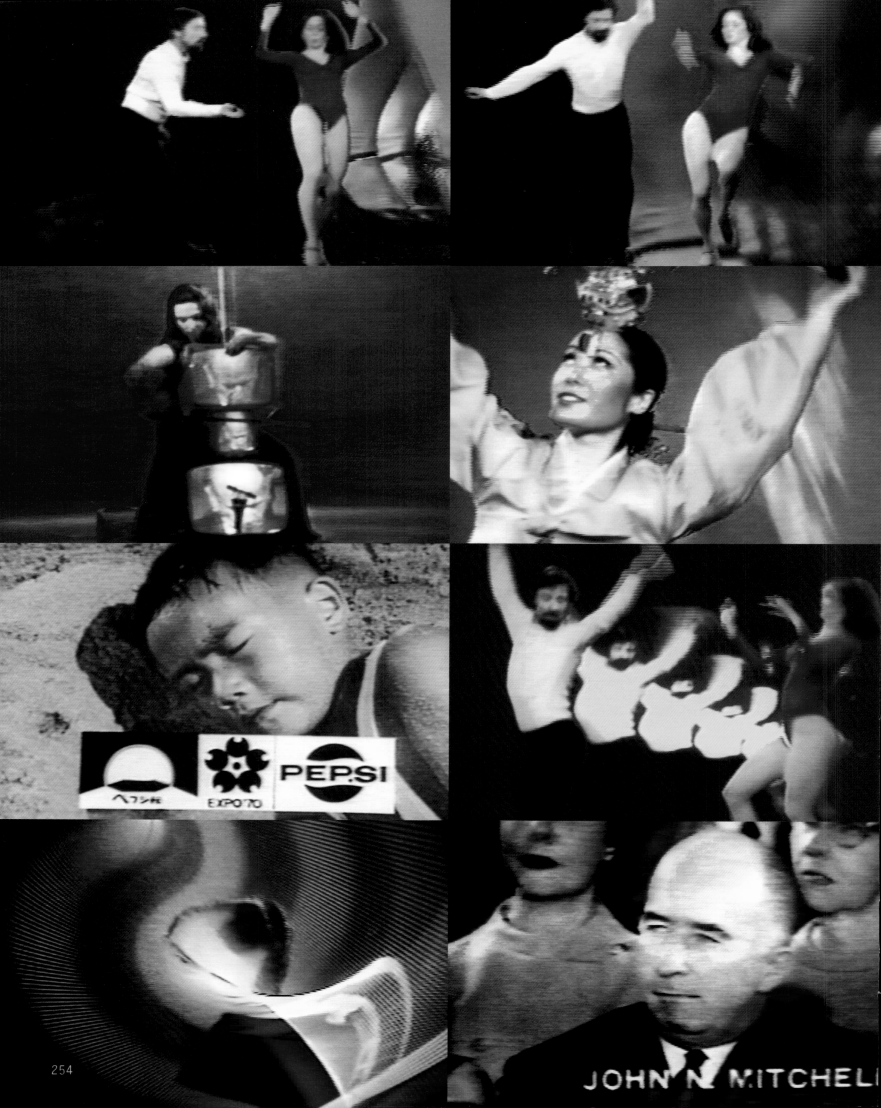

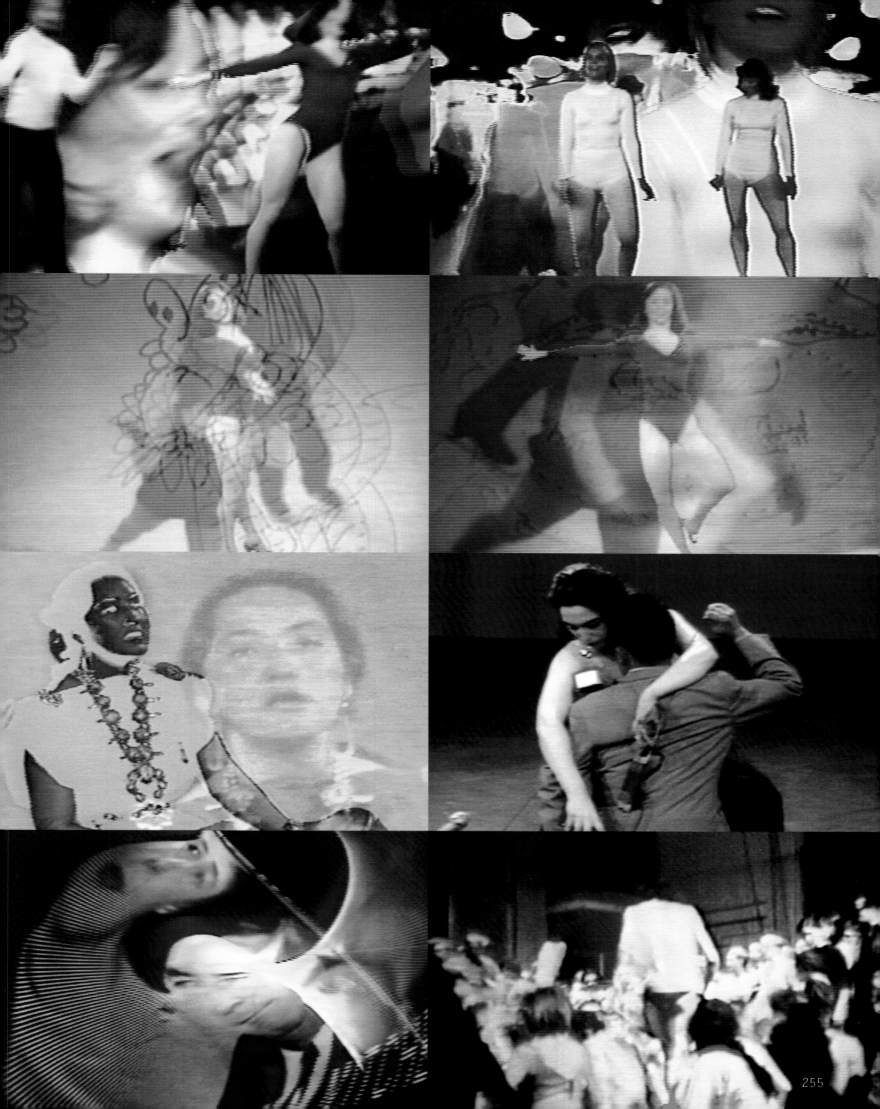

DANCE OF TIME

TIME REVERSIBLE AND
IRREVERSIBLE

Nam June Paik (b. 1932)
Selected Single Channel Video Works

Button Happening, 1965
Video Synthesizer and "TV Cello" Collectibles, 1965-71
Early Color TV Manipulations, 1965-71
Video Commune, 1971
TV Cello Premiere, 1971
Digital Experiment at Bell Labs, 1966
Film Video Works #3, 1966-69 (*Missa of Zen*, 1966-69; *Electronic Moon*, 1966-69)
Video-Film Concert, 1966-72, 1992 (*Video Tape Study No. 3*, 1966-69; *Beatles Electroniques*, 1966-69; *Electronic Moon No. 2*, 1969; *Electronic Fables*, 1966-72, 1992; *Waiting for Commercials*, 1972; *Electronic Yoga*, 1972-92)
9/23/69: Experiment with David Atwood, 1969
Global Groove, 1973
A Tribute to John Cage, 1973, re-edited 1976
Nam June Paik: Edited for Television, 1975
Suite 212, 1975, re-edited 1977
Documenta 6 Satellite Telecast, 1977
Guadalcanal Requiem, 1977, re-edited 1979
Media Shuttle: Moscow/New York, 1978
Merce by Merce by Paik, 1978 (*Part One: Blue Studio: Five Segments*, 1975-76; *Part Two: Merce and Marcel*, 1978)
You Can't Lick Stamps in China, 1978
Lake Placid '80, 1980
My Mix '81, 1981
Allan 'n' Allen's Complaint, 1982
Good Morning Mr. Orwell, 1984
Vusac - NY, 1984
Butterfly, 1986
Bye Bye Kipling, 1986
Wrap Around the World, 1988
Living with the Living Theatre, 1989
MAJORCA - fantasia, 1989
A Tale of Two Cities, 1992
"Topless Cellist" Charlotte Moorman, 1995
Tiger Lives, 1999
Analogue Assemblage, 2000

All images courtesy of Electronic Arts Intermix (EAI.), New York

(254-255) *Global Groove* (in collaboration with John Godfrey), 1973, 28:30 min, color, sound
(256-257) *Merce by Merce by Paik* (in collaboration with Charles Atlas, Merce Cunningham and Shigeko Kubota), 1978, 28:45 min, color, sound
(258-259) *TV Cello Premiere* (in collaboration with Jud Yalkut), 1971, 7:25 min, color, silent
(260) Top to bottom: *Butterfly*, 1986; *Analogue Assemblage*, 2000; *A Tale of Two Cities* (in collaboration with Paul Garrin), 1992; *Bye Bye Kipling*, 1986
(261) Top row: *Button Happening*, 1965; *Rare Performance Documents 1961-1994 Volume 1: Paik-Moorman Collaborations* (in collaboration with Charlotte Moorman), compiled 2000; *Allan 'n' Allen's Complaint* (in collaboration with Shigeko Kubota), 1982
Second row: *TV Cello Premiere* (in collaboration with Jud Yalkut), 1971; *Global Groove* (in collaboration with John Godfrey), 1973; *Hand and Face*, 1961
Third row: *A Tribute to John Cage*, 1973, re-edited 1976; *Guadalcanal Requiem* (in collaboration with Charlotte Moorman), 1977, re-edited 1979; *Electronic Opera No. 2* (from *Video Variations*, in collaboration with WGBH), 1972
Fourth row: *MAJORCA - fantasia* (in collaboration with Paul Garrin and Amy Greenfield), 1989; *High Tech Allergy* (Kunstmuseum Wolfsburg), 1995; *The Electronic Super Highway: Nam June Paik in the Nineties* (by Jud Yalkut), 1995
Bottom row: *Living with the Living Theatre* (in collaboration with Betsy Connors and Paul Garrin), 1989; *Music of Nam June Paik*, 1975; *Electronic Fables* (in collaboration with Jud Yalkut), 1966-72

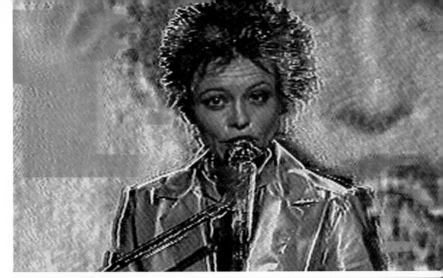

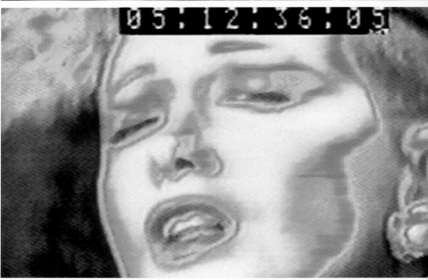
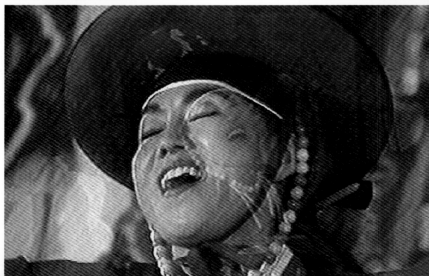

Pipilotti Rist

Pipilotti Rist (b. 1962)
Selected Single Channel Film and Video Works

St. Marx's Cemetery, 1984
Das Gute, 1986
I'm Not The Girl Who Misses Much, 1986
Sexy Sad I, 1987
Japsen (with Muda Mathis), 1988
(Entlastungen) Pipilottis Fehler, 1988
Die Tempodrosslerin saust (with Muda Mathis), 1989
You Called Me Jacky, 1990
Komm, Helvetia, 1991
Pickelporno, 1992
Alles Andere (with Seefrauen), 1992
Als der Bruder meiner Mutter geboren wurde, duftete es nach
Birnenblüten vor dem braungebrannten Sims, 1992
Kompilation videos 86-92 Pipilotti Rist, 1992
Blutclip, 1993
I'm A Victim Of This Song, 1995

All images courtesy of the artist, Luhring Augustine, New York,
and Galerie Hauser & Wirth, Zurich

(264-267) *Blutclip*, 1993, 2:30 min, color, sound
(268) Top to bottom: *You called me Jacky*, 1990; *I'm a victim of*
this song, 1995; *(Entlastungen) Pipilottis Fehler*, 1988; *Als der*
Bruder meiner Mutter geboren wurde, duftete es nach wilden
Birnenblüten vor dem braungebrannten Sims, 1992
(269) Top: *Pickelporno*, 1992
Bottom: *Sexy Sad I*, 1987

Martha Rosler

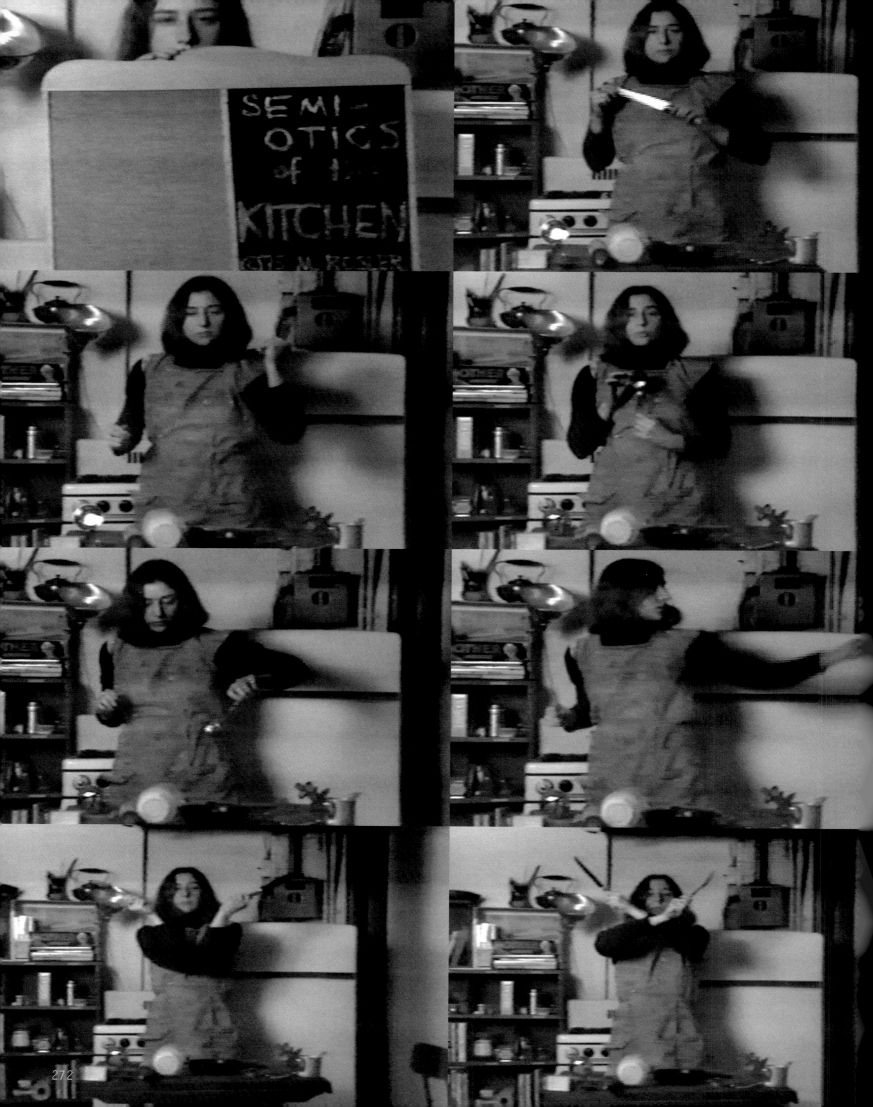

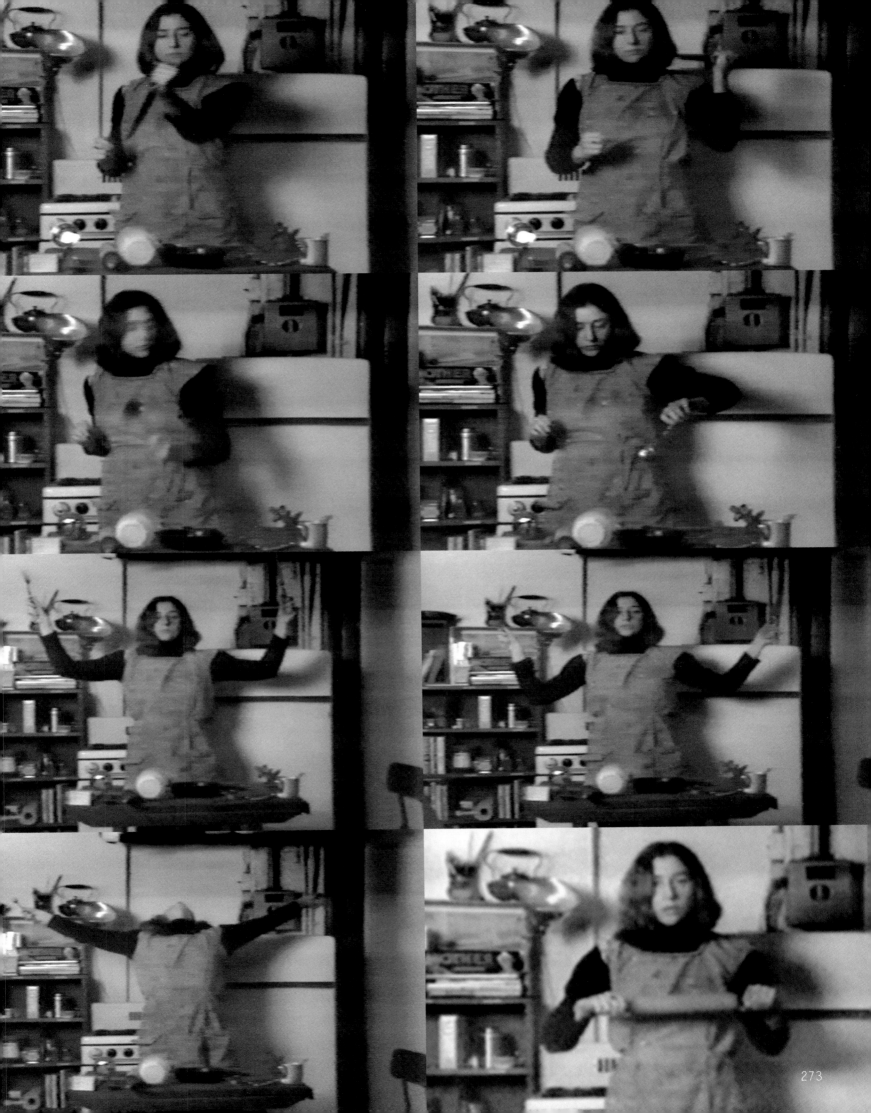

Martha Rosler
Selected Single Channel Film and Video Works

A Budding Gourmet, 1974
Super-8 Shorts, 1974
Semiotics of the Kitchen, 1975
Losing: A Conversation With The Parents, 1977
The East Is Red, The West Is Bending, 1977
Vital Statistics of a Citizen, Simply Obtained, 1977
Domination and the Everyday, 1978
Secrets From the Street: No Disclosure, 1980
Watchwords of the Eighties, 1981-82
Martha Rosler Reads Vogue, 1982
A Simple Case For Torture, or How To Sleep at Night, 1983
*Fascination with the [Game of the] Exploding [Historical] Hollow
Leg*, 1983
If it's too bad to be true, it could be DISINFORMATION, 1985
Born to be Sold: Martha Rosler Reads the Strange Case of Baby SM,
1989
In the Place of the Public: Airport Series, 1990
Seattle: Hidden Histories, 1991-95
How Do We Know What Home Looks Like?, 1993
The Garden Spot of the World: Greenpoint, Brooklyn, 1993
Chile on the Road to NAFTA, 1997

All images courtesy of Electronic Arts Intermix (EAI), New York

(272-273) *Semiotics of the Kitchen*, 1975, 6:09 min, b&w, sound
(274) Top to bottom: *If it's too bad to be true, it could be DIS-
INFORMATION*, 1985; *Losing: A Conversation With The Parents*, 1977;
Vital Statistics of a Citizen, Simply Obtained, 1977
(275) Top row: *Born to be Sold: Martha Rosler Reads the Strange
Case of Baby SM (in collaboration with Paper Tiger Television)*,
1989; *Chile on the Road to NAFTA*, 1997
Middle row: *A Budding Gourmet*, 1974; *How Do We Know What Home
Looks Like?*, 1993
Bottom row: *Seattle: Hidden Histories*, 1991-95; *Semiotics of the
Kitchen*, 1975

274

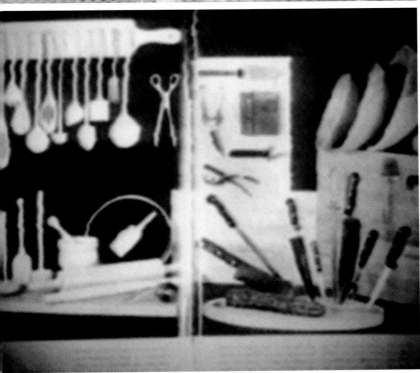

Richard Serra

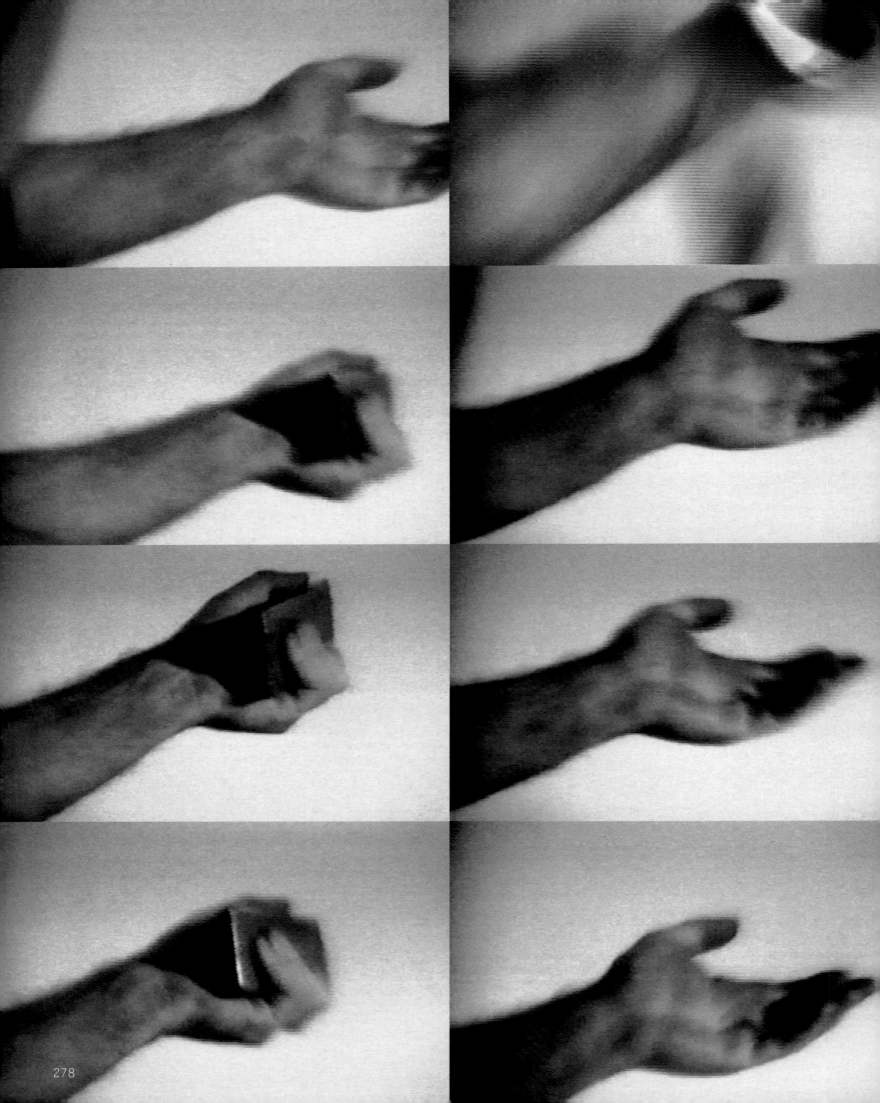

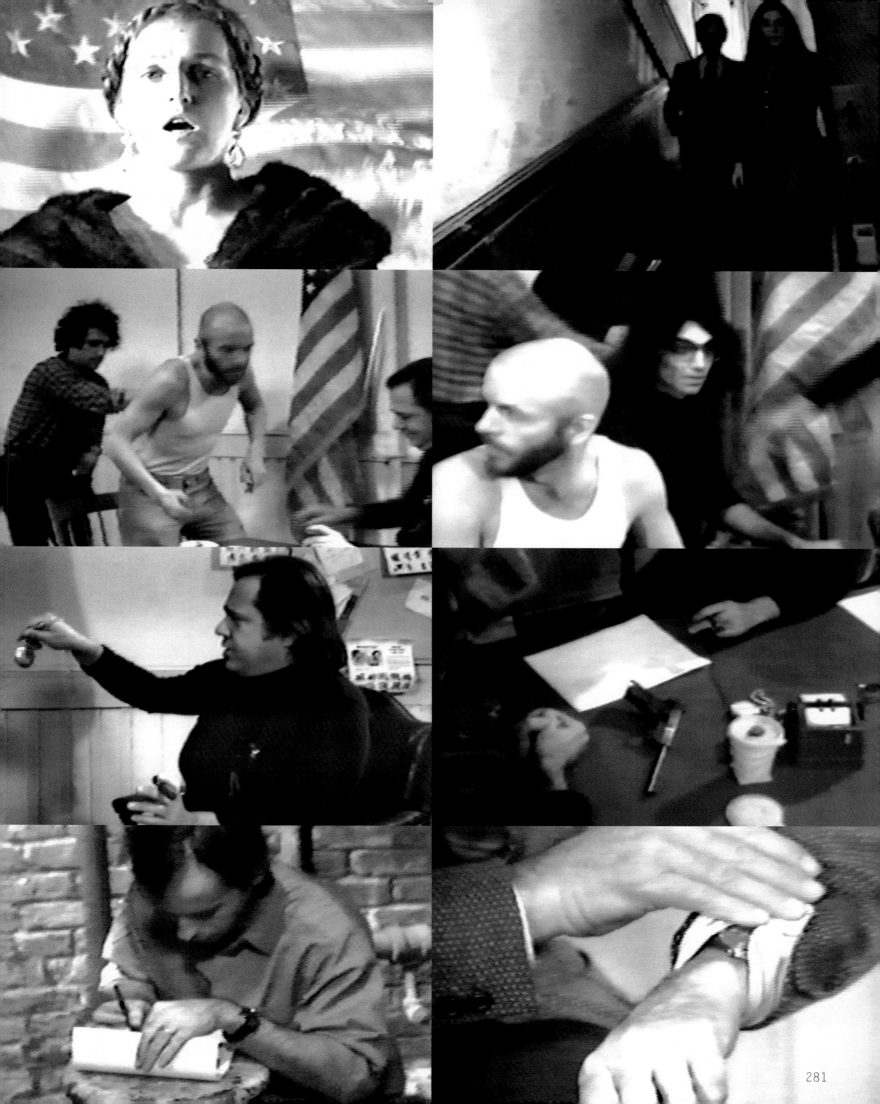

Richard Serra (b. 1939)
Selected Single Channel Film and Video Works

Hand Catching Lead, 1968
Hand Lead Fulcrum, 1968
Hands Scraping, 1968
Hands Tied, 1968
Frame, 1969
Three untitled films, 1969
Untitled, 1969
Untitled, 1969
Color Aid, 1970-71
Paul Revere, 1971
Veil, 1971
Anxious Automation, 1972
China Girl, 1972
Surprise Attack, 1973
TV Delivers People, 1973
Match Match Their Courage, 1974
Boomerang, 1974
Prisoner's Dilemma, 1974
Railroad Turnbridge, 1976
Steelmill/Stahlwerk, 1979

(278) *Surprise Attack*, from Videoworks Vol. 1., 1971-1974, 25:53 min, b&w, sound
(279) *Boomerang*, from Videoworks Vol. 1., 1971-1974, 25:53 min, b&w, sound
(280) *Anxious Automation*, from Videoworks Vol. 1., 1971-1974, 25:53 min, b&w, sound
(281) *Prisoners' Dilemma*, 1974, 40:15 min, b&w, sound
(282) Top to bottom: *Prisoners' Dilemma*, 1974; *TV delivers people*, from *Videoworks Vol. 1.*, 1971-1974; *Surprise Attack*, from *Videoworks Vol. 1.*, 1971-1974
(283) Top: *Anxious Automation*, from Videoworks Vol. 1., 1971-1974
Bottom: *Boomerang*, from Videoworks Vol. 1., 1971-1974

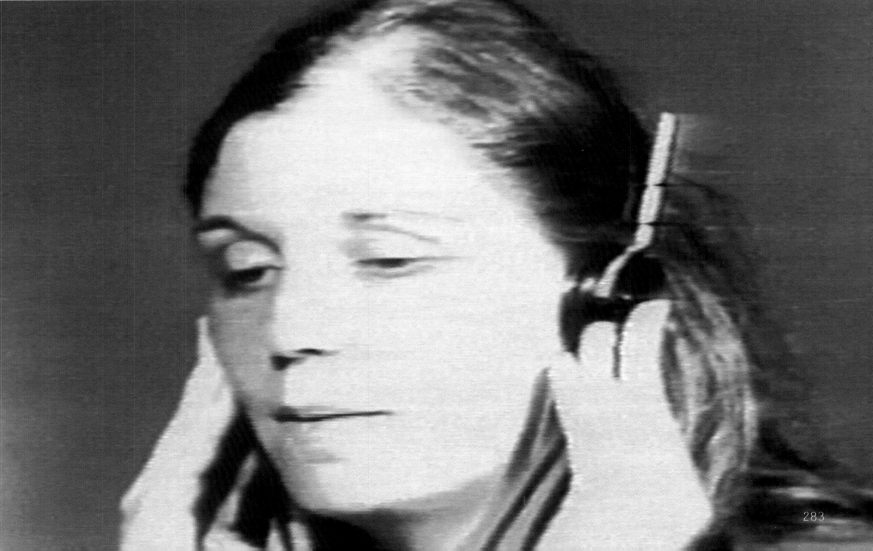

Katharina Sieverding

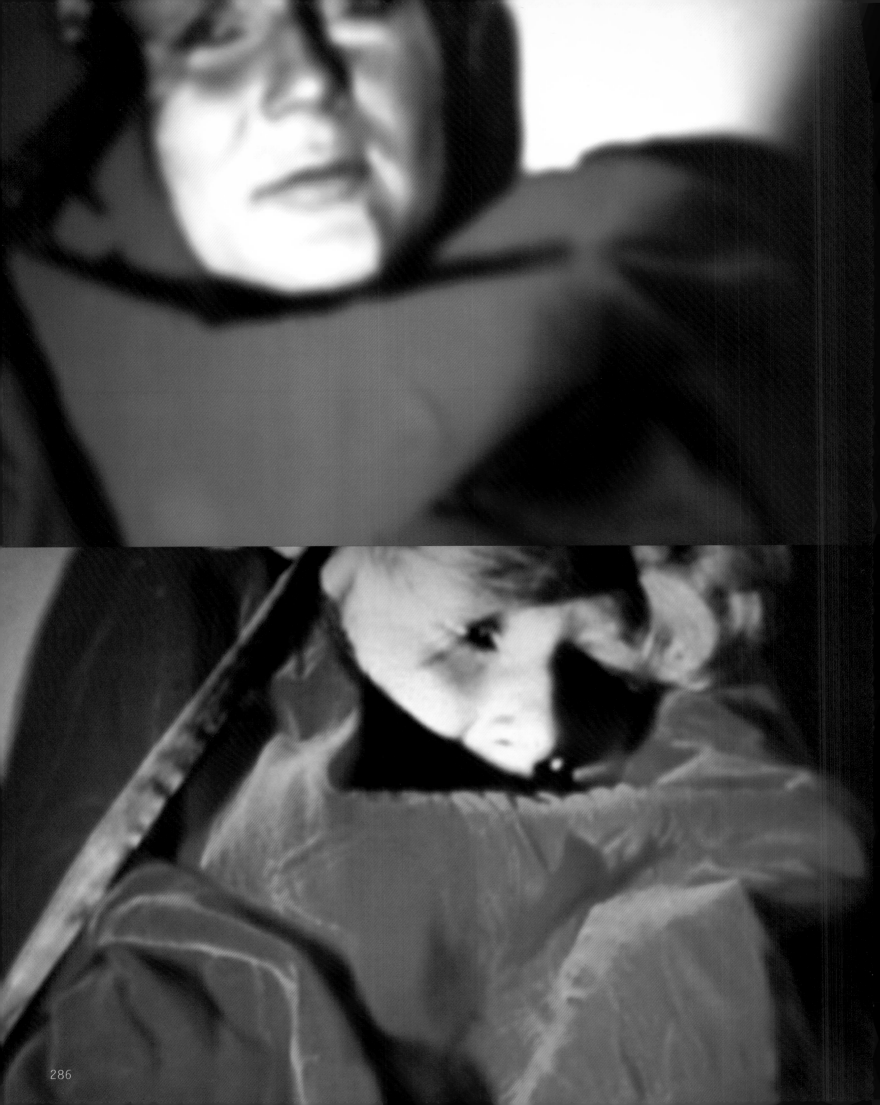

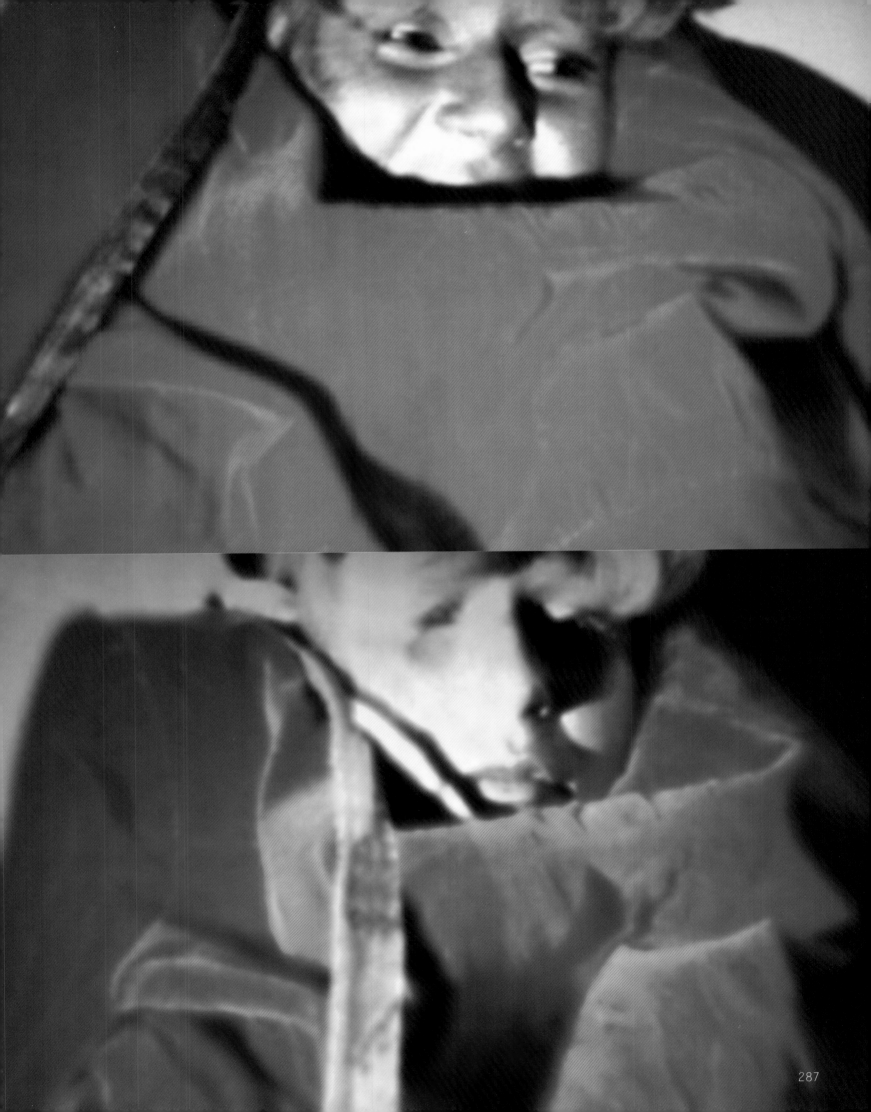

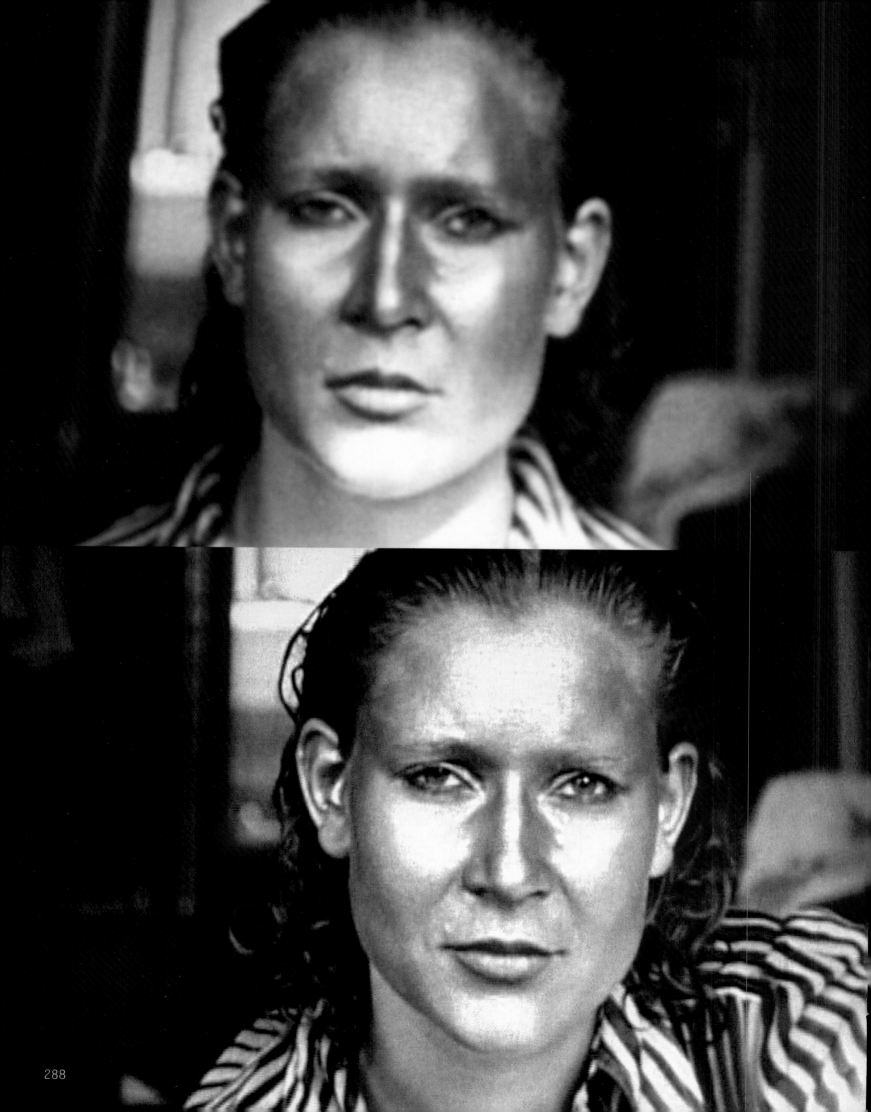

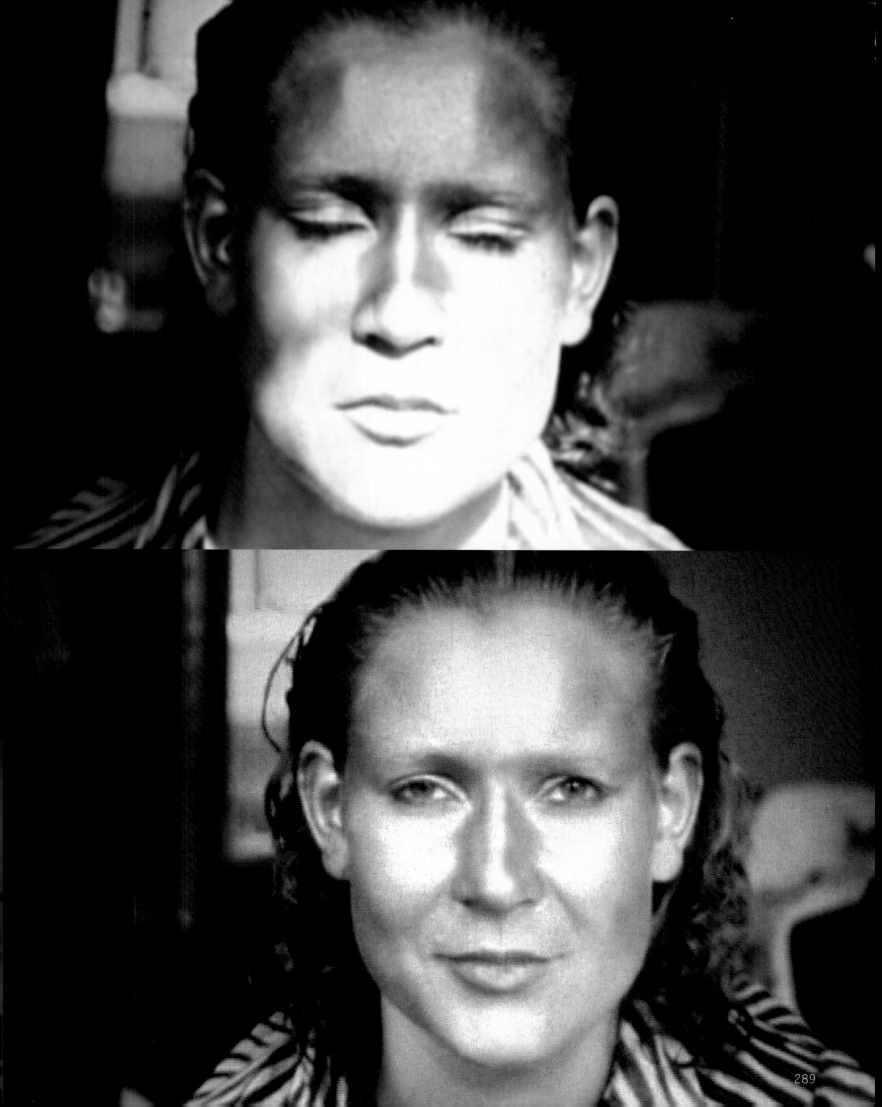

Katharina Sieverding (b. 1944)
Selected Single Channel Video Works

Life-Death, 1969
New York, 1969
Sun Eva, 1969
Hanging Boots, 1969
San Calisto, 1972
Jimmy Joe, 1972
Video Spiegel I-VII/196, 1973
Transformation, 1974
Forbidden Path, 1975
Ergaenzung und Entstellung, 1975
Jugoslavija I/II (collaboration with Klaus Mettig), 1975
China (collaboration with Klaus Mettig), 1978
Weltlinie I, 1999
Weltlinie II, 2001

All images courtesy of the artist

(286-289) *Life-Death*, 1969
(290) Top to bottom: *San Calisto*, 1972; *Life-Death*, 1969;
Weltlinie I, 1999
(291) Top row: *Life-Death*, 1969
Middle row: *San Calisto*, 1972; *Forbidden Path*, 1975
Bottom row: *Jugoslavija I/II (in collaboration with Klaus
Mettig)*, 1975; *China (in collaboration with Klaus Mettig)*, 1978

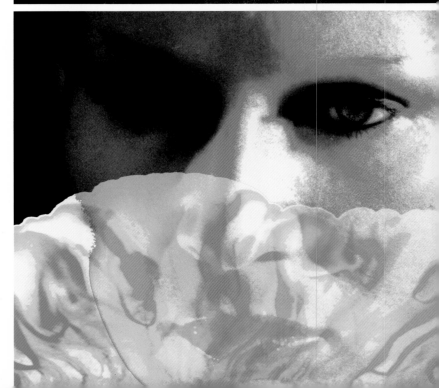

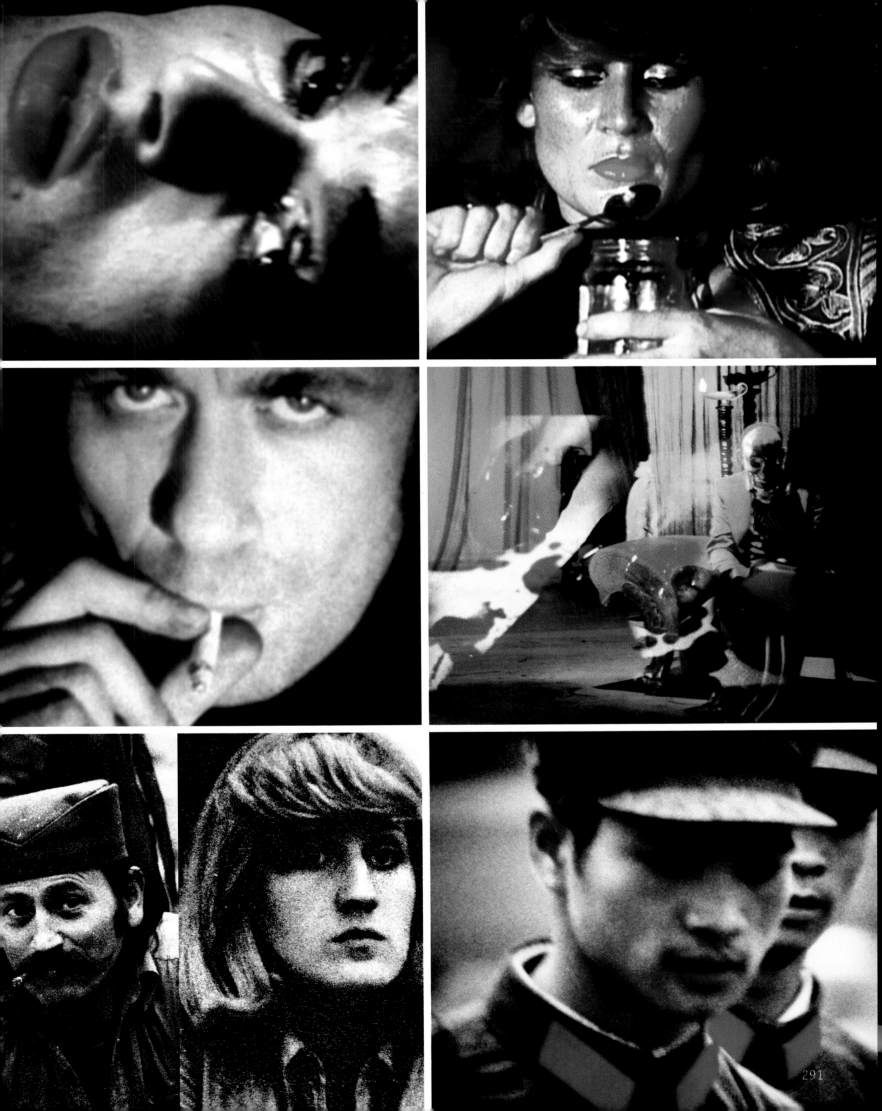

Bill Viola

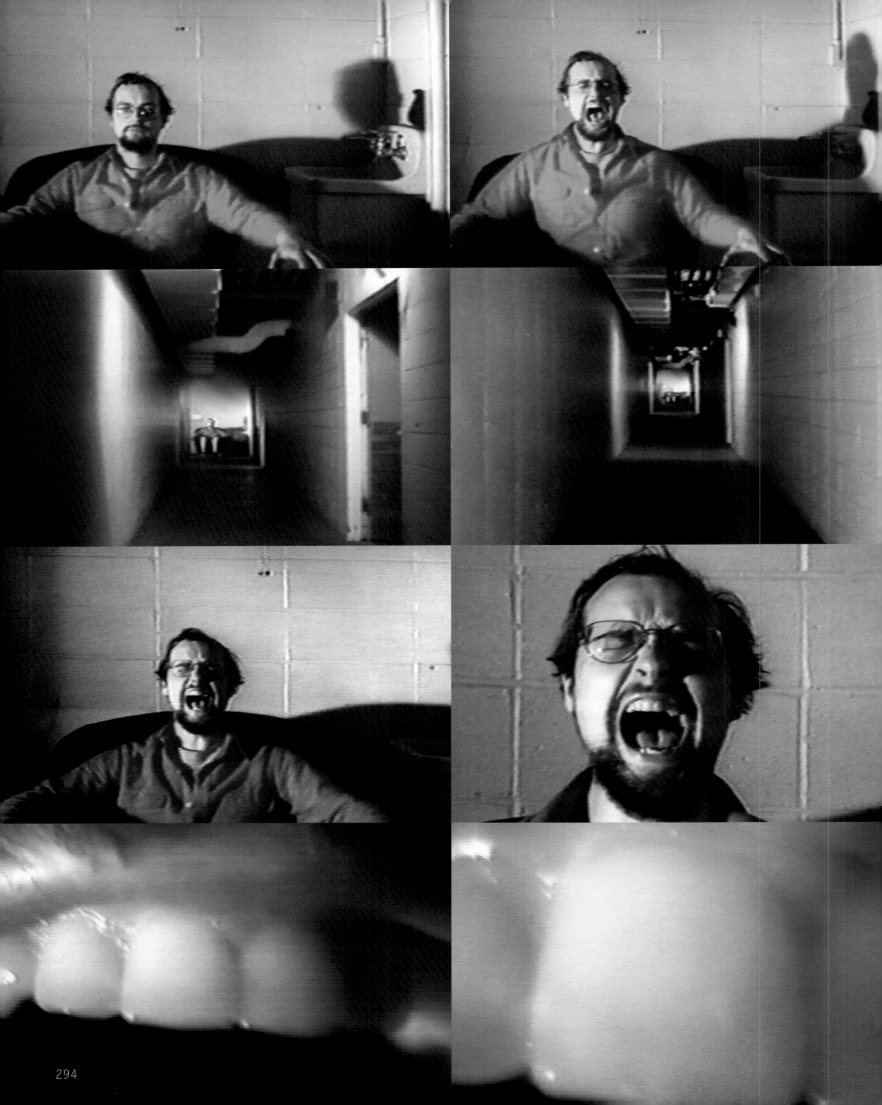

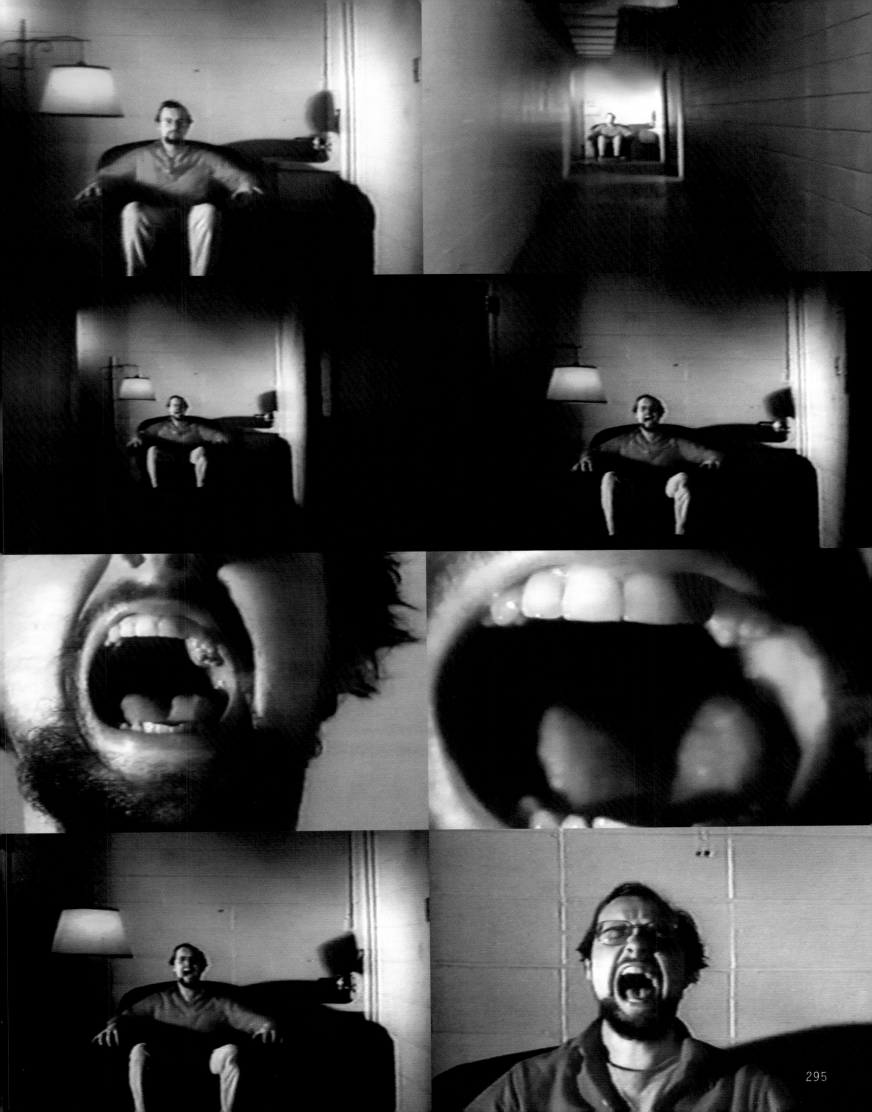

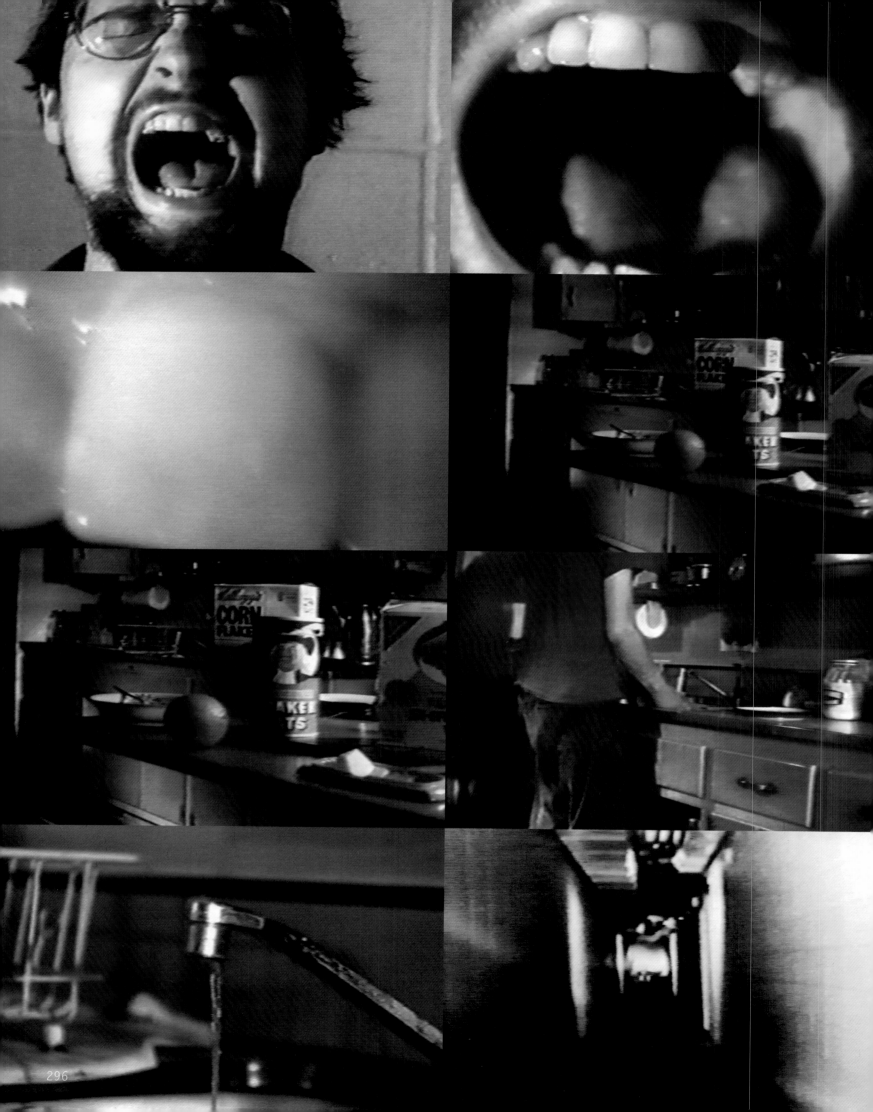

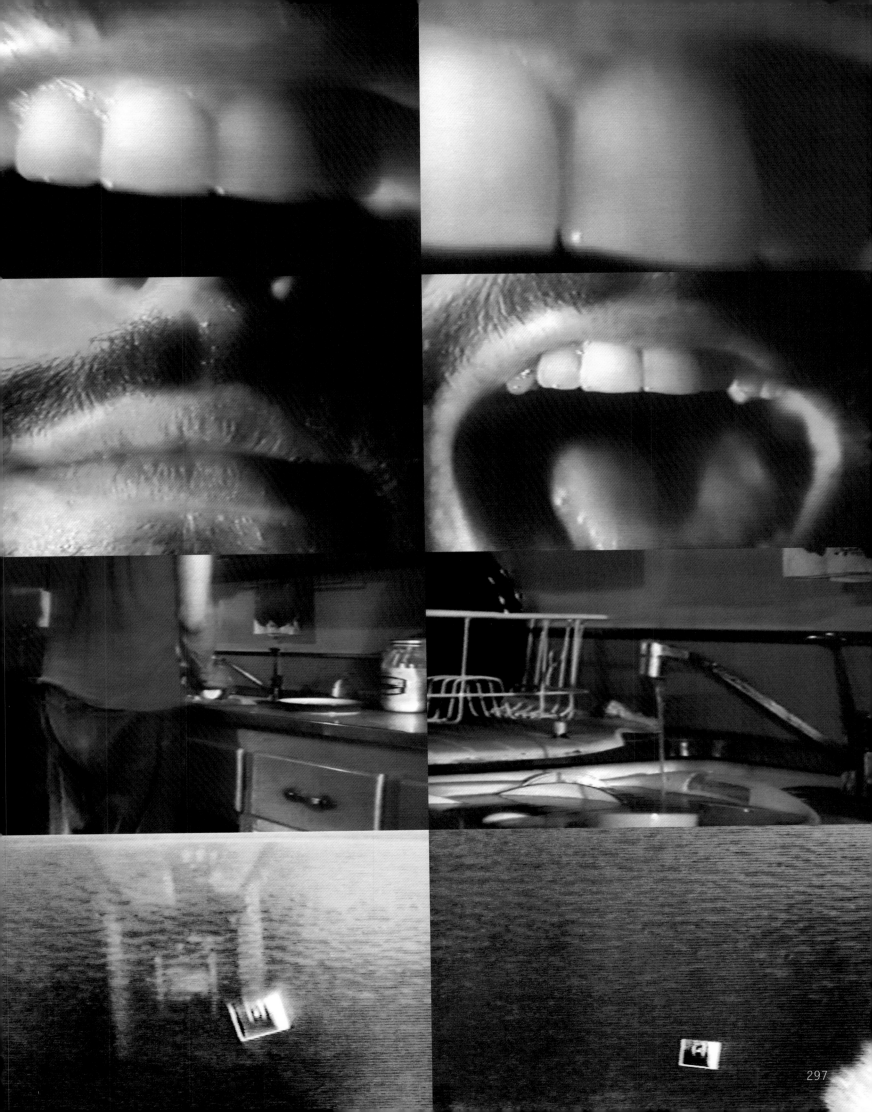

Bill Viola (b. 1951)
Selected Single Channel Video Works

Information, 1973
Red Tape - Collected Workss, 1975
Playing Soul Music to My Freckles, 1975
A Non-Dairy Creamer, 1975
The Semi-Circular Canals, 1975
A Million Other Things (2), 1975
Return, 1975
Four Songs, 1976
Junkyard Levitation, 1976
Songs of Innocence, 1976
The Space Between the Teeth, 1976
Truth Through Mass Individuation, 1976
Migration, 1976
Memories of Ancestral Power (The Moro Movement in the Solomon Islands), 1977
Memory Surfaces and Mental Prayers, 1977
The Wheel of Becoming, 1977
The Morning After the Night of Power, 1977
Sweet Light, 1977
Palm Trees on the Moon, 1977
The Reflecting Pool - Collected Work, 1977-80
The Reflecting Pool, 1977-79
Moonblood, 1977-79
Silent Life, 1979
Ancient of Days, 1979-81
Vegetable Memory, 1978-80
Chott el-Djerid (A Portrait in Light and Heat), 1979
Sodium Vapor (including Constellation and Oracle), 1979, released 1986
Hatsu Yume (First Dream), 1981
Anthem, 1983
Reasons for Knocking at an Empty House, 1983
Reverse Television - Portraits of Viewers (Compilation Tape), 1984
I Do Not Know What It Is I Am Like, 1986
Angel's Gate, 1989
The Passing, 1991
Déserts, 1994

All images courtesy of Electronic Arts Intermix (EAI), New York

(294-297) *The Space Between the Teeth*, 1976, 9:10 min, color, sound
(298-299) *The Reflecting Pool*, 1977-79, 7:00 min, color, sound
(300) Top to bottom: *The Passing*, 1991; *Sodium Vapor (including Constellation and Oracle)*, 1979, released 1986; *Junkyard Levitation (from Four Songs)*, 1976; *Songs of Innocence (from Four Songs)*, 1976
(301) Top row: *Ancient of Days (from The Reflecting Pool - Collected Work 1977-80)*, 1979-81; *Angel's Gate*, 1989; *Anthem*, 1983
Second row: *I Do Not Know What It Is I Am Like*, 1986; *Truth Through Mass Individuation (from Four Songs)*, 1976; *Information*, 1973
Third row: *Sweet Light (from Memory Surfaces and Mental Prayers)*, 1977; *Migration*, 1976; *Moonblood (The Reflecting Pool - Collected Work 1977-80)*, 1977-79
Fourth row: *Palm Trees on the Moon*, 1977; *Reverse Television - Portraits of Viewers (Compilation Tape))*, 1984; *Silent Life (The Reflecting Pool - Collected Work 1977-80)*, 1979
Bottom row: *Territorio Do Invisiel (Site of the Unseen, in collaboration with Carlos Nader and Marcello Dantas)*, 1994; *The Wheel of Becoming (from Memory Surfaces and Mental Prayers)*, 1977; *Reasons for Knocking at an Empty House*, 1983

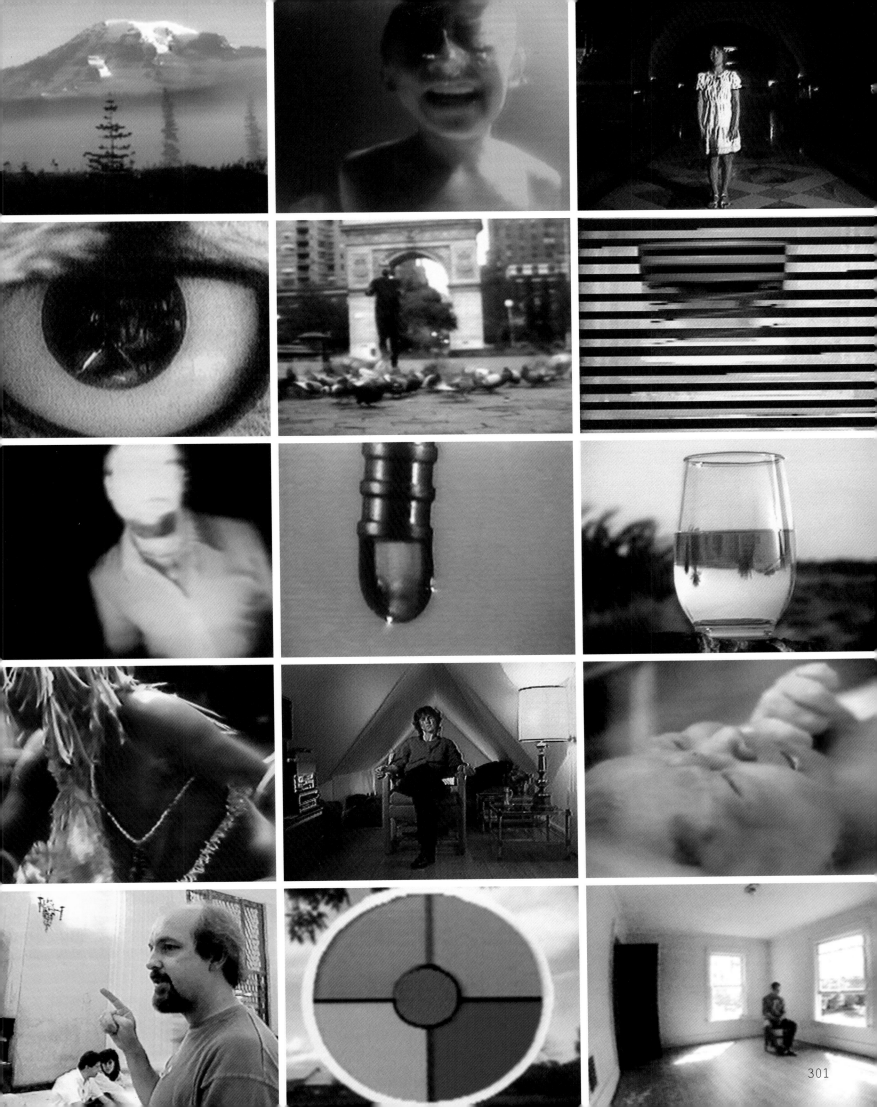

William Wegman

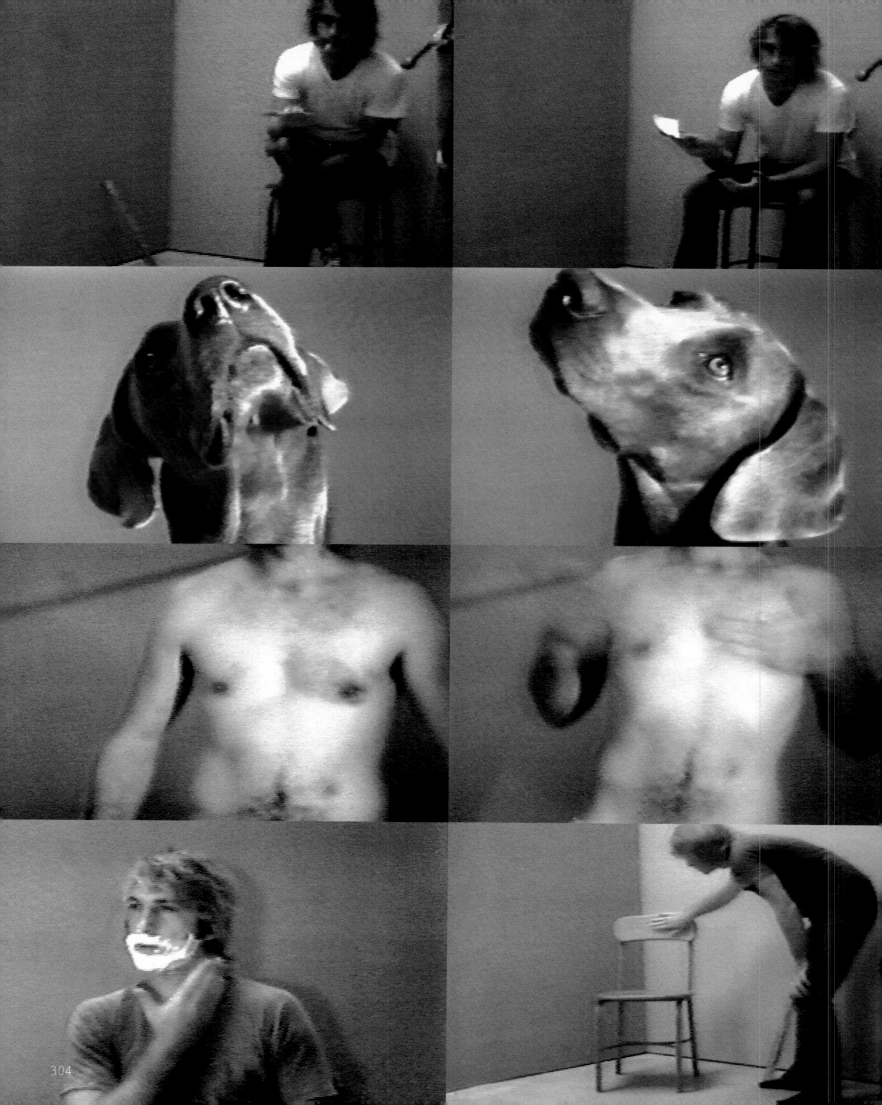

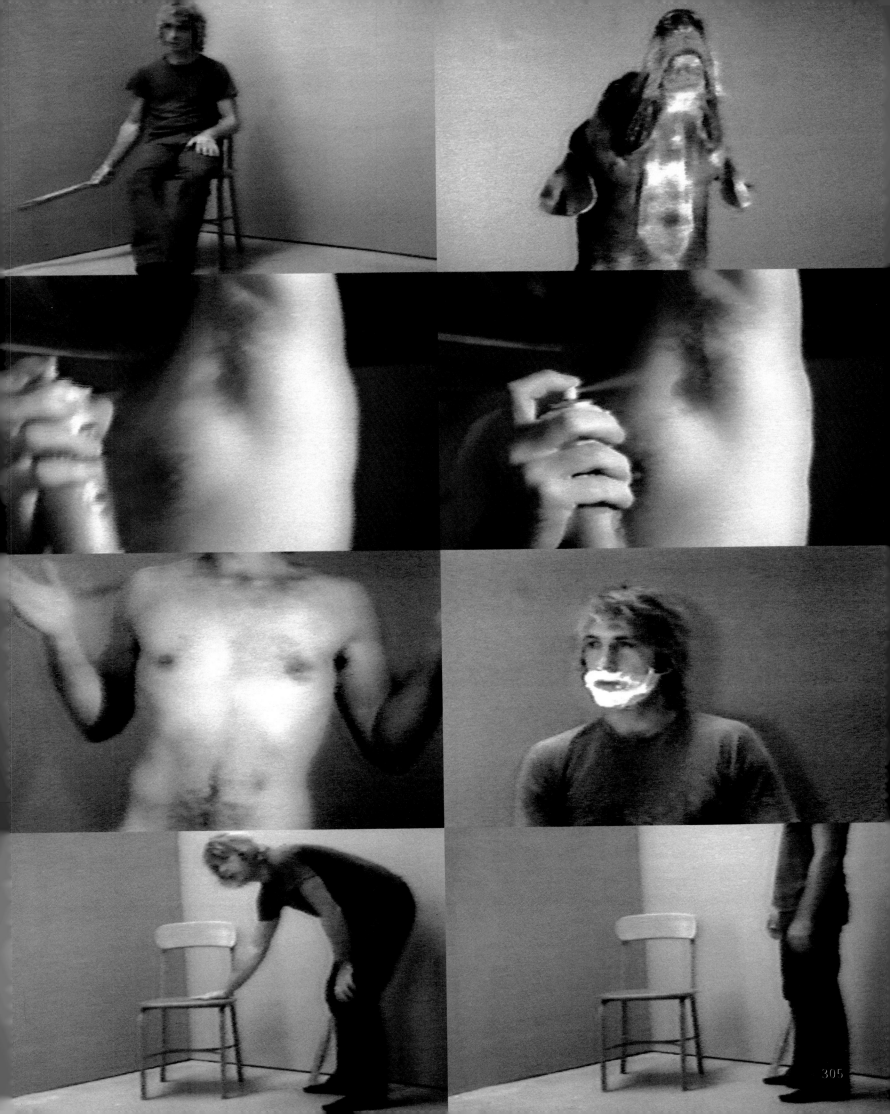

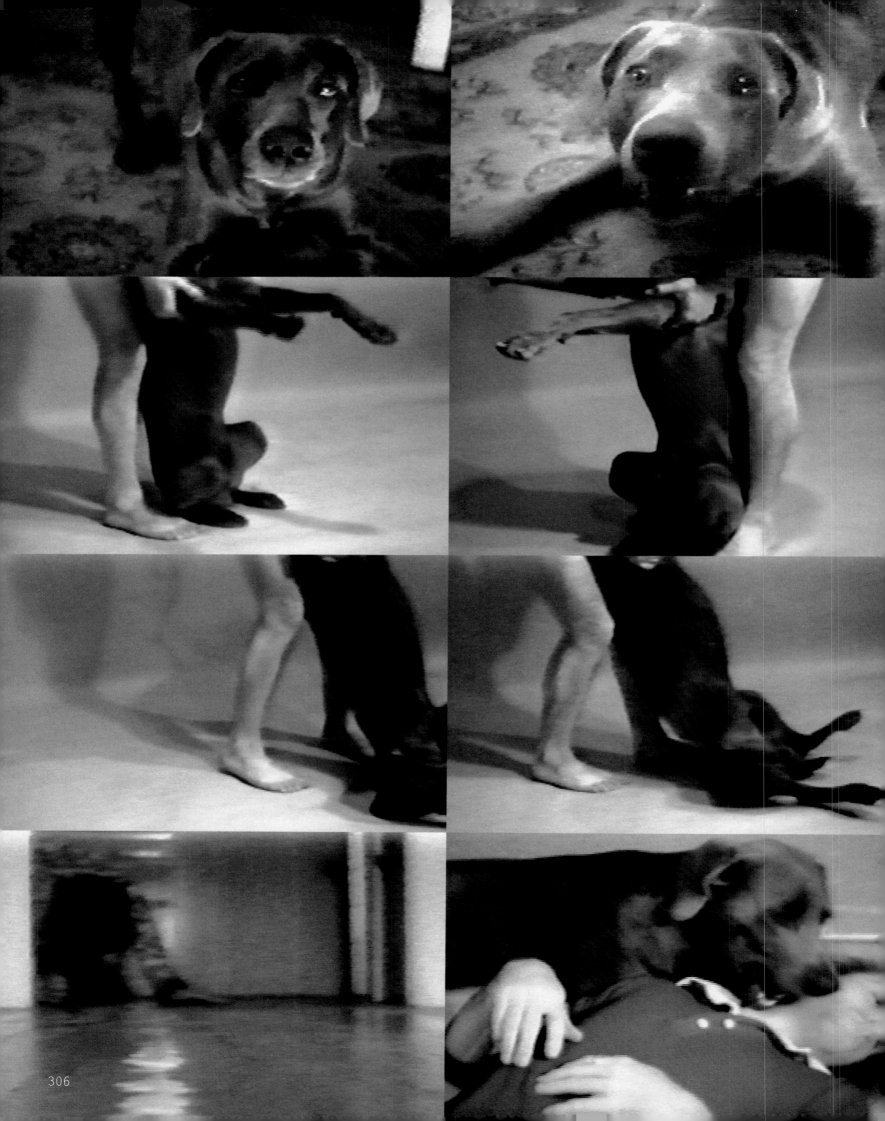

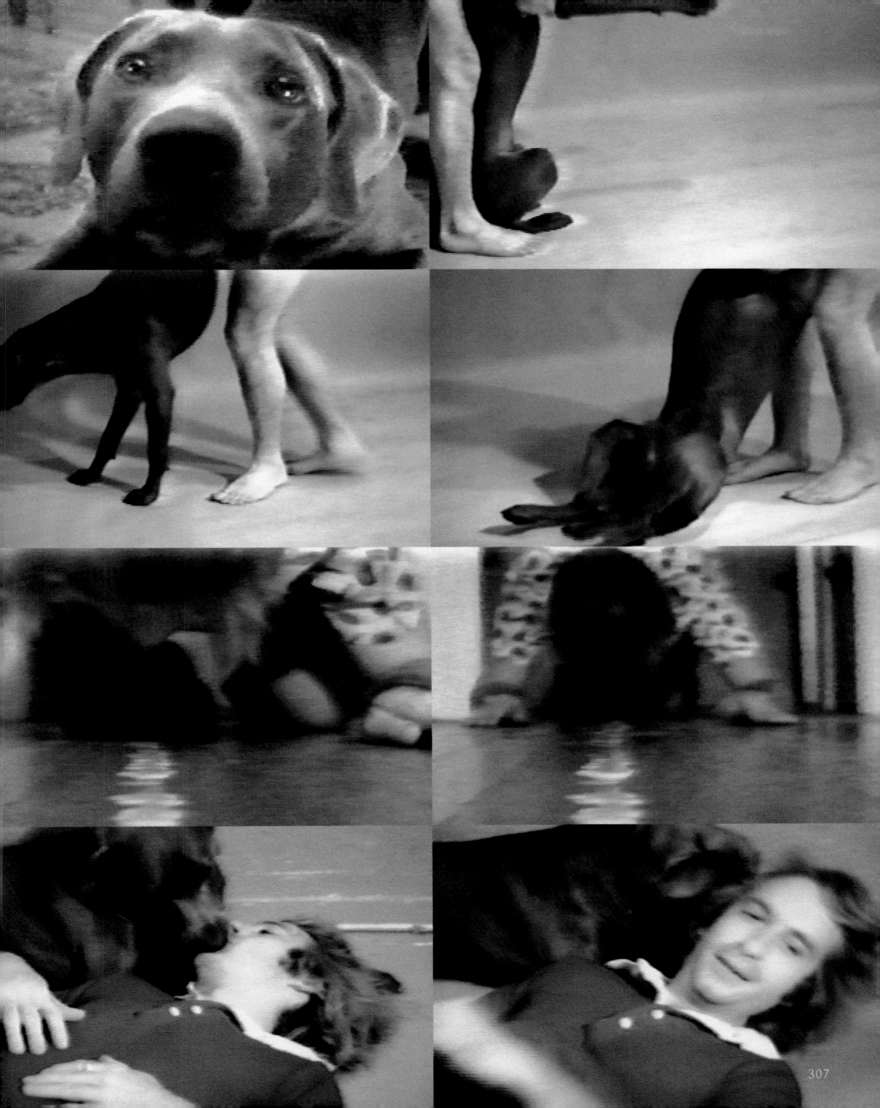

William Wegman (b.1943)
Selected Single Channel Video Works

Spit Sandwich, 1970
Selected Works: Reel 1, 1970-72
William Wegman: Selections from 1970-78, 1970-78
Selected Works: Reel 2, 1972
Selected Works: Reel 3, 1973
Selected Works: Reel 4, 1973-74
Selected Works: Reel 5, 1974-75
Selected Works: Reel 6, 1975
Selected Works: Reel 7 (Revised), 1976-77
Man Ray, Man Ray, 1978
Accident, 1979
Gray Hairs, 1976
How To Draw, 1983
Dog Baseball, 1986
The World of Photography, 1986
Blue Monday, 1988
Sesame Street Fay Ray Segments, 1989
Selected Works: Reel 8, 1997-98
Selected Works: Reel 9, 1999

All images courtesy of Electronic Arts Intermix (EAI), New York

(304-305) *Selected Works: Reel 3*, 1973, 17:54 min, b&w, sound
(306-307) *Selected Works: Reel 5*, 1974-75, 26:38 min, b&w, sound;
Selected Works: Reel 4, 1973-74, 20:57 min, b&w, sound; *Selected
Works: Reel 1*, 1970-72, 30:38 min, b&w, sound; *Selected Works:
Reel 2*, 1972, 14:19 min, b&w, sound
(308) Top to bottom: *Man Ray, Man Ray*, 1978; *Selected Works: Reel
9*, 1999; *Selected Works: Reel 8*, 1997-98
(309) Top row: *Selections from 1970-78*, 1970-78; *Dog Baseball*,
1986
Middle row: *Blue Monday (in collaboration with Robert Breer and
New Order)*, 1988; *Selected Works: Reel 4*, 1973-74
Bottom row: *Selected Works: Reel 3*, 1973; *Selected Works: Reel 7
(Revised)*, 1976-77

The programs at P.S.1 Contemporary Art Center are made possible in part by the New York City Department of Cultural Affairs, the Office of the Borough President of Queens, and the Council of the City of New York.

Kunst-Werke, KW, Institute for Contemporary Art plans to host this exibition in Berlin and has provided additional support for the catalogue.

KW - Institute for Contemporary Art
Kunst-Werke Berlin e.V.
Auguststr. 69
10117 Berlin
T: ++49.30.24.34.59.0
F: ++49.30.24.34.59.99
Info@kw-berlin.de
www.kw-berlin.de

Board of Directors:
Eike Becker
(President)
Eberhard Mayntz
(Vice President)
Kate Merkle
(Treasurer)
Klaus Biesenbach
(Founder and Artistic Director)
Alanna Heiss
(Curatorial Advisor)
Katharina Sieverding
(Artistic Advisor)
Marina Abramovič
Alexandra Binswanger
Lawton W. Fitt
Jenny Goetz
Egidio Marzona

The cultural programs of Kunst-Werke Berlin e.V., Institute for Contemporary Art, are made possible thanks to the support of the Senatsverwaltung fur Wissenschaft, Forschung und Kultur, Berlin and additional support by P.S.1 Contemporary Art Center, a MoMA affiliate. Supported by Stiftung Deutsche Klassenlotterie Berlin (DKLB-Stiftung) and by Dornbracht Armaturenfabrik, Iserlohn/Germany. www.dornbracht.com.

P.S.1 thanks Marina Abramovič, Wolfgang Abramowski,
Vito Acconci, Luhring Augustine, Matthew Barney, Eike Becker,
Judith Becker, Sine Bepler, Kim Bush, Peter Campus,
Hans-Jorg Clement, Stefanie Eckerskorn, Marianne Esser,
Dorothee Fischer, Peter Foley, David Frankel, Jorg Gimmler,
Jenny Goetz, Adrienne Gohler, Carol Greene, Carmen Hammons,
Gabriele Horn, Kate Horsfield, Chrissie Iles, Joan Jonas,
Rainer Jordan, Galen Joseph-Hunter, Marlies Krause-Pitrowsky,
Markus Krieger, Siegfried Langbehn, Niklas Maak,
Abina Manning, Kirsten Mayntz, Bernd Mehlitz, Kate Merkle,
Zach Miner, Sergio Morici, Ralph Muller, Nic Murphy,
Juliet Myer, Bruce Nauman, Josh Nissim of Scharff Weisberg
Inc., Thomas Olbricht, Ed Pusz, Bart Rutten, Imke Schwarzler,
Kevin Scott, Nancy Spector, Iris Steinbeck,
Katharina Sieverding, Orson Sieverding, Holger Struck,
Hans Ulrich Obrist, Leslie Tonkonow, Larissa van Loock,
Matten Vogel, Hortensia Volckers, Antje Vollmer,
Anneke Voorhees, Thea Westreich, Hans-Georg Wieck,
Klaus Wowereit, and Lori Zippay.

We thank the following galleries, organiztions, and studios: Acconci Studio, Artemis - Greenberg Van Doren Gallery, New York; Artist Rights Society (ARS), New York; Bowery Restaurant Supply, New York; James Cohan Gallery, New York; Electronic Arts Intermix (EAI), New York; Konrad Fischer Gallery, Duesseldorf; Gagosian Gallery, New York; Barbara Gladstone Gallery, New York; Marian Goodman Gallery, New York; Gorney Bravin & Lee, New York; Mike Kelley Studio; Sean Kelly Gallery, New York; Luhring Augustine, New York; Paul McCarthy Studio; Metro Pictures, New York; Netherlands Media Art Institute, Montevideo/Time based Arts, Amsterdam; Sonnabend Gallery, New York; Sperone Westwater, New York; Jack Tilton/Anna Kustera, New York; Leslie Tonkonow Gallery, New York; Video Data Bank, Chicago; White Cube, London.

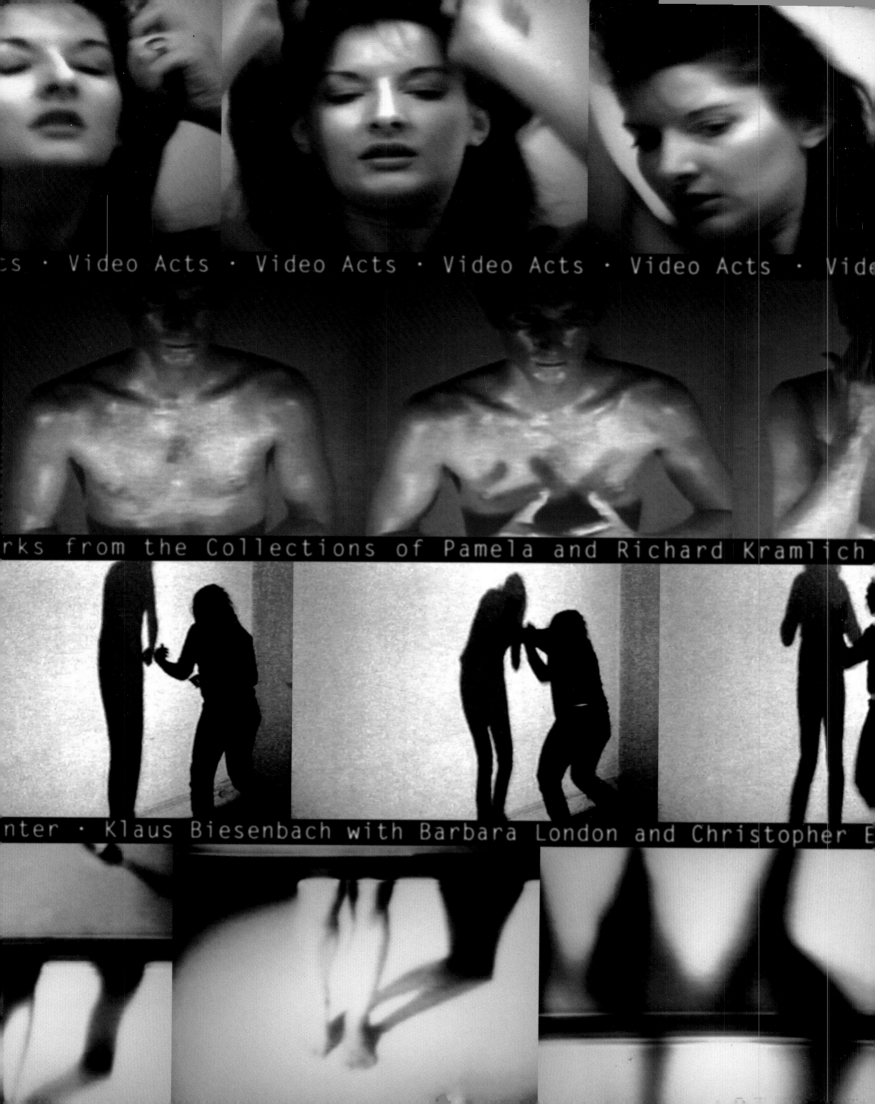

· Video Acts · Video Acts · Video Acts · Video Acts · Vide

rks from the Collections of Pamela and Richard Kramlich

nter · Klaus Biesenbach with Barbara London and Christopher E